• Lot 6 • Low Number • Jack Mack & Heart Attack • Mad Society • Magic • Magister Ludi • Manson Youth • Richard Mars • Mature Adults • The Mau-Maus • Mentors • Mertz • M.I.A. • Micro Mastadons • Middleclass • Midnight Museum • M.D.C. (Millions of Dead Cops) • Mindsweeper • Minimal Man • Minority • The Minutemen • Mr. Clean • Mr. E. & the Necromantics • Mnemonic Devices • Modern Torture • Modern Warfare • Momo • Mods • Mary Monday • The Mondellos • Monitor • Mood of Defiance • Motels • Motive • Mumbles • Mummers & Poppers • Mumps • The Mutants • MX-80 • Naked City • Naked Lady Wrestlers • Name • Naughty Sweeties • Needles & Pins • Negative Trend • Negativland • Hal Negro & the Satin Tones • The Neighbors • Neon • The Nerves • Nervous Gender • Neutrinoz • New Boots • New Critics • New Marines • New West • Nig-Hiest • Nightmare • No Alternative • No Crisis • Noh Mercy • No Imagination • The Noise • Non • No Sisters • No Strife • Novak • The Nubs • Nuclear Valdez • Nu Kats • Null & Void • Nu Models • The Nuns • Odd Squad • Offs • Oingo Boingo • Omelets • 100 Flowers • (On The Rag) • Orchids • Others • Our Daughter's Wedding • Outer Circle • The Outfits • The Outsiders • Overkill • Pale Imitations • Pariah • Passions • Patriotic Shock • Paul is Dead • Pearl Harbor & the Explosions • Peer Group • The Penetrators • Permanent Wave • Peter Bilt & the Expressions • Peter & Peter Peterson • Phast Phreddie & the Precisions • Phranc • Pink Section • Plague • Planet of Toys • Plan 9 • PLH • Plimsouls • The Plugz • Poor Boys • The Pop • Prefix • Pricilla B. • The Prisoners • Programme • Psychopathic Electricians • Psychotic Pineapple • The Puds • The Punts • The Pushups • Questions • The Quick • Radiators • Rads • Rain of Terror • Ralph Pheno & the Twitchers • Randoms • Raul & the Infidels • Rayonics • Reactionaries • Readymades • Real Music • The Realtors • Rebel Truth • Red Asphalt • Red Brigade • Redd Kross • Red Pencils • Red Scare • Red Wedding • Red Zone • Regime • Renaldo & the Loaf • Renegades • The Rentz • The Residents • Revenge • RF 7 • Rhino 37 • Ribsy • Rik L Rik • Rockadiles • Roid Rogers & the Twirling Buttcherries • Romeo Void • Rotters • Rox • The Runaways • The Runs • Runts • RYOT • Saccharine Trust • Saigon • Saints • Norman Salant • Salvation Army • Savage • Savage Republic • Scapegoats • Scarlet Harlott • The Scientists • The Schematics • Screamers • S.E.C. • Secret Hate • Seditionary • See Spot • Seizure • Session • Several Pamulas • Sex Sick • Shadow Minstrels • Shakers • Shakin Street • Sharp • Shashi • Shattered Faith • Shieks of Shake • Shock • The Shitheads • Shut-Up • The Silencers • Silhouette • Silver Chalice • Silvetone • Simpletones • Sin 34 • The Situations • Six O'Clock News • Skin • Skin Head Army • The Skrewz • The Skulls • The Slashers • Sleepers • The Slivers • Slow Children • The Smog Marines • The Snails • Snakefinger • Snuky Tate • Social Dismay • Social Distortion • Social Task • Social Unrest • Society Dog • Soul Rebels • Space Trash • Sparks • Spazz Attack • Spectators • The Speed Queens • The Spikes • Splinter • Spitting Teeth • Spoilers • Sponges • Spys • Spy vs. Spy • Square Cools • Squares • The Stains • S.S.I. • Standbys • Stars • Static Picnic • Stepmothers • Stereo • Stingers • Sting Rays • Stiv Bators • The Strain • Strap-On Dicks • Strict ID's • Suburban Lawns • Suburbs • Suicidal Tendencies • Sudden Fun • Sue Saad & the Next • Super Heroines • Surface Music • Surf Punks • Survivors • S.V.T. • Symbol 6 • The Symptoms • Larry Talbot • The Tanks • Tantrum • Tao Chemical • Target 13 • Tattooed Vegetables • Tazmanian Devils • Teenage Love • Tenants • Textones • Thriller • Thus • Tickets • Tiki Club • Times 5 • Timmy • Titans • Toiling Midgets • The Tokyos • Tuxedo Moon • Tongue Avulsion • Too Bad • The Tools • Top Jimmy & the Rhythm Pigs • Toxic Era • Toxic Shocks • T.S.O.L. (True Sounds of Liberty) • Tupelo Chain Sex • 20/20 • The Twinkeys • Twisted Roots • Twotones • 2=2 • The Three O'Clock • Ugh-Ahhh-Ooo • Ultra Sheen • The Undead • Unaware • The Undertakers • Units • Unit 3 with Venus • The Unknowns • Unnamed Tribe • Uns • The Upbeat • Urban Assault • Urban Leisure • Urban Grillas • The Urge • The Urinals • UXA • UXB • Vacant • Valkays • Vandals • Varve • Vegetables from Mars • Velveeta Underground • Vengeance • Venus & the Razor Blades • Venus & Unit 3 • Verbs • The Verves • Vice Squad • Vicious Circle • The Vidicts • The V.I.P.s • Visitors • The VKTMS • Voice Farm • VOM • Voodoo Church • Vox Pop • VS. • Wall of Voodoo • War Diary • War Zone • Wasp Women • Wasted Youth • Weasels • The Web • Weirdos • Johanna Went • Western Heroes • Whippets • Whipping Boy • Why Not • The Wild • Wild Cat Crew • Wild Combo • Wild Kingdom • Wild Remain • Wild Women of Borneo • Willys • Wolverines • Woundz • The Winds • X • X-Dreamists • X-iles • X-Mas Eve • X-Ray Dog • X-Ray Ted • Xstrems • The Xterminators • You • Young Alcoholics • Young Pioneers • Youth Brigade • Youth Gone Mad • Yvonnes • Earl Zero & Cornerstone • Zero Population Growth • The Zeros • The Zippers • Zits • Zoogz Rift •

Copyright © 1983 by Peter Belsito and Bob Davis.

All rights reserved. No part of this book may be reproduced or transmitted in any form or by any means electronic or mechanical, including photocopying, recording, xerography, or any information storage and retrieval system, without permission from the authors.
Manufactured in the United States of America.
Library of Congress Card No. 83-081513
ISBN No. 0-86719-314-X

Published by THE LAST GASP OF SAN FRANCISCO, P.O. Box 212, Berkeley CA 94704. Ron Turner, managing editor.

HARDCORE CALIFORNIA was edited by Peter Belsito and Bob Davis.
Designed by Peter Belsito.
Photo Consultant: f-stop Fitzgerald

1st printing — August 1983
2nd printing — September 1984
3rd printing — August 1989

Printed in Hong Kong

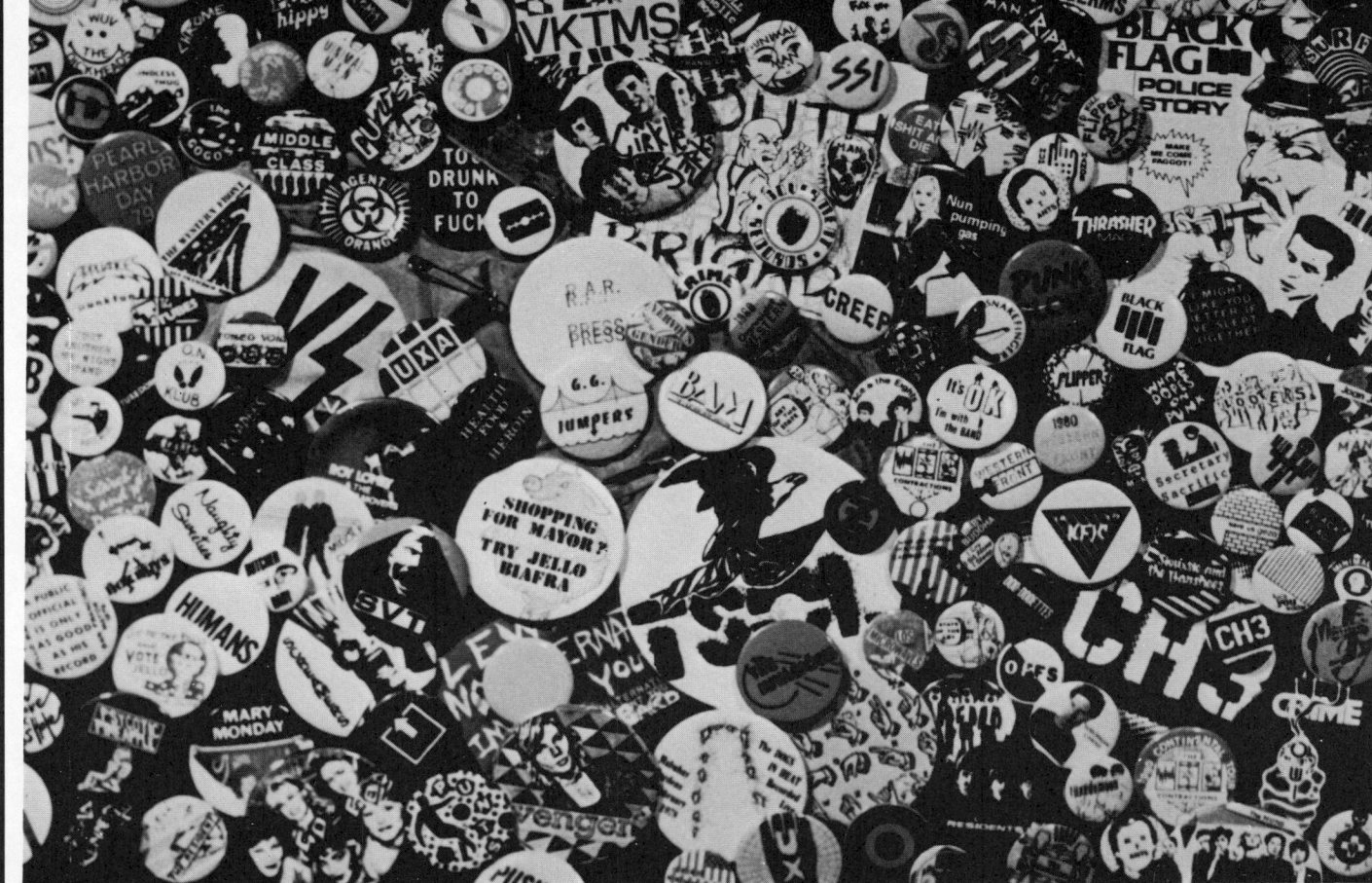

2.

1. *Front Cover*. BAD POSTURE, On Broadway, San Francisco, 1982. Photo: George Sera.

2. An assemblage of buttons and stickers. Photo: f-stop Fitzgerald.

HARDCORE

PETER BELSITO

BOB DAVIS

CALIFORNIA
A HISTORY OF PUNK AND NEW WAVE

ACKNOWLEDGMENTS

The editors' gratitude goes to the following individuals, organizations and bands for their assistance: Bruce Kalberg (No magazine), Jay Jenkins (X manager), Canzoneri management (Go-Gos), Lynda Loo, AIM Records, Barry Beam, the Mutants, Rick van Santin, Adolescent Records, Diane Aziza-Ooka, SST Records, Raymond Pettibone, Black Flag, Subterranean Records, Kathy Hatch, Bomp Records, Diane Zincavage, Paul Grant, Faulty Products, Mark Cope, John Guarnieri, Slash Records, Bob Biggs, Susan, Rachel, Chris D., Mark Trilling, Posh Boy Records, Robby Fields, Jonathan Seay, Lisa Francher, Frontier Records, Tina Hopkins, Ephemera buttons, Jeff Errick, Ed Polish, Government Records at the Compound, Government Records in San Diego, J. Sats Beret, Robert Kulakofsky, Fatima Records, Richard Duardo, Jerry Maguire, Laura Garcia, Tim Yohannon, Queenie Taylor, Lou Cooper, Technical Knockout Graphics, Flipside, Al and Hudley, 415 Records, Howie Klein, Chris Knab, Brad Lapin, Kim Gardener, CH3, Los Angeles Personal Direction, Spock, Better Youth Organization, Mark and Sean Stern, Joseph Jacobs, Factrix, Monte Cazzaza, Rough Trade, Steve Montgomery, Damon Edge, Chrome, Mark Takeuchi, Ira Sandler, Doug Diaz, Mark Chester, Tim Tonooka, Ripper magazine, Paul Rat, RRZ, Russell and Fredda, Tequila Mockingbird, Shawn Kerri, Gary Panter, Helen Sinelnikoff, f-stop Fitzgerald, Joegh Bullock, Vince Fronczek, 20 x 20 Gallery, Richard Gaikowski, Mary Monday, Dirk Dirksen, Ginger Coyote, Jennifer Waters, Jim Stockford, Lisa Fredenthal, Paulette Denis, Corey Kanagawa, Karl Hinz, Shelly Wolfe, Anneliese Margot Simons, G. Howard, Maati Lyon, Scratz, Anne Nilsson, Chris Marlow, John Surreal, Kim Seltzer, Marian Kester, and Deidre Belsito.

We would also like to especially thank Peter Strange, Marcia Crosby and Carole Zingeser for their help and friendship.

This book is dedicated to Alan and Teri Elmont and to Ron Turner, without whose help and confidence this book would not have been possible.

3. Chris Cross, Valencia Tool and Die, San Francisco, 1983. Photo: Gary Robert.

INTRODUCTION
—Jonathan Formula

I realize that I have no business writing about something which expresses itself so well through music, words and visual imagery. I have no business reinterpreting people's lives, or their tastes, or their songs or their clothes. A lot of people will hate what I've said, some will love it, most won't care. That's as it should be. No one needs to speak for, or apologize for, or be so foolish as to try to "explain" the people in this book. But here it is.

ATTACK

I was given a rough draft of the text to this book, three days notice, and an utterly impossible task to accomplish: to deliver a precis of half a decade of cultural mutation in California, establish the writers' roles in it, toss in a few personal anecdotes and finish up with a tight, witty, concise outline of the changing of the avant-garde which took place and is captured in this work.

No problem.

I came to California from Mexico City at age eighteen for various reasons: I'd gotten my draft registration from the U.S. embassy, I'd gotten swellheaded about some success I'd been having with photojournalism and wanted to get to The Big Pond, but mainly, there wasn't enough music happening to satisfy me. San Francisco seemed the best choice since it was closer than New York and I had some cousins and friends living there. Ever since age twelve, when I started playing, singing and writing music, it had seemed like Mecca.

My politics were also of the shut-up-and-dance variety at the time, but I wound up with a bunch of people who were concerned enough with the Black Panther Oakland Schoolchildren's Breakfast Program to raise funds for it by any means. I spent four years in the state pen at Soledad for a $70 robbery and returned to San Francisco when I got out in late 1976.

SUSTAIN

"Painting is not done to decorate apartments. It is an instrument of attack and defense against the enemy. Good painting, any painting, ought to bristle with razor blades."
—Pablo Picasso

"Nobody ever called Pablo Picasso an asshole."
—Jonathan Richman

This book is a film, a silent documentary trying to describe its own soundtrack. It is made to create a yearning for What Was and What Can Be Again, and, possibly, to transmit a spark of the fire that burned in the souls of the people whose light was reflected into the lenses of the photographers.

The photographs, needless to say, stand on their own as artifacts from the period and culture covered in the book as well as journalistic documentation of those years and those tormented, obsessed people.

The text attempts to impose historical linearity upon an account of overlapping, prolonged and mostly simultaneous events which took place in two particular cities, San Francisco and Los Angeles, over a particular period of time, 1977 through 1983. A brave attempt, since, in retrospect, those events seem as chaotic, noisy, dynamic and indescribable as great waves crashing on some wild beach.

The truth, though, is that the crashing of these waves did not take place on a faraway beach, but rather in the very hearts of two of America's most active cities, both of which are reknowned for being at the cutting edge of contemporary growth, both social and cultural, political and economic, financial and demographic.

These world centers provided a growth medium for the furious bacteria whose names appear in the forthcoming text, and their facts testify that they were hellbent-for-leather to infect all the world with their unease.

Publisher Ron Turner asked me to elucidate the micro-organism metaphor, and I suppose I should since I'm using his typewriter: I mixed sound for Black Flag for a few months, and at a show with DOA at the Whiskey in Hollywood, I was up in the sound booth in the balcony. The booth jutted out over the dance floor, and throughout the first set I looked down at the boiling, roiling, leaping, writhing, frenzied crowd and saw a vision. I couldn't focus my eyes on the kids thrashing down below, I could only see a huge, bubbling mass of boots, bandanas, chains, black and red and faded blue, contorted faces, crazy colors and chromed spikes, swirling like a colony of angry young urban microbes under a microscope. It was like looking into the face of a tidal wave.

DECAY

Both the conservative and liberal wings of the Fourth Estate responded perfectly predictably to the explosion. The daily papers and TV news bureaus capitalized on the initial real violence of the thrash-punk boom and presented it to the American public as the sole attribute of an entire generational trend. The actual violence, it should be noted, was greatly reduced by the process of a peer group policing itself. This is reflected in the Dead Kennedys' song title

4.

JONATHAN FORMULA is a sound engineer and has worked with many of the bands in this book. He was a house sound man at the Savoy Tivoli up until its demise in 1981. He was a senior editor of *Damage* and played briefly in Tuxedo Moon, Other Music and the Hormones. He is currently involved with the Lifers and Snakefinger, and is a contributor to *EGO* magazine.

4. Boots. Photo: Ed Colver.

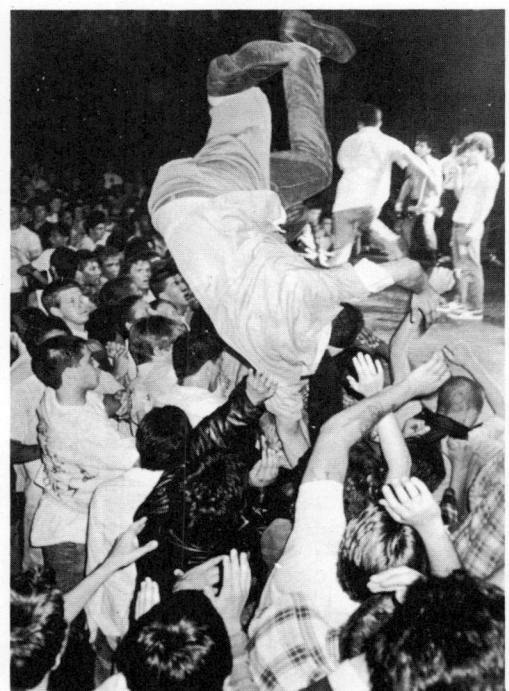

5.

CRAIG LEE played in the following punk and post-punk bands: The Bags, Catholic Discipline, The Boneheads, Funhouse as well as performing with Phranc. He has written for the following periodicals: *Slash, Damage, Flipside, L.A. Times*. Currently Music co-editor for the *L. A. Weekly*. Currently working on a fictional novel about, what else, sex, drugs and rock and roll.

Definitely the voice of future rock journalism, 16 year-old SHREADER has his own fanzine called *Rag and Chains*, has written extensively for *Flipside* and contributes to the *L.A. Weekly* on a regular basis after he gets home from high school.

5. Crowd at Circle Jerks concert, The Country Club, Los Angeles, 1982. Photo: Ann Summa.

"Nazi Punks Fuck Off."

The liberal press, on the other hand, tried to de-fang the beast, ignore the political and cultural cries for change, and try to do the Big Amoeba Dance: absorb an angry flurry of ferment and transform it into a nice, safe, consumable fad based on nothing more weighty than hairdos, fashion and the revival of various retro musical styles.

Virtually never, if ever, were the real causes for the dissatisfaction and anger explored, and when it came to coverage of "punk" in the media, there was a lot of titillating fantasy and very little journalism offered. And not unexpectedly, the upper strata of society took the drama and excitement from movement in the underside layers and used it to sell products to the middle: examine the new trends in the pages of *Vogue* over the past couple of years, the use of punky imagery in ads for *parfum*, cola and cars on network TV.

Although there are indeed parallels between beat, hippie and punk cultures, the press recorded the outward ones, the insignia and regalia, and missed the real ones. A pity: when it comes to *news*, truth and depth make for better copy than conjecture and sensationalism.

The Mutants are good for a pertinent quote: "We're living in the New Dark Ages, read about it in the magazine pages..."

Most of the people spraying anarchy symbols on the walls don't know what it really means, but a few do: the most furious dedication to responsibility for one's own behavior, and a fierce enough love for life to fight for it against death. A moribund people lie in wait for the end. They don't make much noise. This alone should be enough to demonstrate that the noisy, frivolous, gaudy people this book salutes want to smash the temples of doom, not eat babies. But this shit *is* dangerous. It is seditious, insidious, contagious and, like good art, any art, is a whole lot more fun than you generally think you're allowed to have.

Naturally, as there are no atheists in foxholes or nuclear waste disposal sites, there are no perfect saints in the subway. This book is about the hardcore, the committed and those who should be. Just about everyone in this book, both the baby demagogues who can't rock out without tossing in some political message, *any* political message; and the baby Monroes who are apolitical and just wanna dance, man, every one of them wants everything on the Big List: Fame, Warm milk — happy-face popsters or heroes of the rank and file, everyone wants to be a star.

And one more thing: these people, and the countless others who support them by going to their performances and buying their merchandise, are more valuable to the human gene pool than the "normal" members of their generation because they're more intelligent, curious, daring, defiant, critical, active, ambitious and determined than the rest of their demographic, who seem to be grimly chasing the latest perversion of the American Dream with the same zombie fervor displayed by Ron Cobb's famous cartoon character stumbling through the post-holocaust rubble, broken TV set under his arm, plug extended in hand, searching shellshocked for a functioning outlet.

RELEASE

Another aspect of this film is worth touching upon: religion. It's been said many times about the boldest and most visionary progenitors, i.e. Jim Morrison, Iggy Pop, Patti Smith, that they are "shamans," and that the catharsis experienced by performers and audiences is possibly the closest thing to a genuine religious experience that can be claimed by most people.

The inter-religion catechism of fellowship is mimicked by the way people are brought together for a communion with the spirit through a performer. Ask any fan about their current fave rave, and he or she will testify at length. People find words in song lyrics which articulate that which they cannot otherwise express.

In Tibetan Buddhism there is a vast pantheon of archetypes and demi-gods, some mighty, some weak, some true, some false, as in the pages of *Flipside* or *Trouser Press*. In the Catholic faith there are patron saints for every aspect of life. In the Hindu *Vedas* great battles are fought against evil and corruption, and this is mimicked by the true believers in truth, freedom and justice as expressed by some of the young political rockers, who believe they are fighting battles no less epic against personal complacency, sloth and resignation.

And for myself, sex, drugs and voodoo were part of every good show. Aldous Huxley wasn't around to see what was going on in the past few years, but if he had been, he may well have admitted that the frenzy of a noisy Elite Club show could transport someone to the antipodes of the mind as effectively as 125 mg. of mescaline.

FEEDBACK

They did a good job as curators, Peter Belsito and Craig Lee and Shreader for S.F. and L.A., respectively. All three are journalists and were Part of Everything. Peter was a co-founder of *Damage* magazine and ran one of the clubs mentioned in the book. Craig played in at least a couple of the bands mentioned, and he and Shreader have written extensively in various publications about new music. In the editor's preface the monumental work which went into this project is discussed, as well as the invaluable administrative contributions of Bob Davis, and of course, the battalion of contributing photogs.

Like any project of this nature, it is incomplete, and the editors would be the first to tell you the agonies involved in selection of material. All in all, it's got more meat and substance than any of the other attempts which have been made to document these years.

They nearly killed me, those years, and quite a few people didn't make it. I guess I'll dedicate my part of this book to them.

PREFACE

PETER BELSITO is the editor of *EGO* magazine and a contributing writer to the *Seattle Rocket, Another Room,* and ⓡ magazines. He also co-authored *STREETART: The Punk Poster In San Francisco* with Bob Davis and Marian Kester, co-founded *Damage* magazine in 1979, and Valencia Tool and Die in 1980.

BOB DAVIS, administrative editor, is also co-editor of *Break Glass In Case Of Fire: The Anthology from the Center for Contemporary Music at Mills College,* and *STREETART.* He also composes music for the avant garde theater company SOON 3 in their productions of *Renaissance Radar, Voodoo Automatic,* and *Red Rain.*

He is sound engineer for performance artist Laurie Anderson, and a member of the music faculty at City College of San Francisco since 1976.

This is a book about people who did it themselves. Kids who established their own sub-culture and created a recognizable style and musical sound to identify it. In California, there is precedent for youth movements. Cal Punk established a new cultural strata built on the ashes of the flower children and beat generation. They took what they needed from these previous movements and drew momentum from their contemporaries in New York and England. But, the California hybrid takes youth's traditional stance of defiance into the eighties with a renewed sense of desperation.

The working title of this book was STREET-LEVEL. We thought it conveyed the anti-institutional essence of San Francisco and Los Angeles Punk origins. These California scenes began in dank, ill-lit basements, abandoned synagogues, insolvent Filipino nightclubs, and biker bars — locations discarded by society. And, like spoons molded from bomb shells, these buildings were transformed into scenes of living theater. It's that kind of determination that makes people open a club knowing that the loud music and clientele will bring the police to close it. It sounds absurd, but it's hardcore compulsion that's driven by boredom, alienation, and a desire to antagonize authority. Even its own authority.

Everyone mentioned in this book originated in the hardcore. Hardcore: a bleached-blonde defiant sixteen-year-old living alone in a downtown hotel; sleazy but on her own. Hardcore: the S.S.I. recipient being paid off by the government to stay out of trouble and renting a rehearsal studio with his monthly check. Hardcore: the corporate flunky who quits his job to manage a band of acned adolescents. Not everyone in this book has continued in the hardcore, but they all know what it means.

The title of this book is HARDCORE CALIFORNIA: A History of Punk and New Wave. In our estimation it is the most complete document in existence dealing with this subject. This book is a visual history of what it was like to be present in these two West Coast underground music scenes. Obviously, we cannot tell anyone what it was like to be omnipresent in San Francisco and Los Angeles. This would have turned the book into a dull encyclopedic listing of bands, members, record release dates and producers. Instead, we projected an image based more on experience than dry research. Some characters are better defined than others and some may not appear at all.

The authors of this book were deeply immersed in the scenes they described. But it is also possible to find individual performances or groups where the writers had to rely on the grapevine and friends for information. It didn't come from the record room at the library; consequently, the book is sometimes subjective.

The editing process, especially for the photographs, was brutal. Over 7,000 photographs, contact sheets, and negatives were considered for their combined aesthetic and documentary value. We thought we were being tough until the end of an edit when we realized we had double the number of photos intended. After that, the cutting began in earnest. That night our sleep was filled with visions of enraged photographers dipping us into vats of developing solution, screaming, "That was my favorite shot!"

Every 18 to 24 months a new generation passes through the scene. There are bands discussed in this book which weren't even formed when we began compiling information in 1981. The people change, but the scene stays young. Later, even the title of the pop underground and its philosophy *will* change. Regardless of the name they choose, the hardcore are always the hardcore.

—Peter Belsito and Bob Davis

6. *(Following page)* FEAR concert, 1982, Photo: Ed Colver.

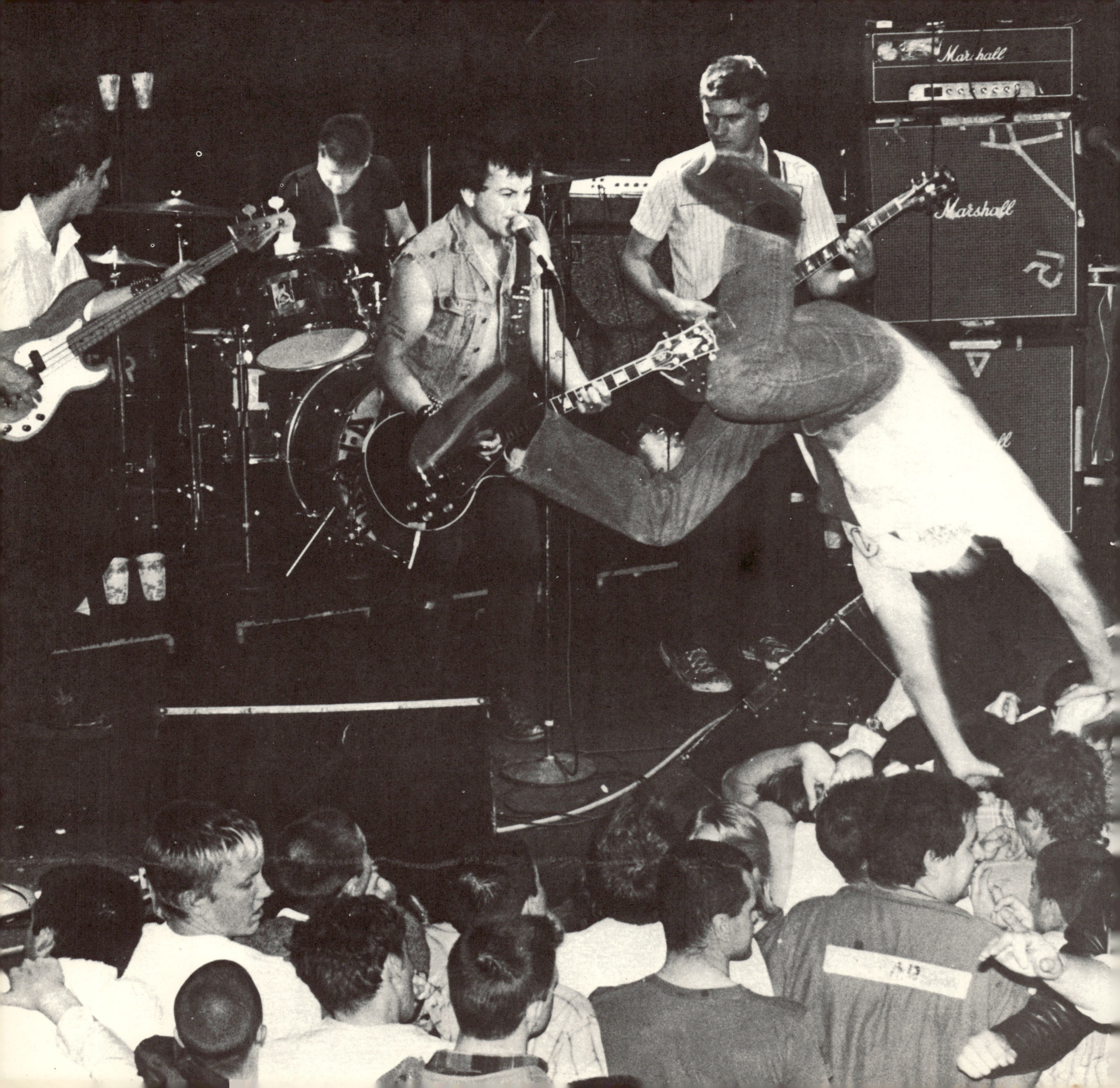

LOS ANGELES

TEXT BY CRAIG LEE AND SHREADER

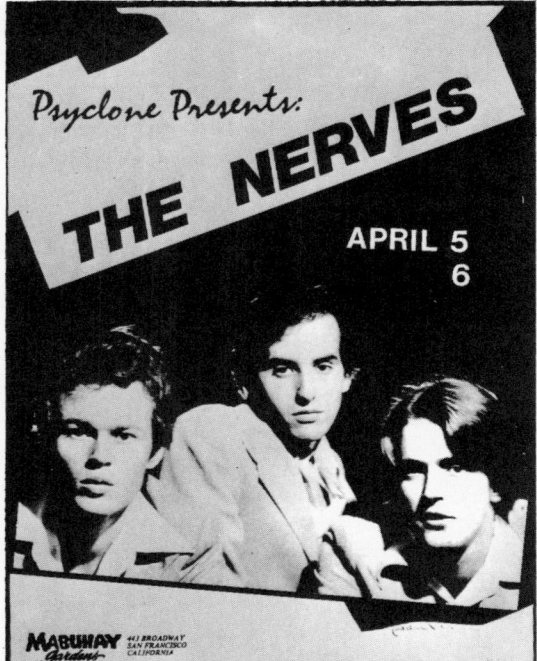

Fig. 1.

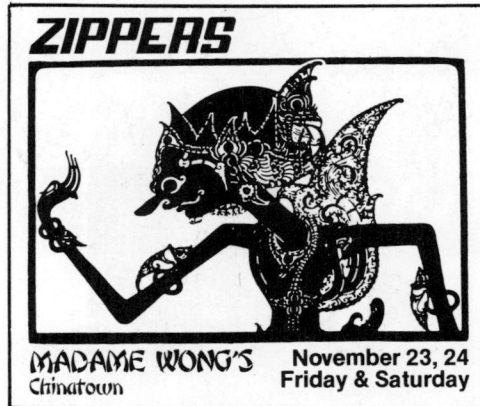

Fig. 2.

Fig. 1. Poster. Nerves at the Mabuhay Gardens in San Francisco, 1977. *Courtesy Dirksen-Miller Productions.*

Fig. 2. Poster. Zippers at Madame Wongs, Hollywood, 1979, Anonymous.

7. RODNEY BINGENHEIMER, KROQ disc jockey, the Starwood, West Hollywood, April, 1980. Photo: Gary Leonard.

8. WEIRDOS, (l-r) Dix Denny, John Denny, Willy Williams, Art Fox, Cliff Roman. Mabuhay Gardens, San Francisco, November, 1979. Photo: Elaine Vestal.

The '70s had not been very kind to the state of rock and roll in Los Angeles. Partly in reaction to the excess of the '60s, the '70s were a dull, bland period of insipid musical retreats. It was the time for big business M.O.R. (Middle of the Road) rock, lulling damaged souls to subservience. It wasn't a hell of a lot of fun. The only real movement that tried to chafe against and break this mold of submissive complacency was the glitter rock cult that found a home in Rodney Bingenheimer's English Disco. It was trashy, fun, drugged-out Hollywood ersatz glamour. But, as can be expected from a music culture whose main drugs were downers, glitter finally passed out for the last time and the closure of Rodney's left a void.

If there is one person who has inadvertently kept the underground music spirit alive in L.A., it's the unlikely Mr. Bingenheimer. The eternal teenager managed to wind up with a weekend radio show on the tiny, fledgling KROQ. It was an essential show for several reasons: one, Rodney played obscure English and New York stuff, giving local kids their first taste of bands like Blondie and the Ramones; two, Rodney would also play anything put out by local groups, and in those days, (as now) this radio exposure was crucial to unsigned L.A. bands that had no place in the Linda Ronstadt/Led Zeppelin megabuck industry.

For a brief time KROQ had its own club, the Cabaret, giving new bands a place to play. Among those groups coming up in the pre-'77 period were the original Motels, the Dogs, the Berlin Brats, the Zippers, New Order and the Pop. A fanzine from the South Bay, *Back Door Man* advocated total rock and roll supremacy and gave these groups their first taste of media recognition. Many of the bands grouped together, and made an essential statement by promoting their own concert event, "Radio Free Hollywood." This proved that an independent, local music scene could be created in the Hollywood of cocaine-snorting record execs.

An important group in the pre-'77 period was the Nerves. Forerunners of what would eventually be labelled "power pop," the band would go onto better things: Peter Case would form the Plimsouls, Paul Collins would have his Beat and Jack Lee would write for Blondie and start his own solo career. The satin-suited, Beatlesque Nerves exemplified the self-reliant spirit that bands were adopting in order to survive. They produced their own single (a rarity at the time), promoted and booked their own mini-tour, and found small halls for their gigs. One of these places, the tiny Orpheum Theater on Sunset Blvd., presented a few essential shows.

The Nerves, however, were not the big news at their own gig. The band of the hour was a bizarre group dressed in clothes that looked like a hellish collision between Robert Rauschenberg and Jackson

7.

Pollock. Taking the intense, bombastic stage style of Captain Beefheart and welding it to a frenzied wall of Ramones power chords, this band was called the Weirdos, and their shock rock tactics demanded you "Do the dance, do the dance, do the dance!" Of course the band owed a debt to the Ramones, but the mental-ward grimacing of John Denny and the band's screeching white light frenzy was far more visceral and intense than the good-natured Ramones' dumb act.

8.

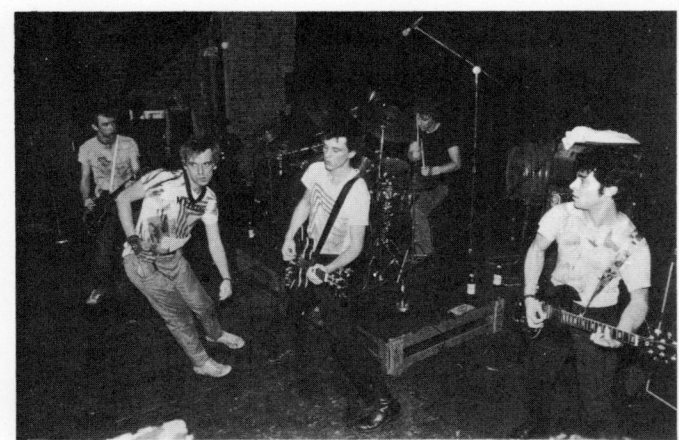

May, 1977

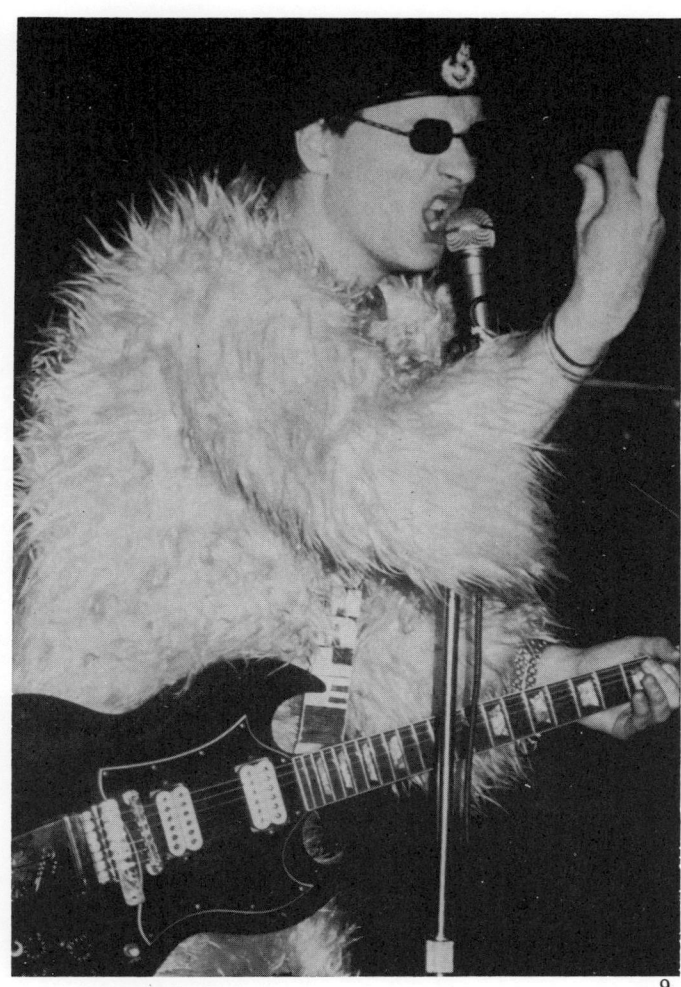

The Damned came to town. By now English Punk was the prevailing trend. The Ramones-inspired leather jackets were starting to sprout a profusion of safety pins. People still claimed the right to wear leopard spots and sunglasses (what could be more natural for Hollywood than '50s trash kitsch, which was literally created on Hollywood and Vine). But, the New York Bowery/CBGB scene didn't fit the L.A. consciousness. It's fitting that Television played the same weekend as the Damned's visit. The schism between New York and England immediately became obvious; New York was too cool, too pseudo-intellectual, too *boring* for the California set. Kids in L.A. have no real physical center to hang out in. Everything is spread out in endless suburbs. There's a constant feeling of dislocation. Like driving a car, action is fast, flashy, and primarily physical. Rodney was fueling the atmosphere up with doses of the Sex Pistols. The kids were charged up for the mad release English Punk promised.

As the Damned charged through the sloppy, intense, shambles of a set at the Starwood, the L. A. kids immediately picked up on the energy and the theatricality of the band. It was making them FEEL SOMETHING. By the end of the Damned set, people looked around, some with a shock of recognition on their faces. Bonds were forming. The poseurs were being separated from the possessed.

Words like "anarchy" and "nihilism" started working their way into the vocabulary. While the Damned visited the Weirdos and crashed on the floor at the house of the Screamers, a new group who had yet to play a gig, a definite Punk core was forming. L.A. anarchists were not political activists. They weren't dealing with English economic oppression. L.A. punks were instigating fashion anarchy and musical chaos as a way of striking back at the complacent, dull scene they had suffered for the last decade.

What was needed at this point was some kind of focus to put this energy in critical perspective. *Slash* magazine was started, featuring a Damned interview, and the focus was found.

Slash was created by Steve Samiof, a doorman at a Venice blues bar, who was following the alternative art scene with his girlfriend, photographer Melanie Nissen. Samiof knew a French dishwasher, Claude Bessy, who had done some exciting writing about his (up to then) favorite music, reggae. Bessey took on the reggae-inspired pseudonym "Kickboy Face" and became the leading voice of *Slash's* literary reign of terror.

Bessey was resolutely committed to the anger and fury of Punk. His intense zeal gave the early *Slash* an almost Biblical fire-and-brimstone righteousness. The words flew out fast, furious, disconnected, a code that only those in the know could truly under-

Another band made one if its first appearances at the Orpheum. The Germs were four teenage brats that were primarily Runaways/Bowie/Queen fans, known for throwing the wildest parties in Hollywood. These teenage monsters didn't know how to play their instruments so singer Bobby Pyn covered himself in red licorice whips and the band played the same song over and over again, with people screaming "go home" at them in between laughing. They'd be heard from again as the years went on.

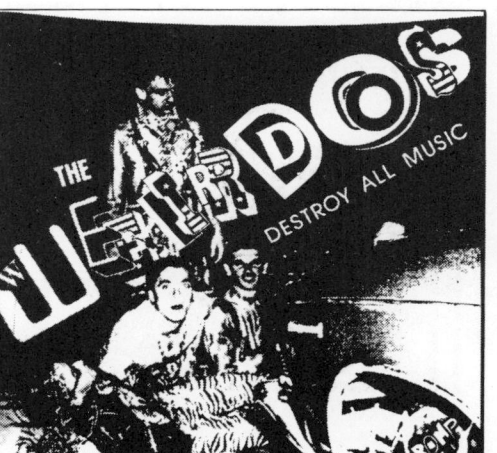

Fig. 3.

Fig. 3. Cover art for the Weirdos *Destroy All Music* 45. *Courtesy of Bomp Records.*

9. THE DAMNED, Captain Sensible. Photo: Lynda Burdick.

10. CLAUDE BESSY in his office at *Slash* magazine. Photo: Ann Summa.

11. STEVE SAMIOF, founder of *Slash* magazine, at the New Masque. Photo: Al Flipside.

11

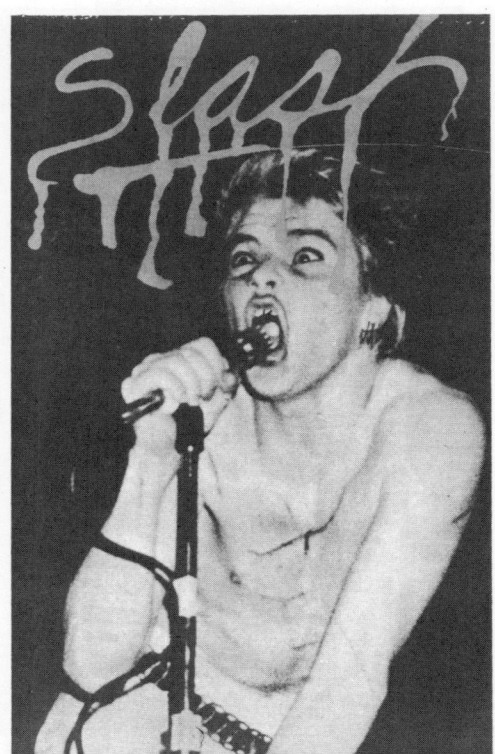

Fig. 4.

stand. One felt slightly out of it if they didn't know what *Slash* was ranting about. The curious became intrigued to find those records or see those bands that *Slash* declared were the only true lights in an awfully dim world. It didn't matter if the Screamers, who had a pictorial in the first *Slash*, had never played a live show. If *Slash* said so, then the Screamers were IT!

Debuting at a *Slash* party, the Screamers turned out to have a sound to back up their distinctive image. Using two synthesizers, drums, and no guitar, this dissonantly modern combo was fronted by a hypnotically abrasive performer, Tomata Du Plenty, who created the perfect visual foil for the Screamers ether-ward sounds of modern anxiety. Combining a European sense of stylish decadence with this week's stick-up hair, the Screamers' uncanny sense of fashion and sound made them an immediate L.A. original. The band was particularly masterful at playing the publicity game, so that every appearance by the group was a strategic event in a master plan only they seemed to know. Punk had barely started, but the hype machine was in full operation.

A master of Hollywood hype, Kim Fowley, was always the first to try to seize a trend and manipulate it to his own ends. Coming off the semi-success of his previous endeavor, the Runaways, he tried to promote a weekend series of Punk shows at the Whiskey. Unfortunately the majority of the bands were heavy metal re-treads trying to climb on the bandwagon by wearing funny sunglasses and a few safety pins, or they were Blondie clones, like Needles and Pins, who were trying to resurrect Phil Spector's long abandoned style. A few groups stood out. The Germs showed up and threw buckets of food off the stage while being recorded for posterity (you can hear the concert on a ROIR cassette). The Weirdos retained their title as supreme L.A. Punk rock band and a trio of Carlsbad lads got to the hardcore of things with a lean, tough, politically-activated sound. This group was called the Dils.

Fig. 4. Cover *Slash* magazine no. 9, March 1978. Pictured is Bobby Pyn of the Germs. Photo: Anonymous. *Courtesy of Slash Records.*

Fig. 5. Screamers logo by Gary Panter. *(Facing page)*

12. SCREAMERS (l-r) Tomata du Plenty, K.K., performing *Palace of Variety* at the Whiskey, Hollywood, June, 1981. Photo: Ann Summa.

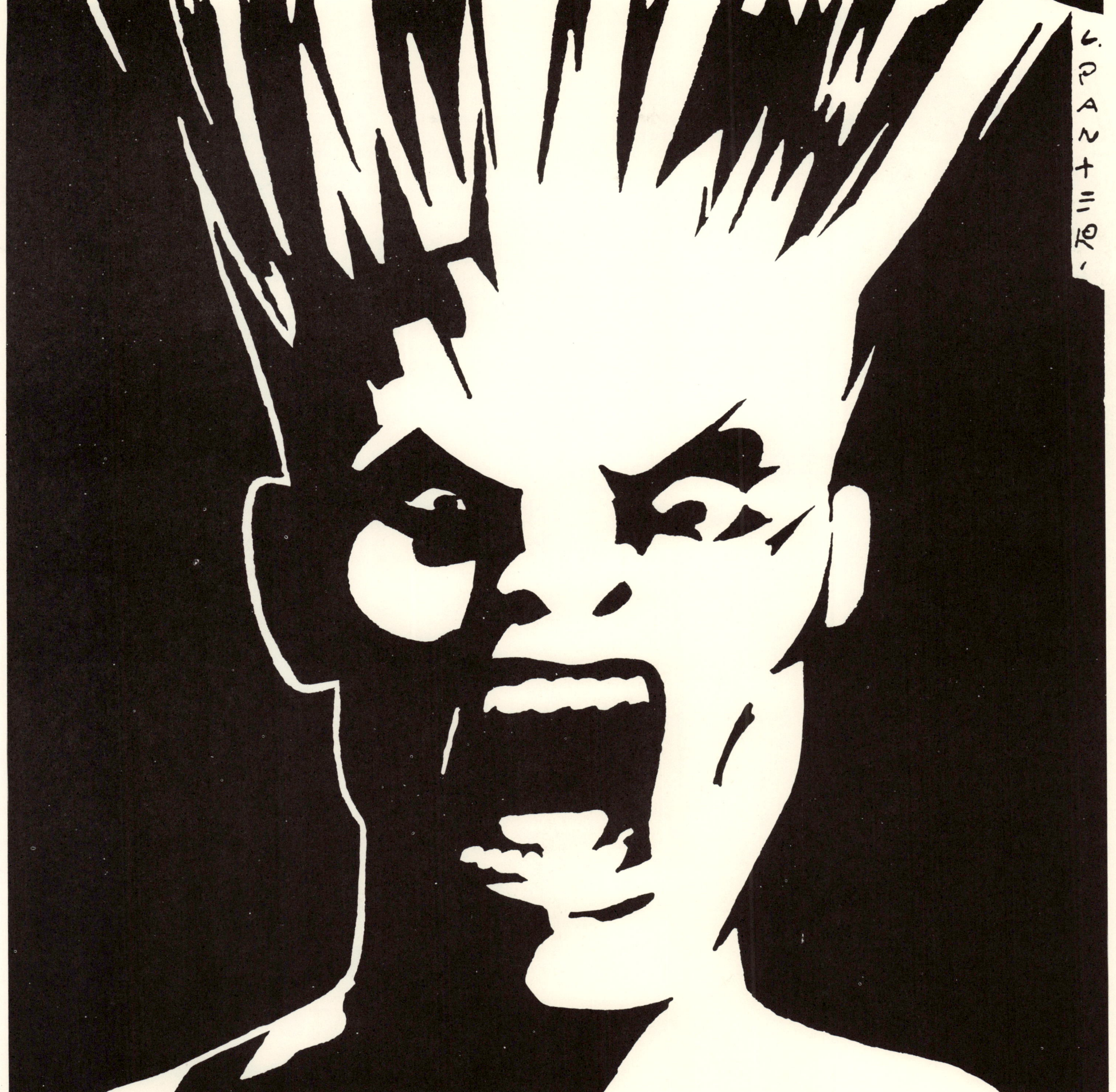

Fig. 5.

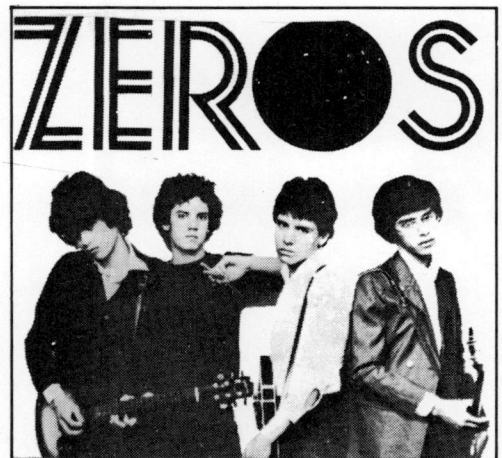

Fig. 6.

September, 1977

eople had been intrigued by a short film that had turned up of an Ohio group called DEVO. Around September the band was flown out to L.A. by interested A&R people at A&M Records. The group played with the Weirdos and Dils at a seedy downtown ballroom called Myron's. Reaction to DEVO was decidedly mixed — a visually, musically distinctive combo, many kids were immediately enthralled by the de-evolutionary spell, but other Punk purists found the choppy rhythms and theatrical presentations calculated, gimmicky and disturbingly insincere.

Around the same time NBC aired a late night program on the English Punk scene which showed lots of footage of English kids "pogo" dancing.

The NBC executives will probably never realize what a crucial role they inadvertently played in the development of the California Punk scene. Suddenly kids were strangle-dancing and madly pogoing into each other at shows. It was done with a sense of self-deprecating humor. The new punk kids, adorned in saftey pins, bondage gear, dozens of buttons advertising their favorite group, and monster makeup, were now madly bashing into each other. They threw beer cans at the Weirdos' heads and fell into bass drums, screaming and laughing as groups like the Zeros, a young Mexican quartet from San Diego, thundered songs like *Hand Grenade Heart* or *Don't Push Me Around*. It was a small group — half the musicians would be in the audience before they played, and the common question after the gigs was "Where's the party?"

The next step was to find a permanent home for this burgeoning non-stop music party/revolution. Shows at the Whiskey were infrequent, and only for bands that had something of a 'name'. The Starwood closed itself off to local Punk bands after the Screamers abused the American flag at a 4th of July gig. This managed to disturb the Starwood owner's sense of patriotism. There were constant searches for any small hall that could be rented for a quick gig before the owners realized what was happening. One of the first small shows was a *Slash* benefit at Larchmont Hall. The highlights included dwarf janitors desperately trying to sweep up the broken glass amid the leopard-spotted pants, torn t-shirts, bizarre sunglasses, crazy-colored hair, and the women with safety pins in their hands or cheeks. A second *Slash* benefit at Larchmont featured the Dils, the Screamers, and possibly the first Germs show where the band actually played a whole set (when singer Bobby Pyn wasn't throwing himself into the audience, or slicing at his chest with broken glass, screaming "we must bleed, we must bleed, we must bleed!"). Sometimes noses bled, or ears were in pain, but the whole air of early Punk shows had this vibrant ELECTRICITY that couldn't be contained or duplicated. All that was needed for the Punk scene was a real home, and one was soon to open.

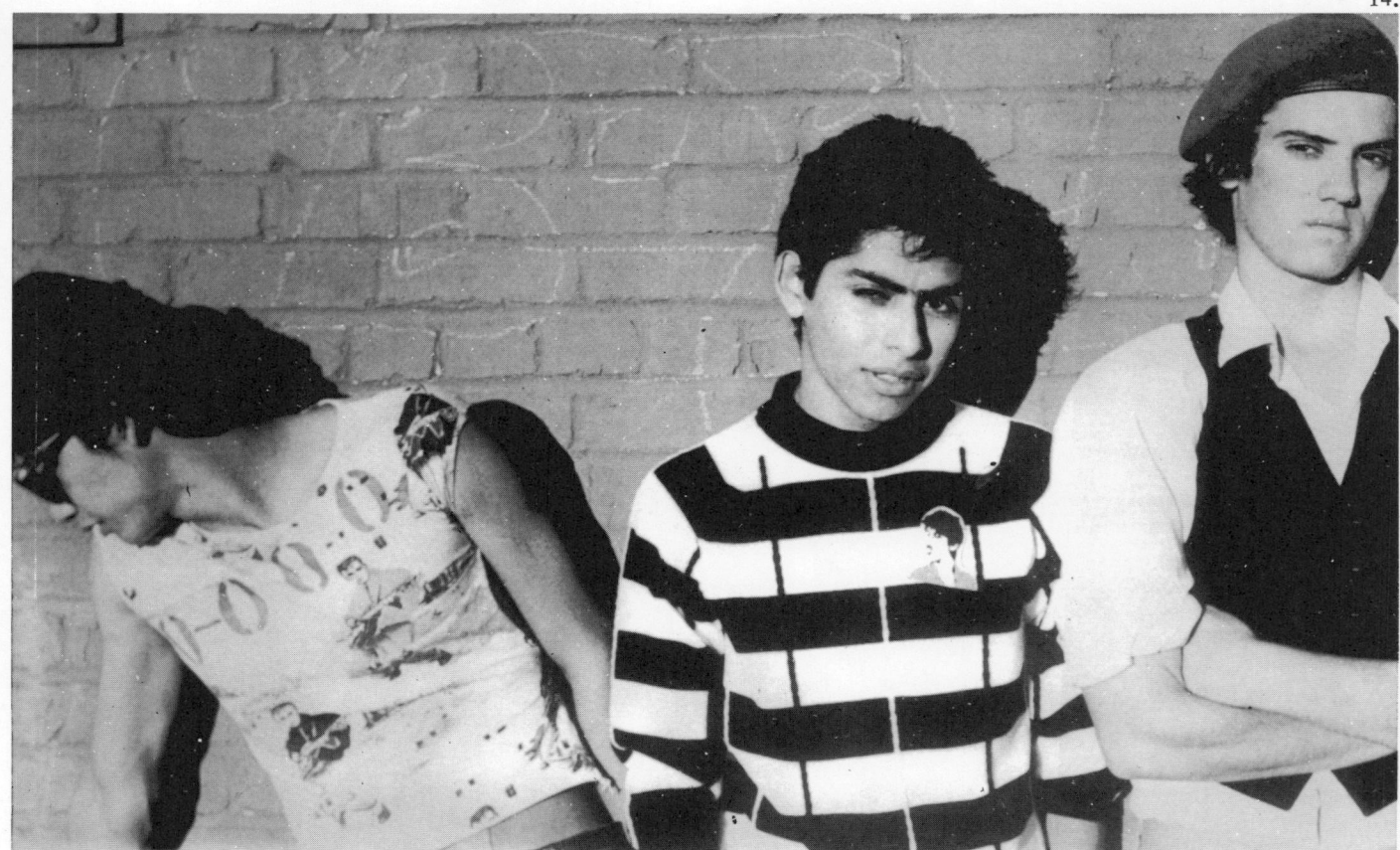

14.

Fig. 6. Cover art for Zeros 45. *Courtesy of Bomp.*

13. Fan at Music Plus Record Store during Ramones appearance, Hollywood. Photo: Gary Leonard.

14. ZEROS (l-r) Javier Escovedo, Hector, Babba. Photo: Jill Von Hoffman.

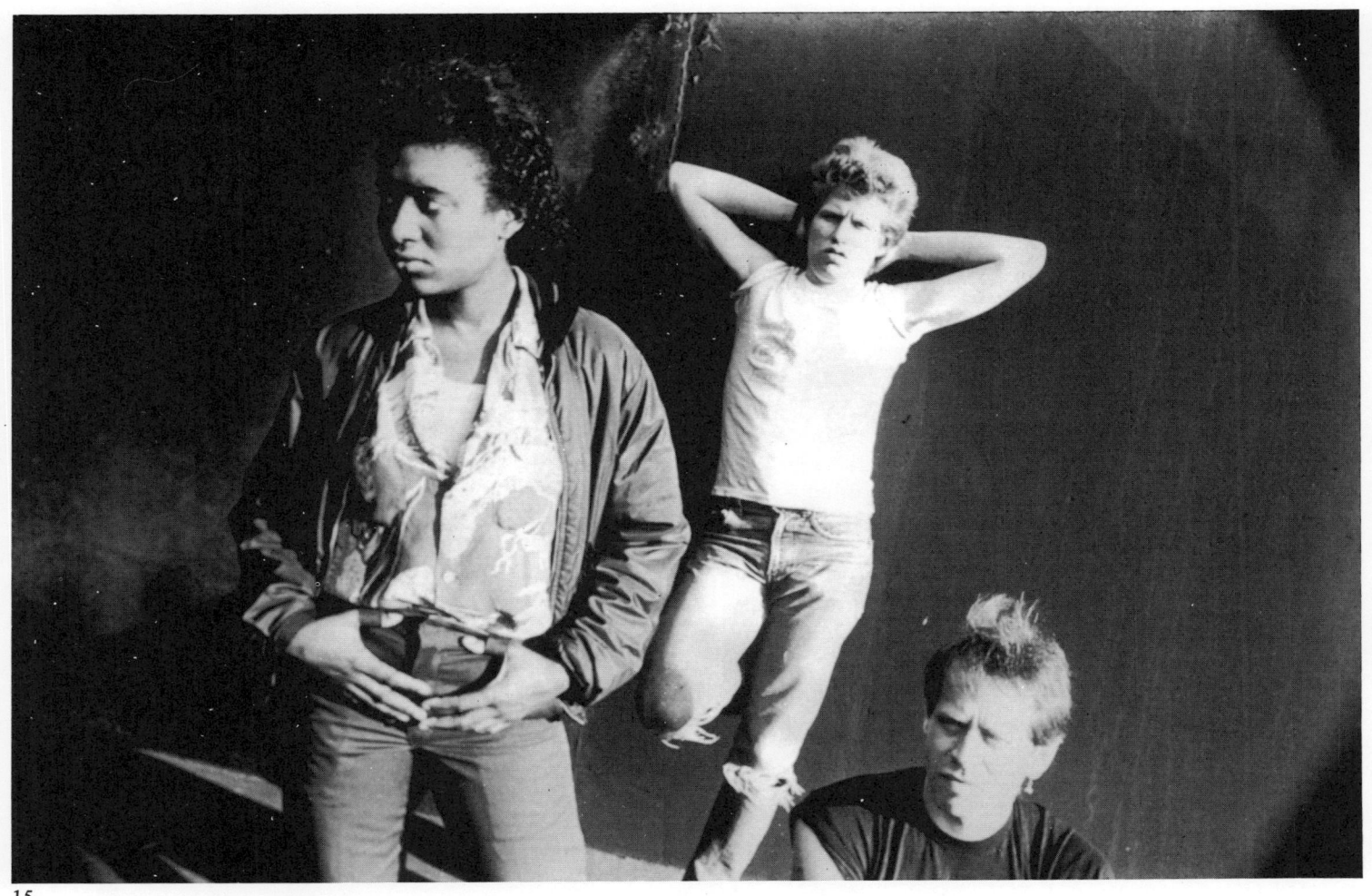

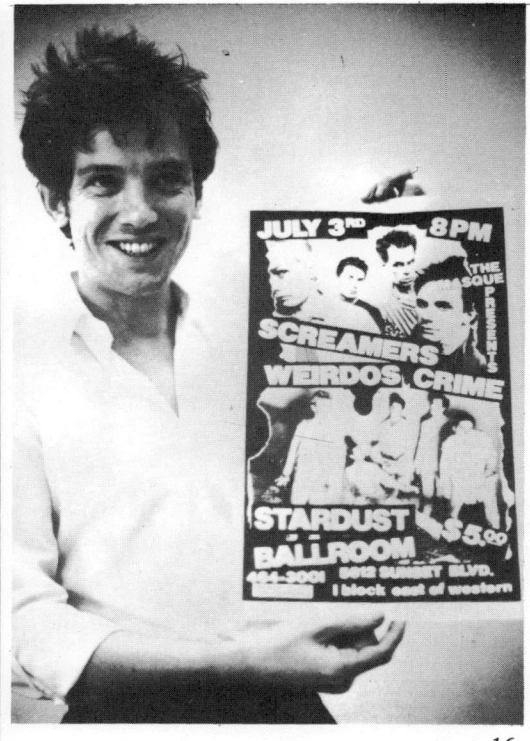

A Scots-Irishman, Brendan Mullen, fell down some steps one drunken night and found an underground, cavern-like space that he quickly rented and turned into a rehearsal studio for the bands he had been following. A frustrated drummer, Mullen eventually approached one of the bands, the Controllers, about playing a party for some friends. Mullen named the delapidated dungeon the Masque, and the first show in the subterranean space was enough to encourage more. It didn't matter that acoustics were horrendous. Where else were these bands going to play? The Masque was primarily a showcase for new bands and virtually none were paid. The next Masque show, featuring the Alleycats, Skulls, Germs, and Needles and Pins, was a great success. The chaotic energy the Germs were generating opened Mullen's eyes to the possibilities of the new scene. *Slash* officially deemed the Masque: "the pit's pajamas."

Independent records were starting to crop up documenting the new bands. The Germs were the first, with their recording of *Forming*, a minimalist classic on What? Records. The B-side contained a cassette recording of the band playing at the Roxy, of all places, for the filming of some Cheech & Chong movie. Unfortunately, the Germs segment which included Bobby Pyn throwing peanut butter at horrified spectators never made it into the film. The Germs single was a success, constantly heard on the Rodney Bingenheimer show, and was followed by the Dils *I Hate the Rich / You're Not Blank*, also on What?.

Bomp Records played an important part in this stage of the Punk scene's development. Bomp had helped *Slash* put on their first benefit, and the Bomp record store was where fans of English punk music could buy their copies of *Gary Gilmore's Eyes* or X-ray Spex and Buzzcocks singles. English bands were god-head at the moment — there was a total and deep infatuation with the English Punk scene. If a picture of Sue Catwoman appeared one week, you'd see a girl like Hellin Killer imitating her hairstyle the next. Bomp Records released the first Weirdos and Zeros singles.

Meanwhile a group of scenesters were planning their own label: Dangerhouse. Named after a communal house in East Hollywood, the Dangerhouse crew included David Brown, who had just left the Screamers; Rand McNalley, an engineer/producer; the Screamers' drummer K.K.; and a former video artist and conceptual lunatic named Black Randy, who had a well-deserved reputation for various vile and sordid acts of degenerate behaviour.

15. THE CONTROLLERS (l-r) Mad Dog Karla, Spike, Stingray. Photo: Ronn Spencer. *Countesy Slash magazine.*

16. BRENDAN MULLEN, 1978. Photo: Jill Von Hoffman.

17.

July, 1977

A couple of weeks of frenzied Masque activity culminated in the club being temporarily shut down after a tumultous performance by a new group called the Bags, who came on stage wearing bags over their heads. After Bobby Pyn had torn the bag off Alice Bag's head, he'd gone outside in a drugged stupor and antagonized policemen who then put the clamps on the Masque for not having a police permit. In the meantime the Whiskey had started having afternoon Punk shows where one might see a bill like Blondie/Devo/the Germs for $3.00. By October the Masque had reopened as the hip testing ground. If a band did well there they'd show up the next week at the Whiskey. Bands coming up in the wake of the original Weirdos/Screamers/Dils/Zeros/Germs assault included the jazzy dada-Punk Deadbeats, a bouncy Pop-Punk trio called the Eyes (whose drummer would join X later on, and whose bassist Charlotte would become known as a Go-Go), the Controllers playing a rough MC5-meets-Bobby Fuller sound with a female drummer who looked like a part-time stripper, the Alleycats, a rock trio featuring an exotic Hawaiin bassist, Dianne Chai, as well as the Bags. X was forming

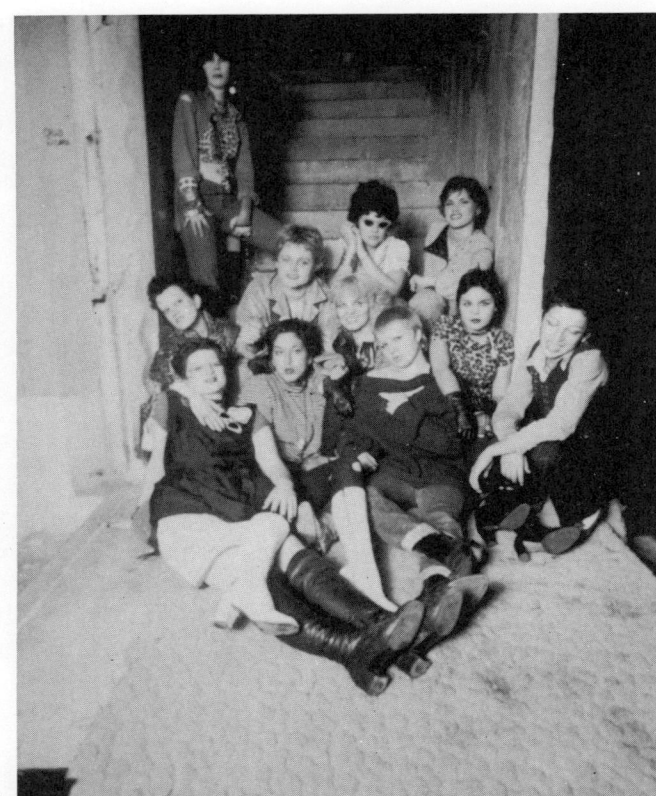

18.

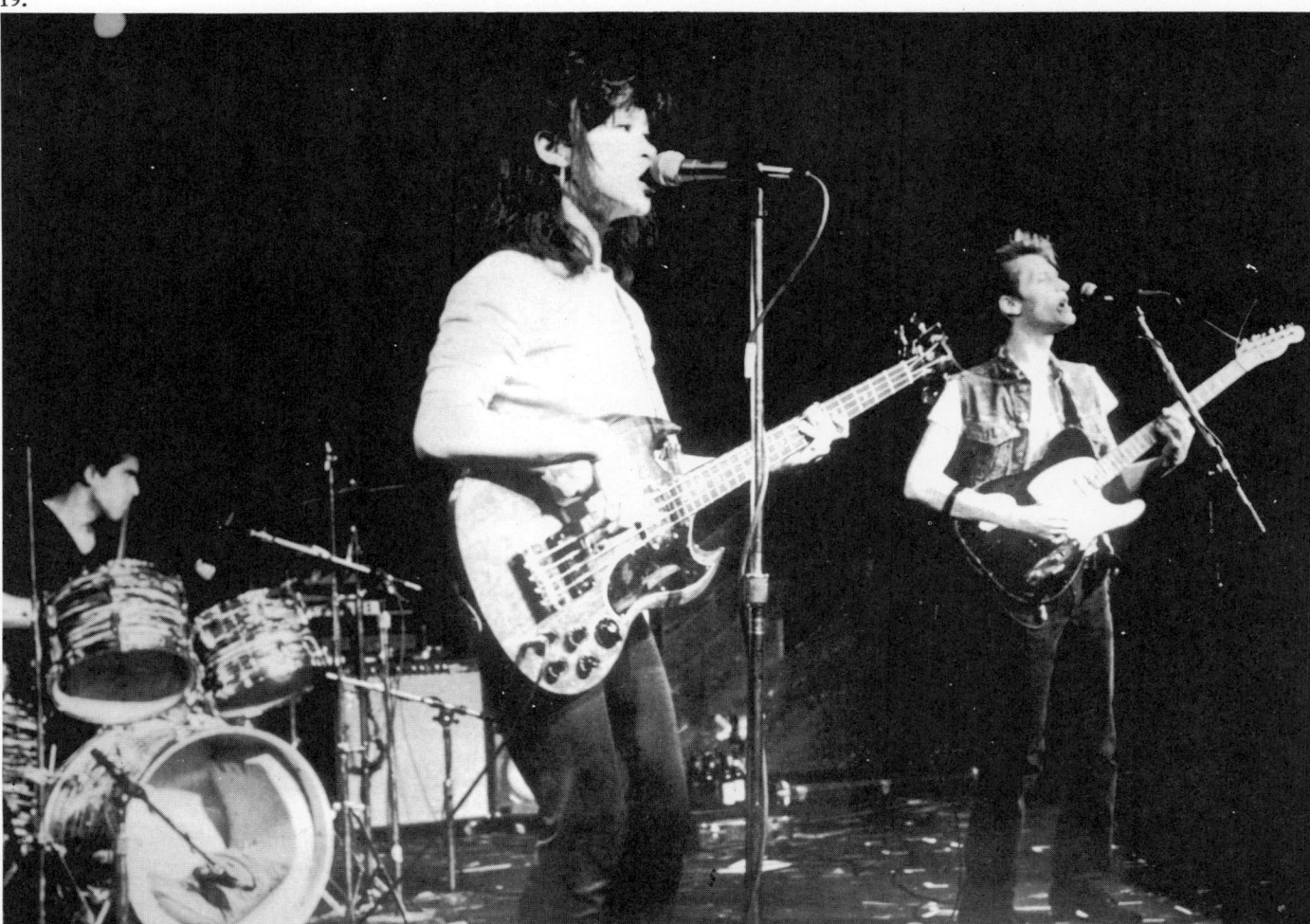

19.

17. ALLEYCATS (l-r) John McCarthy, Randy Stodola, Dianne Chai. May, 1981. Photo: Ann Summa.

18. Punk women (seated front l-r) Connie Clarksville, Alice Bag, Hellin Killer, Delphina, (seated on steps) Trixie, Belinda Carlisle, Lorna Doom, unknown, (seated back row) Pleasant Gehman, Trudie, (standing) unknown. Photo: *Courtesy Slash magazine.*

19. ALLEYCATS (l-r) John McCarthy, Dianne Chai, Randy Stodola. Photo: Ed Colver.

around this time. It's interesting, in retrospect, to notice what a major part women played in the early days. Female bass players were almost a requirement, and it seemed that it was often the women who dominated and controlled the Punk scene. This equality of the sexes was just another breakdown of traditional rock and roll stereotypes that the early scene was perpetrating.

The band that made the biggest impact during the Masque days was the Dickies. Friends of the pre-punk glitter-pop group, the Quick, the Dickies once claimed they got into Punk "because they couldn't play anything," although they were accomplished musicians. The band's first show caught everyone by surprise. Having followed a band called the Spastics that were so awful that some punks had turned a fire hose on them, the Dickies looked like normal suburban nerds. But, when the band erupted in a tight, jackhammer, speed-of-light assault, playing goofball comedy Punk with a ferocious punch, the Masque exploded into frenzied dancing, bodies carooming off each other (such as the ever inebriated Bobby Pyn.) Dubbed the "punk Monkees," the Dickies had a meteoric career rise.

At this point the Punk scene had become very in-bred and cliquish. There was a lot of talk about who was a "poseur" and who wasn't. Commitment and sincerity were essential, and one had to have punk credibility to join the clan. In a way it was a self-destructive protectiveness. Many kids who were eager to get into this new music felt rejected by the Hollywood 50, and even though there was always talk of how to make Punk break through the limited music scene barriers, the in-crowd syndrome of the Punk scene kept it isolated. It was a private party, and if your hair was too long, or if you wore flares, or if you liked the wrong bands, you were not invited. Many punks had come from social situations where they had been the outsiders. Having escaped suburbia, having been outcasts, they now had their own group from which they could sneer and deliver visual jolts to the unimaginative, dumb, suburban world. Hippies that dared to go in the Masque might find their hair 'accidentally' burned off. Polyester? Forget it. Disco fags? Laughed back to West Hollywood. Though some early punks were gay, they kept it to themselves. If you didn't have the right degree of street cool, you'd find yourself pogo'd to the floor. Though the Masque punks had considerably longer hair than the current breed of hard-core skinheads, then, as now, style dictated commitment.

20.

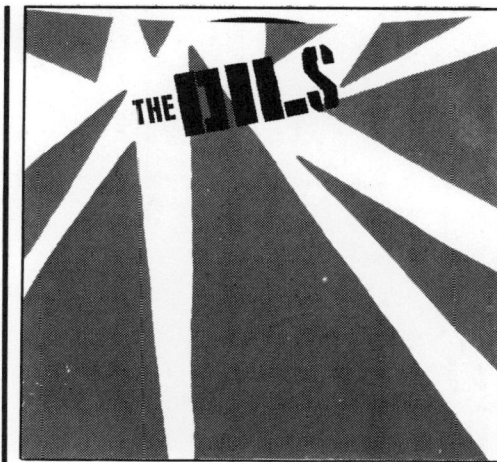

Fig. 7.

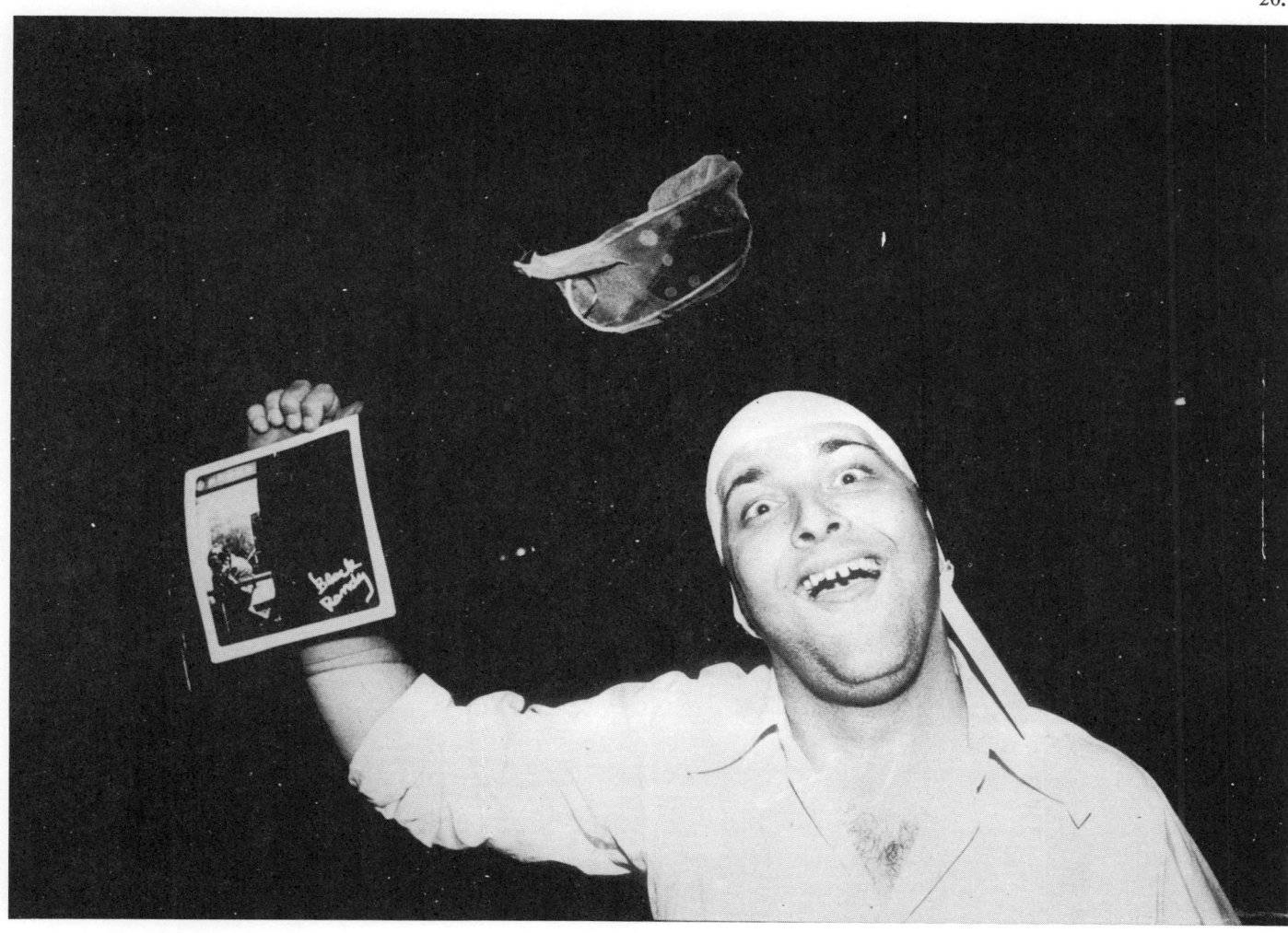

Fig. 7. Cover art for the Dils 45. *Courtesy of Bomp Records.*

20. BLACK RANDY, 1979. Photo: Ruby Ray.

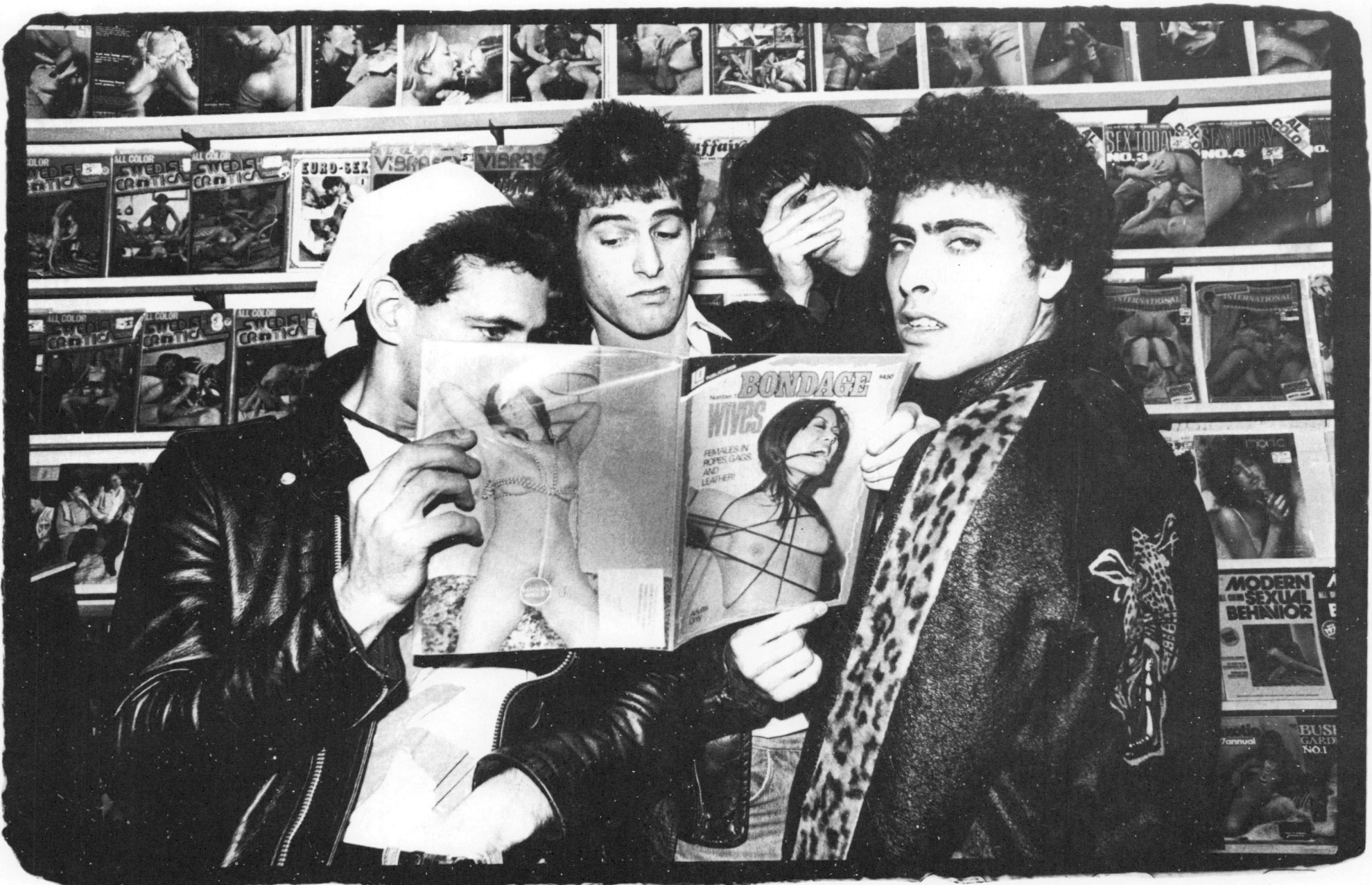

21. DICKIES, 1977. Photo: Ruby Ray.

Even though punks were, as X would put it, "shut out of the public eye," more support groups came up to validate the new scene. An essential part of the scene were the fanzines, xeroxed or mimeographed papers featuring the bands and their followers. *Flipside* came out of Whittier, cost a quarter and featured a nasty, trashy, authentically teenage look at the scene and its fans. *Flipside* was the younger, cruder side of *Slash*. *Slash* was always a bit intellectual, while *Flipside* was just straightforward, dumb fun. Pleasant, a former member of the Germs camp, started a gossipy, Hollywood type fanzine, *Lobotomy*, while two girls, Jade and Zandra, started a fanzine named after their favorite English group, *Generation X*. Other fanzines were *Raw Power* and *"/"*.

Dangerhouse became a reality, and released early L.A. recordings by the Randoms (a house band with members including Screamers drummer K.K and John Doe from X); Black Randy's classic tale of Hollywood hustling and confrontation, *Trouble At the Cup;* a powerful *196 Seconds of the Dils*; and a 3 song effort by L.A.'s favorite band from San Francisco: the Avengers.

First appearing at an ill-fated "Punk Rock Fashion Show" featuring Blondie, the Weirdos, Devo, and lots of kids pretending they were part of a scene they knew nothing about, the Avengers started to create waves after appearing at a *Slash* benefit with the Dils. The opening band at that show didn't get much of a reaction, but after their first public appearance, X would go onto bigger and better things.

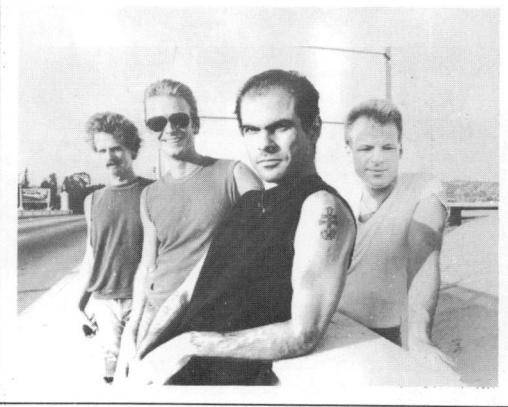

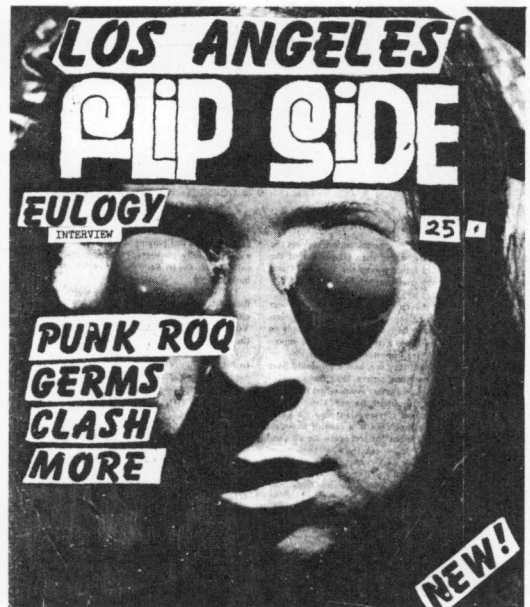

Fig. 8. Cover of Flipside no. 1. *Courtesy Al Flipside.*

22. CHRIS DESJARDINS of the Flesheaters and Ruby Records. Photo: Frank Gargani.

23. FLESHEATERS (l-r) Chris Wahl, Don Kirk, Chris Desjardins, Rodyn Jameson. June 1982. Photo: Ann Summa.

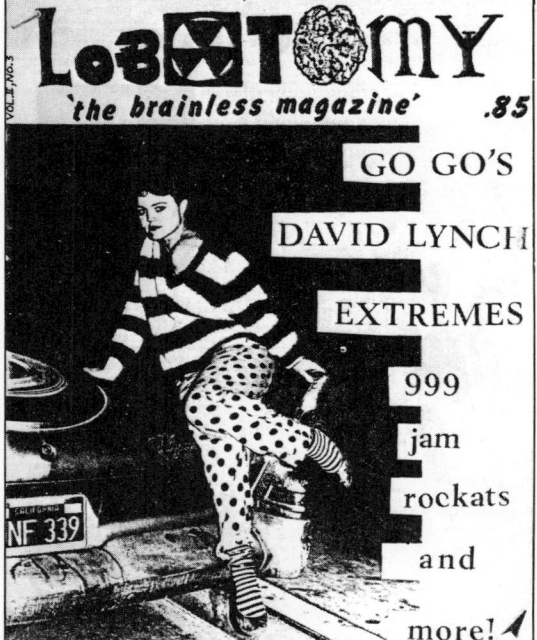

Fig. 9.

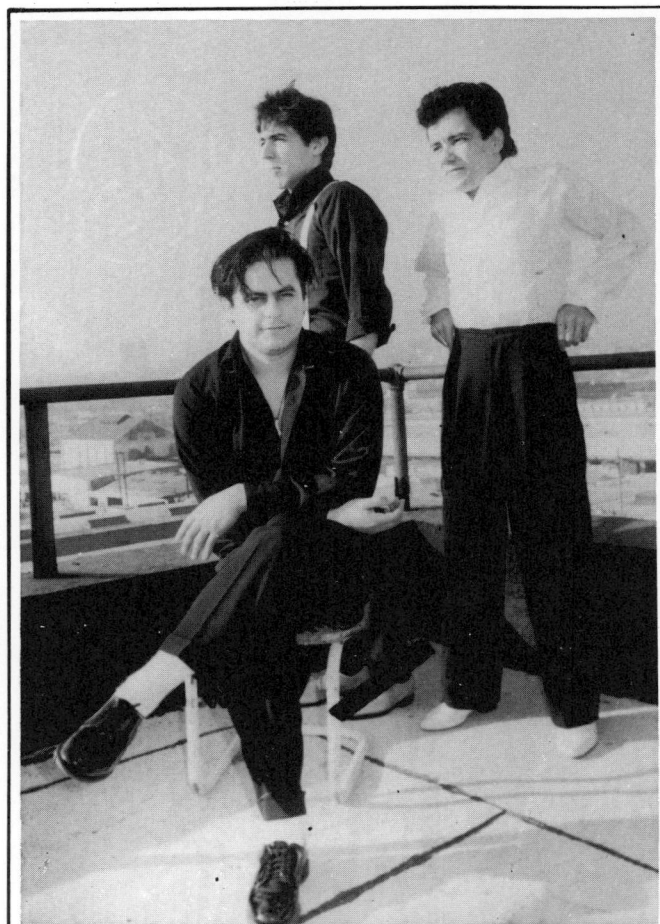

24.

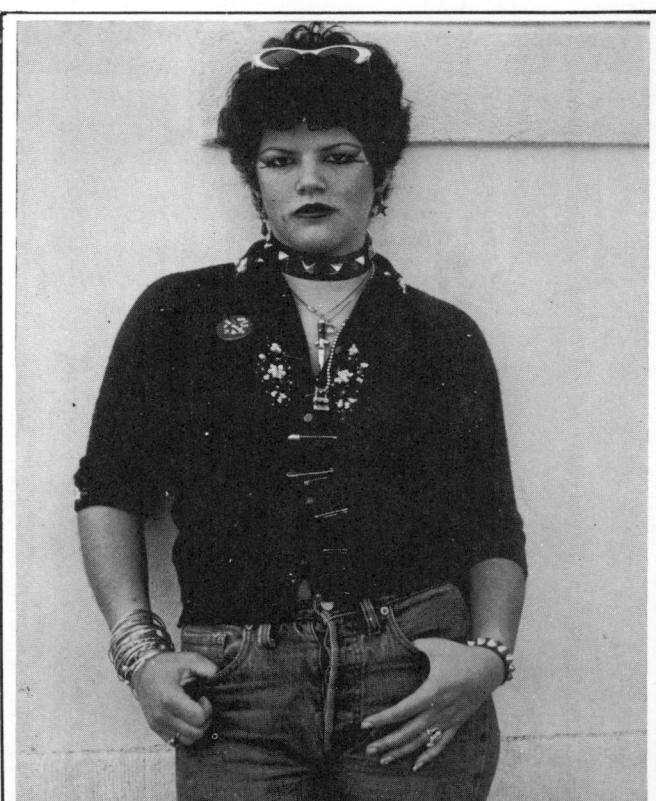

25.

October, 1977

lash remained the essential Punk guide, reporting on new bands like the Wildcats (three long hairs and an English kid with some charisma), F-Word (teenagers from Covina fronted by an Iggy Pop admirer named Rik L. Rik, who were front runners for the whole suburban Punk scene); the Masque house band, Arthur J. & the Gold Cups; a new quartet called the Plugz (who would undergo some personnel changes and become an electrifying power trio) and an on-again off-again group fronted by *Slash* writer Chris D. called the Flesheaters. The most promising of the new bands was a group called the Skulls. They were the personification of raucous, English-based L.A. glitter-punk, with a singer named Billy Bones and a guitar player, Mark Morbid, who would always lose his pants somewhere during the set. The Skulls were an amazing, aggressive, fun band, the perfect opening group when *Slash* held a benefit at the Masque with the two groups that were certified punk stars, the Weirdos and the Screamers.

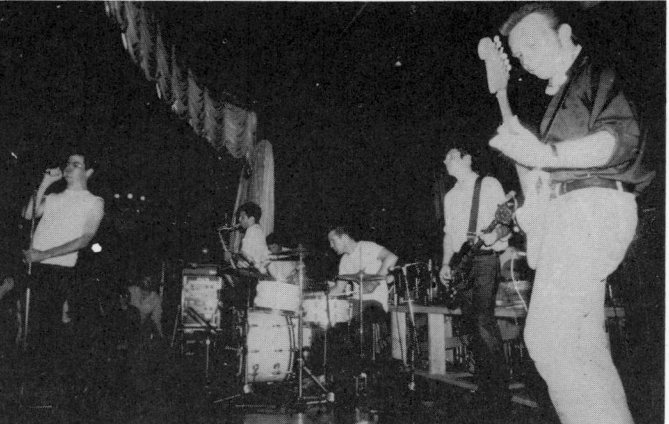

26.

December, 1977

The Screamers were headlining the Whiskey with exciting shows using visual props in addition to the band's increasingly sophisticated and bizarre techno-shock music. The Weirdos were at the pinnacle of their power, creating an unbridled enthusiasm in their audiences that few bands have ever matched. New Year's Eve featured Black Randy making his debut at the Masque, doing send-ups of James Brown with a backup chorus of Tomata Du Plenty, John Denny and Bobby Pyn. It was a typically wild party. One woman was taking on five different men, including the 300 pound security guard "Tiny". Beer was all over the floor. An obnoxious punk groupie had her coat shoved down a shitty toilet by angry punkettes: the Plungers. People were stoned, drunk, dancing, falling down, glaring at poseurs, and having the time of their lives. Like the Clash had predicted, the L.A. kids were having a riot of their own. They had the Masque,

Fig. 9. Cover of *Lobotomy* fanzine.

24. PLUGZ (seated) Tito Larriva, (standing l-r) Chalo Quintana, Tony. December 1982. Photo: Ann Summa.

25. PLEASANT GEHMAN. Photo: Lynda Burdick.

26. FLESHEATERS an early line-up of (l-r) Chris Desjardins, Steve Berlin, Don Bonebreak (X), Bill Bateman (Blasters), John Doe (X) and Phil Alvin (Blasters). Photo: Ann Summa.

they had *Slash* and *Flipside*, they had Dangerhouse. They had control of their music and their scene and it didn't seem as if anything could take it away. Everybody was anticipating the Sex Pistols' upcoming appearance in San Francisco, and it seemed like the major Punk revolution was on the verge of becoming a realistic fact instead of a small cult party. And then the shit hit the fan.

January, 1978

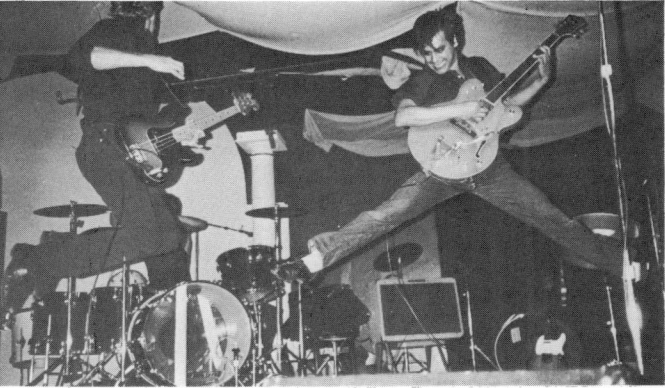

It seemed appropriate that *Slash* would come out with a cover featuring dozens of pictures of local scenesters, the Punk scene was so much more than the bands — even the fans had their own instant star personas. There was Cherie the Penguin, wearing her catwoman glasses, mercilessly terrorizing the unconverted, introducing Screamers shows with lines like "Cambodia was never this fun!" There were graphic artists like Delphina, the girlfriend of Alan McDonnell, the notorious Basho Macko of *Slash*. There were the budding hairdressers like Connie Clark. There were the Plungers, a group of girls that lived in a prime Hollywood party pad. Trudie was the best known, a vivacious, energetic girl that had this youthful innocence even in her most loaded state. She was the punk princess, "L.A.'s most popular punk rocker" as the *New York Rocker* put it. She lived with Hellin Killer, who once carved "SID" on her arm. Hellin would go the farthest of any punkette. There were vampires like Trixie, making her teeth look like she had sharpened them with a file, or Mary Rat calmly walking around with a safety pin in her hand. After gigs you'd always find a group of people partying at the Plungers'. You might see Englishmen like Mark Plummer and Robbie Fields (a publicist-turned-manager-turned owner of the independent Posh Boy label) fighting it out, as people ground potato chips into the carpet that would still be there at next week's party. Someone would run in saying, "John Denny's fucking in the back," and everyone would run out and surround the car that Denny was going at it in, while Lorna Doom of the Germs cackled in her unmistakable laugh. A young woman named Gerber would wander topless in a drunken haze, screaming "show your tits!" And if there wasn't a party at the Plungers', there'd be one at the Screamers' house, where some fashion models would shove a Hostess Snowball in photographer Jenny Len's ass, as deadbeat guitarist/engineer/producer Geza X and K.K. slid around the kitchen having a spaghetti fight. And, if Hollywood was dull, people would drive down to Hermosa Beach where Germs fan club president Malissa gave a party in a basement where Bobby Pyn passed out on stage.

As all this free-for-all excitement was going on, the main concern of the Hollywood punks was the upcoming appearance of the Sex Pistols in San Francisco. What promised to be a pinnacle event capping a year of Punk frenzy turned out to be not only a let-down, but the closing chapter on that period of English-inspired music and fashion. The minute the Pistols hit America, the Plungers immedi-

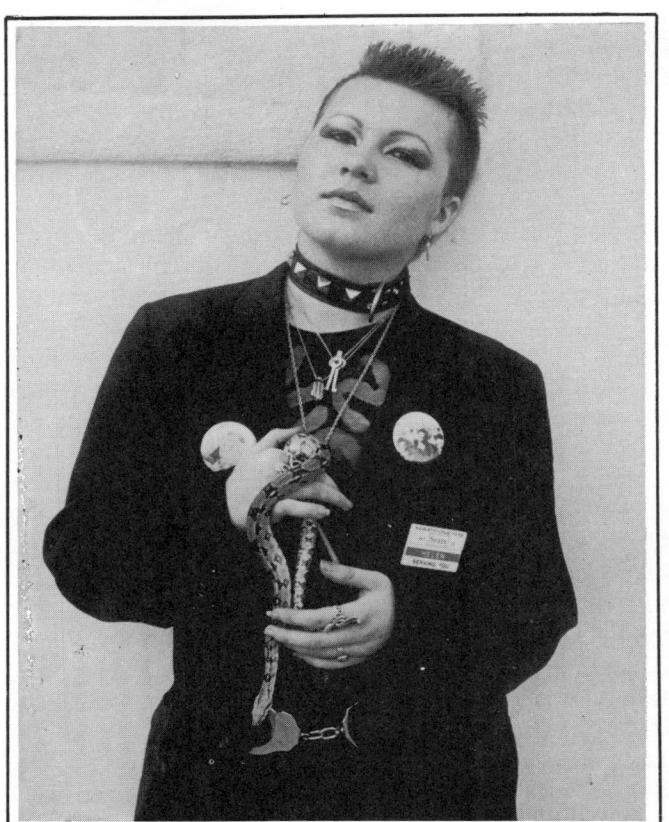

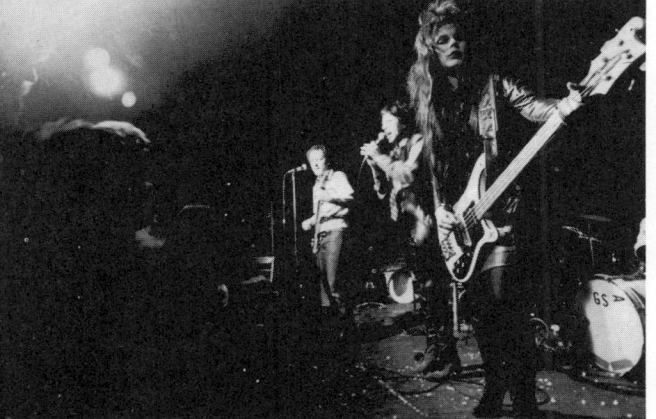

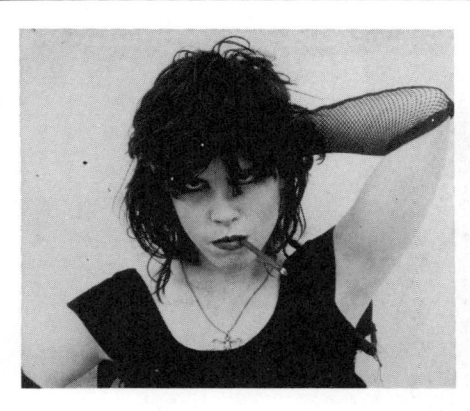

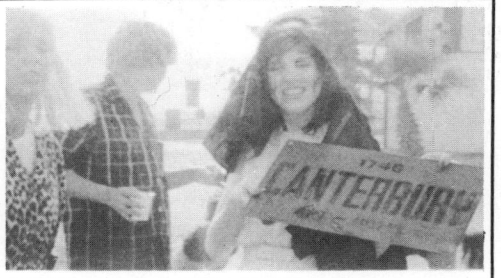

27. HELLIN KILLER. Photo: Lynda Burdick.

28. PLUGZ (l-r) Barry McBride, Tito Larriva, at the Savoy Tivoli, San Francisco, May, 1980. Photo: Elaine Vestal.

29. BAGS (l-r) Craig Lee, Alice, Pat. Mabuhay Gardens, San Francisco. Photo: Richard McCaffrey. *Courtesy BAM magazine.*

30. TRUDIE. Photo: Lynda Burdick.

31. TRUDIE holding the Canterbury sign. Photo: Al Flipside.

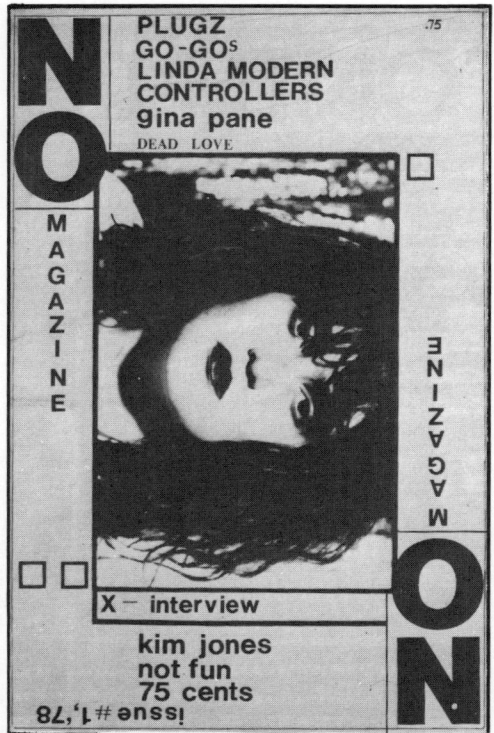

Fig. 10.

atly got in a beat up Volkswagen, following the band across the country. In Texas, Hellin Killer socked Sid Vicious in the nose, endearing the bassist to the young Killer. But the Pistols' last show in San Francisco was uncomfortable, stiff, and surrounded by thousands of ugly, stupid, witless suburbanites playing at a scene they had no commitment to.

This Pistols non-event (compounded by the depressing stories of the band falling apart) was followed by a serious blow to the L.A. underground. Fire marshalls had invaded the Masque with citations, preventing Brendan Mullen from staging further shows. Suddenly, a bright future had its lights punched out. It had the worst sound of any place that's ever provided live entertainment. Half the bands were literally growing up on stage, in between the booze, the ludes and the clandestine fucking. But, it was home, and a fight was started to reclaim it that was never won.

In the meantime Michele Myer, a former associate of Kim Fowley, had taken to booking the Whiskey and tried very hard to legitimize Punk in the club scene. She booked bands like the ever improving X, the enormously popular Dickies, and up-and-comers

32.

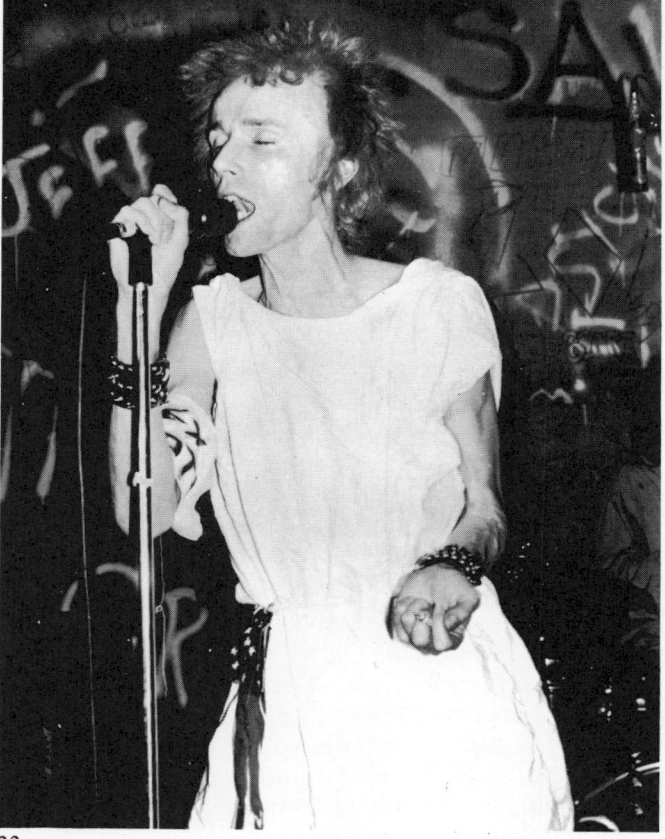

33.

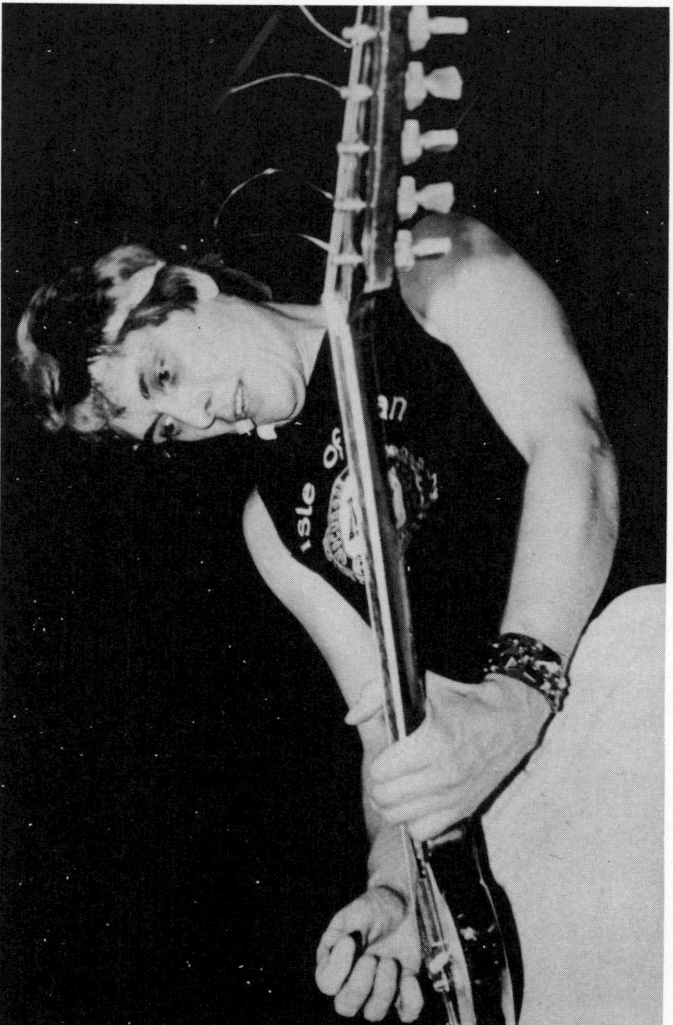

like the Controllers and Wildcats. The Troubador thought it could get in on the Punk action, since the folk scene it had once sponsored was a quaint thing of the past. But after fans objected to the lack of dance space by turning over tables during a Bags set, the Troubador's mellow waitresses signed a petition demanding no more Punk shows, and that was *that*.

Even though the Masque couldn't have shows, it still remained a practice space for struggling bands like the Mau-Maus and Model Citizens. The space was still used for parties. After one Masque event, a popular punk named Rod Donahue invited people back to his apartment in a large, run-down apartment complex called the Canterbury.

Claimed to be the scene of the famous Blue Dahlia murder of the Hollywood 40's, the Canterbury was run by a Rastafarian 'minister.' Its three stories of faded grandeur were occupied by black pimps and drug dealers, displaced Southeast Asians living ten to a room, Chicano families, bikers from a halfway house, in addition to various bag ladies and shopping cart men. The owner had no objection to people with pink and green hair moving into this menagerie, and whole contingents of punks started moving into the building. By February, members of the Screamers, Germs, Extremes, Weirdos, Bags, Deadbeats and members of the Plungers' disbanded commune lived there with some of the bands rehearsing in the basement.

One of the most popular punk girls was a roly-poly, friendly little crazy-colored fan named Margot

Fig. 10. Cover of *No* magazine no. 1, 1978. *Courtesy of Bruce Kalberg.*

32. GEZA-X. Photo: Ed Colver.

33. RICK WILDER of the Mau-Maus. Photo: Ed Colver.

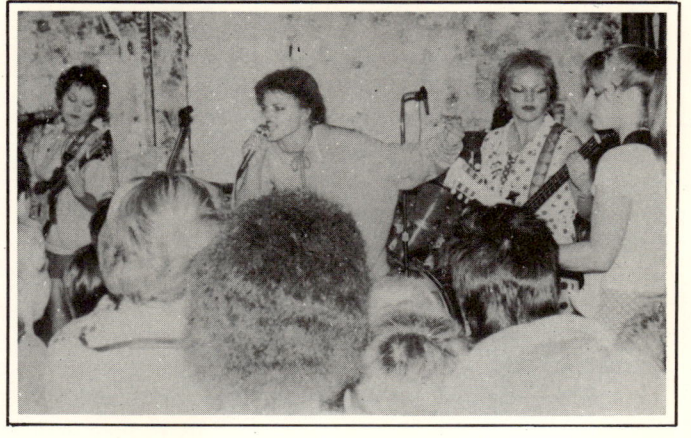

Olaverria. Known by some as one of the wildest party girls, Olaverria had met a girl named Elissa Bello and the two of them decided they'd form an all-girl band. Margot went about recruiting new members and asked Belinda, the roommate of Germs bassist Lorna Doom, to sing. Then she approached tiny Jane Wiedlin, who was vaguely pursuing a fashion designer's career, to play guitar. Though none of the girls could play their instruments, they started writing songs in the apartment Jane shared with boyfriend Terry, the drummer for the Bags. They decided to call themselves the Go-Gos. Though people scoffed at the idea of these wild punk girls ever actually playing on stage, there was hope that the Go-Gos would pull together the first all-girl punk band, which the Plungers had never really been able to do.

34. The early GO-GOS (l-r) Jane (Draino) Wiedlin, Belinda Carlisle, Margot Olaverria, Charlotte Caffey (drummer was Elissa Bello). Club 88, Los Angeles, 1978. Photo: Al Flipside.

35. BAGS (l-r) Patricia, Alice, Mabuhay Gardens, San Francisco. Photo: Ruby Ray.

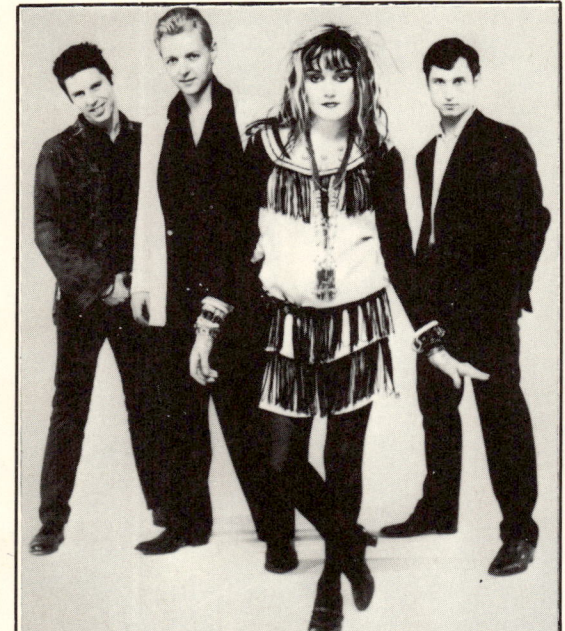

36.

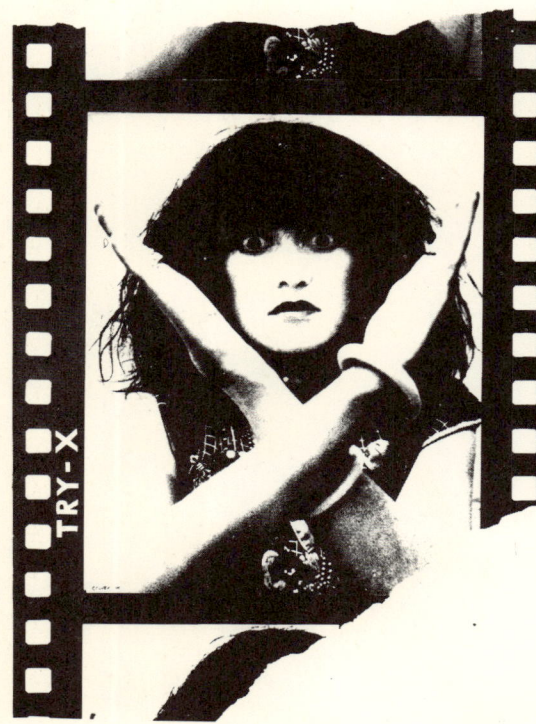

37.

Fig. 11. *(Page 25)* RODNEY ON THE ROQ, various artists. Photo: Barry Linwell. Design: Kevin J. Walker. *Courtesy of Posh Boy Records.*

Fig. 12. *(Page 26)* WILD GIFT, X. Photo: Frank Gargani. Design: John Doe and Exene. Package: J. Ruby Productions, Inc. *Courtesy of Slash Records.*

36. X (l-r) John Doe, Billy Zoom, Exene Cervenka and Don Bonebrake. Photo: Frank Gargani. *Courtesy Elektra Records.*
37. Try X. Photo for early X promotional material. Photo: Ed Colver.
38. EXENE. Photo: Ruby Ray.

38.

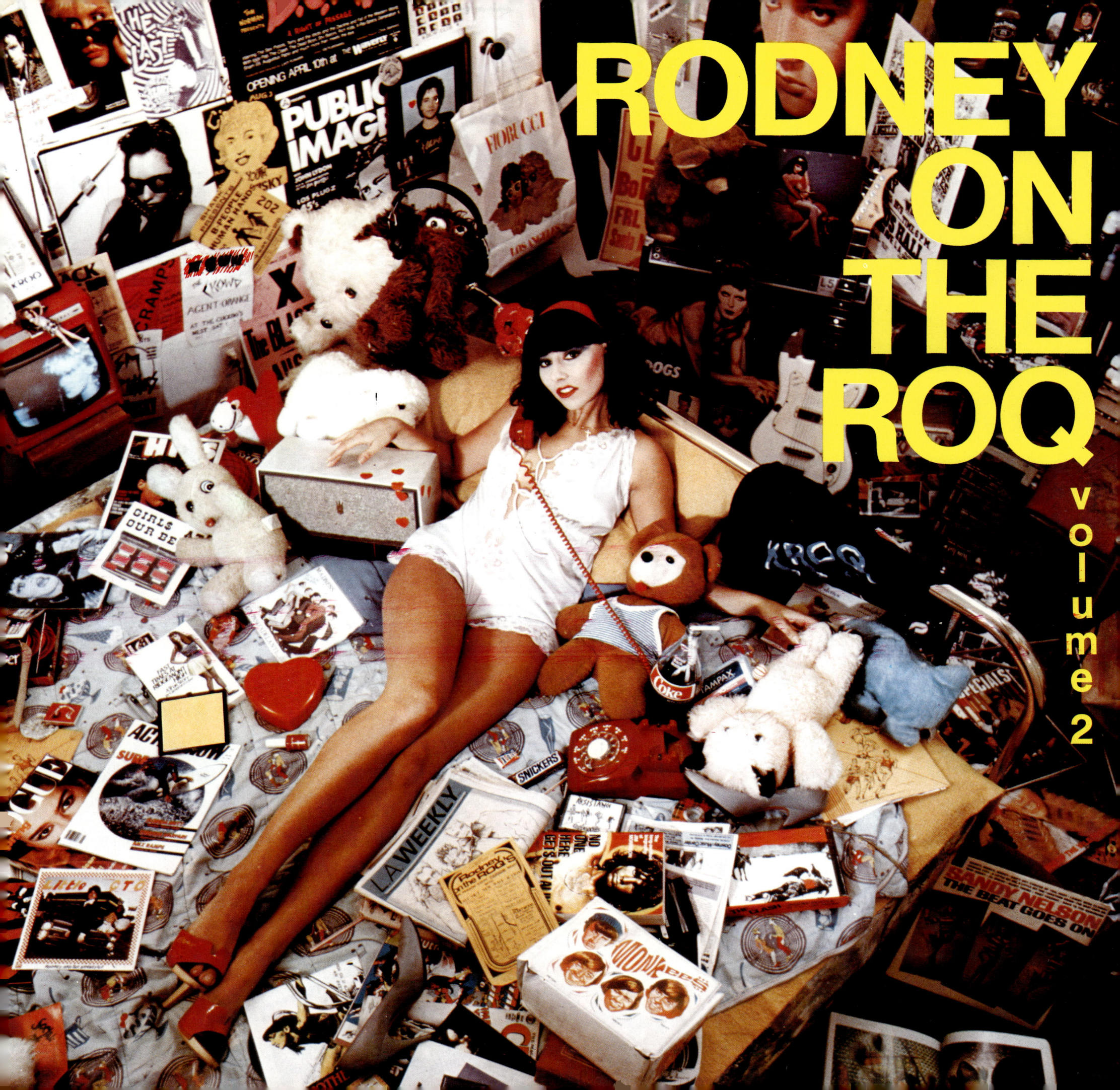

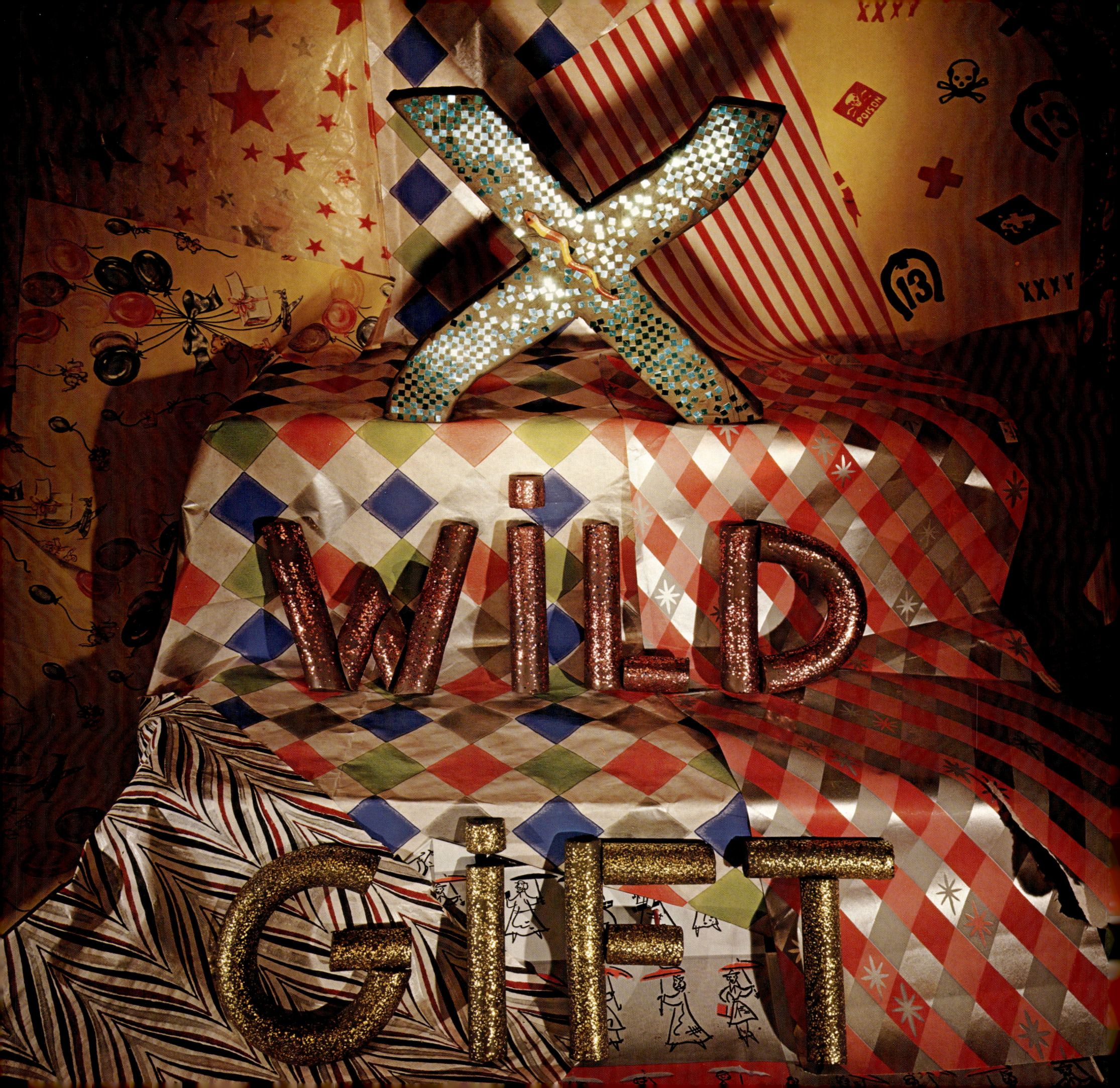

THE DECLINE
of western civilization

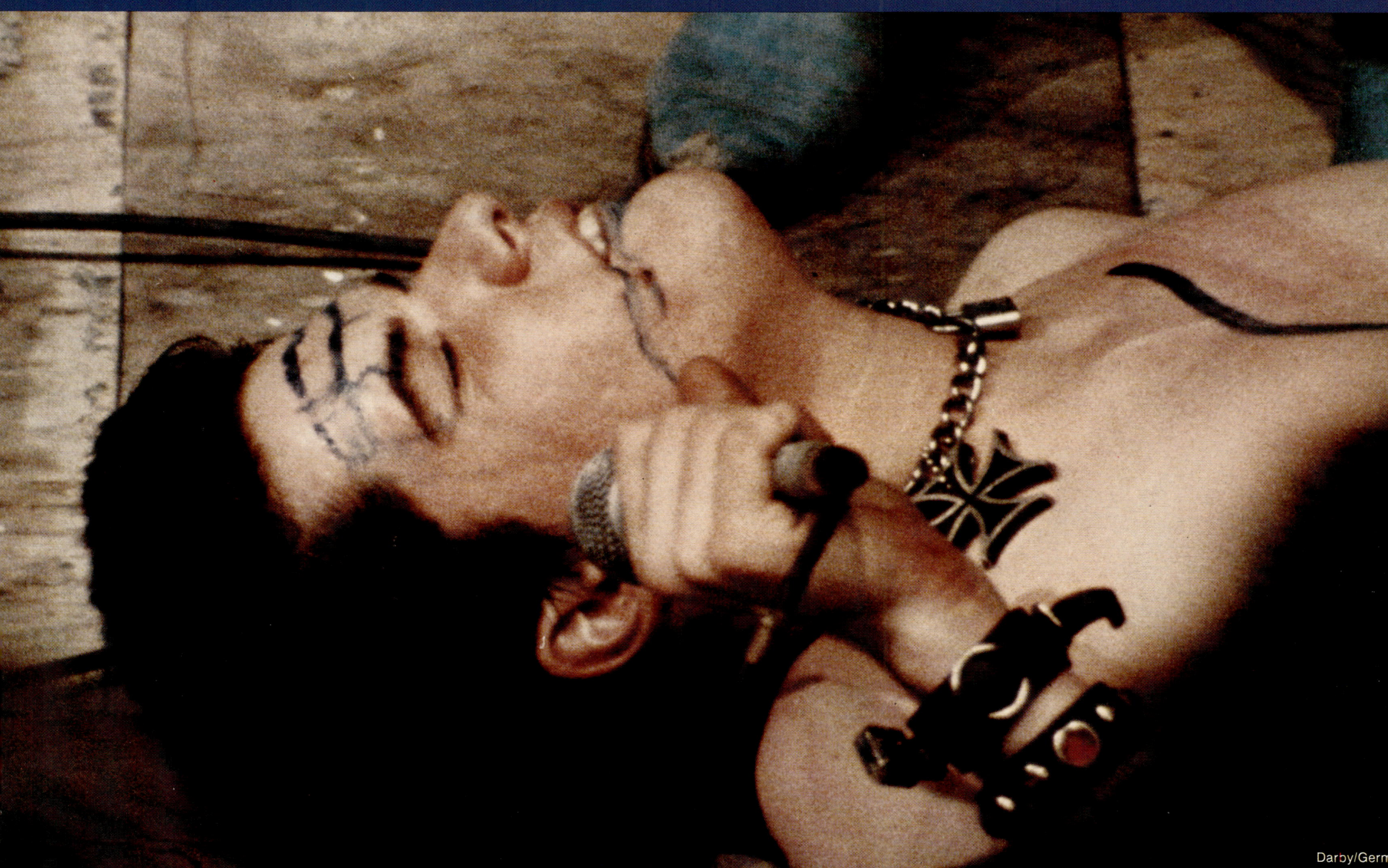

Darby/Germ

the original soundtrack from the film

February, 1978

Brendan Mullen was desperately trying to raise money to bring the Masque up to fire code regulation, and started organizing a two day Masque benefit. Held in a beautiful old downtown building, Elks Lodge (which would play an important part in the local scene's history a year later), the benefit offered the most comprehensive picture of the L.A. underground to that point, featuring every essential band in the Punk scene. There was L.A.'s first Punk-rock band, the Weirdos, whose popularity was starting to wane, the Screamers, at the height of their popularity and creative powers, the Dickies, who bypassed the Weirdos and had a rabid following madly pogoing to their zany antics, the Germs, whose Bobby Pyn had changed his name to Darby Crash, the Bags, featuring two exotic girls, Alice and Patricia, the Zeros, the Skulls, the Controllers, F-Word, the Deadbeats, Shock, the Flesheaters, and the Plugz. But probably the most historically important set came Sunday afternoon when X, who had only played a few gigs up to that point, borrowed Eyes drummer Don for their set. It was the first indication of the real X, the powerful yet intimate band that would come to dominate the L.A. scene. The mad two-day affair ended with a loaded Black Randy trying to find satirical coherence amidst a stage full of people jamming on instruments. In the meantime some punks had found a refrigerator filled with cupcakes and were throwing them at the audience. It was typical of the great spirit of '77 — end the gig in a food fight, another shambles, another great party.

After the party was over, there were some basic truths that had to be dealt with. For some there was a bitter after-taste. Part of the Punk scene's ethic had been that the bands were equal, that there be none of the star-trips that one associated with the corporate music industry. Yet the bands had been bitching and bickering about their position on the Benefit bill. There had been a camaraderie based on the need for survival among the bands: this too was slipping away. The Screamers were elitist and secretive, very much playing up the star syndrome. The Weirdos kicked out their original bass player because a record producer claimed he didn't sound good in the studio. The Dickies were starting to be looked on as opportunists who had manipulated the Punk scene in order to get a recording contract, using unlimited guest lists full of Punk fans to impress A&M into finally signing the band.

As the months wore on, there was this desperate feeling of being on a sinking ship. *Bomp*, one of the first magazines and record stores to endorse the Punk scene, had turned its attention to calmer, safer 'power pop' bands. Live shows were increasingly infrequent. The Skulls, one of the best of the Masque bands, were falling apart, fighting and changing drummers every other week. Everybody was feeling a little dislocated. There was no real center with the Masque unable to operate and *Slash* losing its early, brittle focus.

39.

Fig. 15.

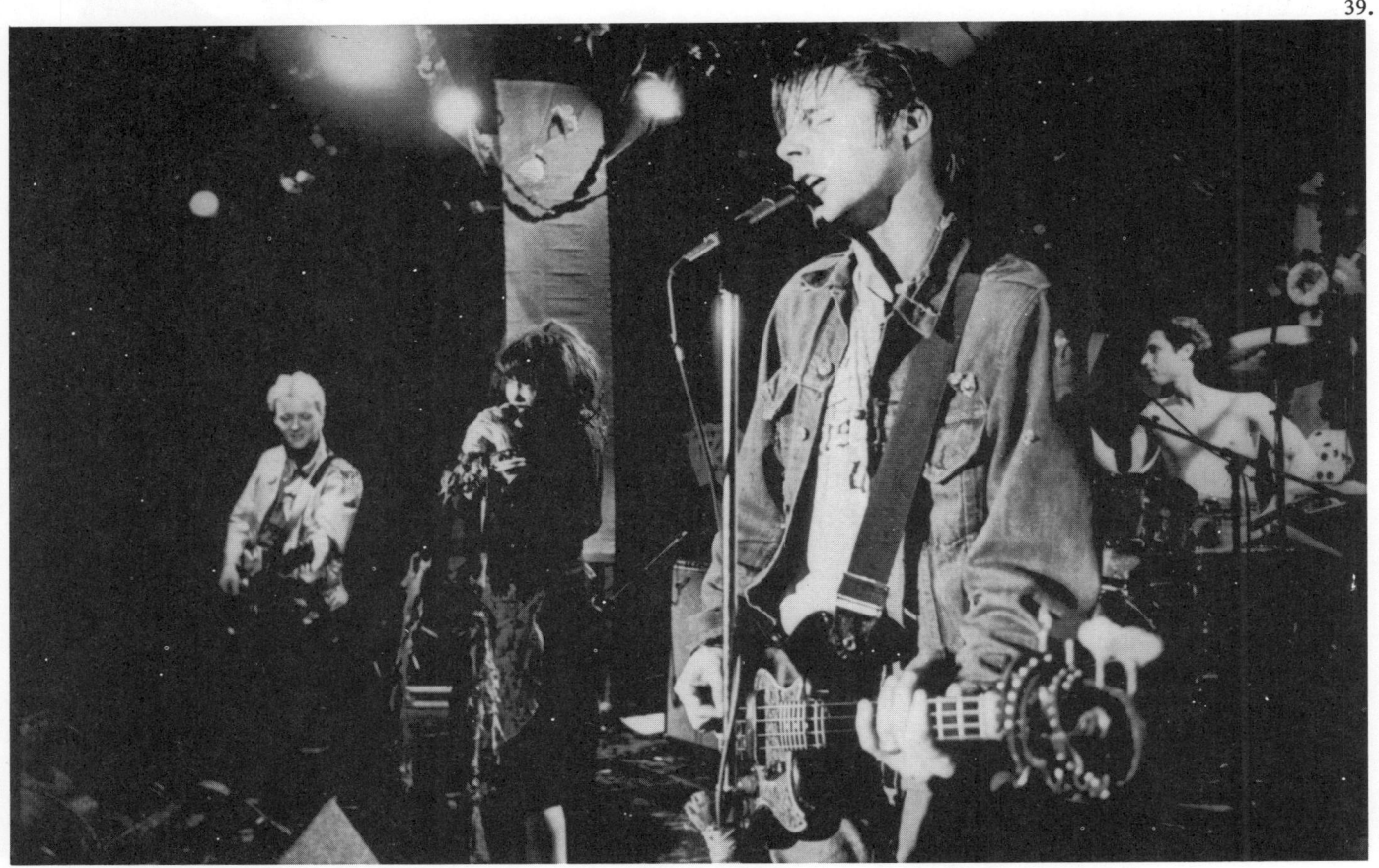

Fig. 13. *(Page 27)* THE DECLINE OF WESTERN CIVILIZATION, various artists. Photo: Still from the film by Penelope Spheeris. Design: Jeff Price. Package: J. Ruby Productions. *Courtesy of Slash Records.*

Fig. 14. *(Page 28)* GROUP SEX, Circle Jerks, Art: Dianne Zincavage. Photo: Ed Colver. *Courtesy of Frontier Records.*

Fig. 15. Poster by the band X.

39. X (l-r) Billy Zoom, Exene, John Doe, Don Bonebrake. The X movie, May, 1980. Photo: Gary Leonard.

29

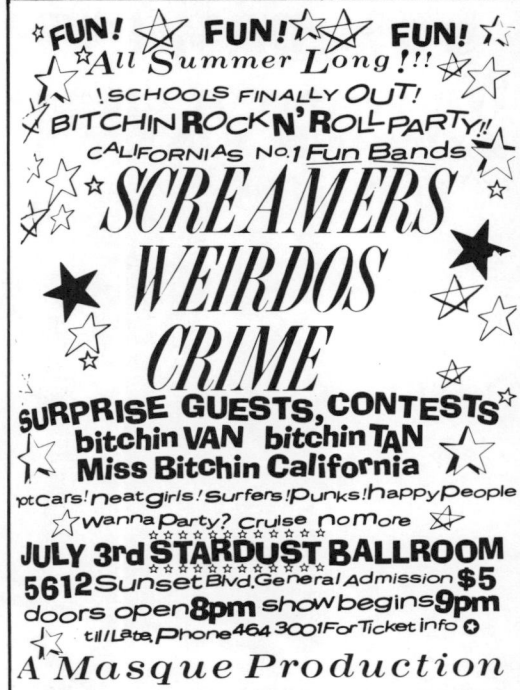

Fig. 16.

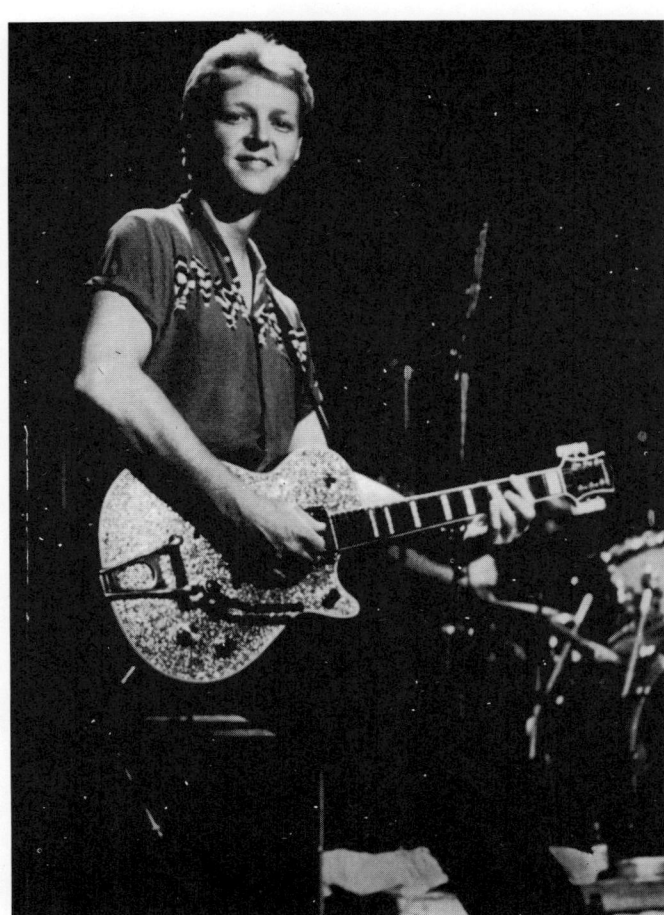

40.

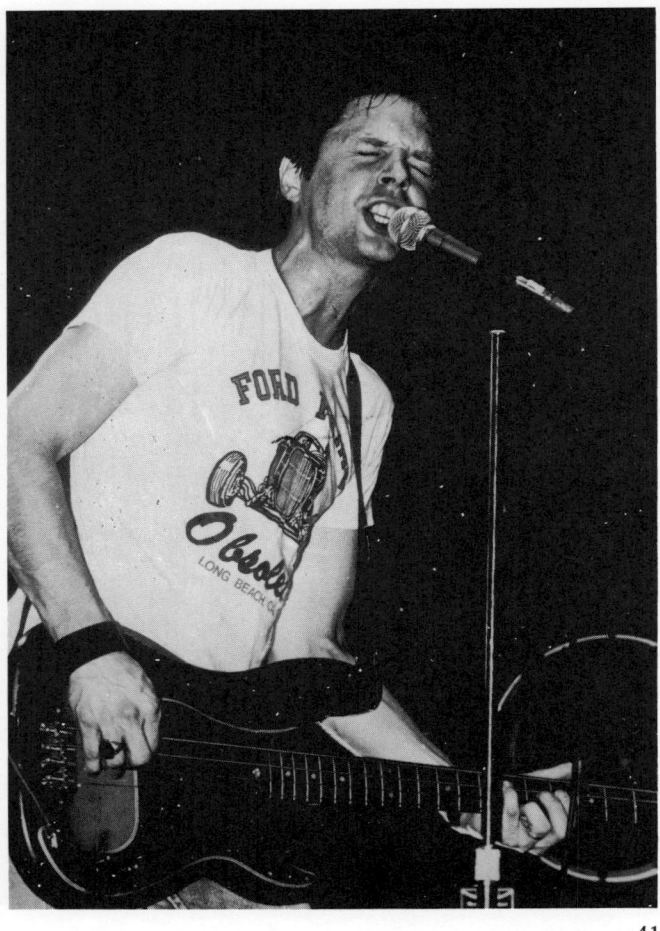

41.

Fig. 16. Poster for Stardust Ballroom show, July, 1978.

40. BILLY ZOOM of X. Photo: Ed Colver.

41. JOHN DOE of X. Photo: Glen E. Friedman.

August, 1978

A show at Larchmont Hall (co-produced by Hector, former member of the Zeros) introduced a band from Orange County called Middle Class, who looked like four typical suburban teenagers, but played with an incredibly fast, harsh, sonic blare that was a true predecessor to suburban hard-core. The Go-Gos were gearing up for their first show, having recently been joined by former Eyes bassist, Charlotte Caffey. A new group from Long Beach, Rhino 39, appeared on the scene. A group from Arizona, the Consumers, had come to L.A. for the Masque benefit, and some friends of the band had stayed, joining the Germs and the Bags. The Controllers had replaced their former drummer with a black teenage girl named Mad Dog.

The Whiskey still promoted the occasional Punk show, with the Cramps coming to L.A. and immediately becoming everybody's favorite band from New York. San Francisco's Mabuhay did a weekend trade with the Whiskey, and the Nuns, Sleepers, Negative Trend and Offs came to town.

The Screamers played a biker bar in the Valley called the Rock Corporation and the Weirdos and Bags quickly followed suit. For a while it became the only alternative space for a lot of bands, including a new group founded by F-Word manager, Posh Boy, called the Simpletones. A girl gang called the Piranhas prowled the Canterbury, getting a girl group member stoned on ludes and covering her body with bite marks as the new Dangerhouse single by X, *Adult Books,* played in the background.

The Screamers had just toured the Northwest and were set to play New York. The band seemed destined to follow the Dickies in signing a record contract. There were rumors that Brian Eno was interested in the group. With major coverage in the Los Angeles *Times*, the band was becoming widely known outside of the small Punk cult. But the Screamers didn't record, claiming they were more interested in multi-media work than the standard record format. The Screamers and the Weirdos appeared with San Francisco's Crime and the Controllers at one of the biggest Punk gigs since the ill-fated "Punk fashion show" at the Palladium. The high ticket price of this event at the Stardust Ballroom, and the somewhat misleading promotional devices for the show (being advertised as having a "bitchin van — bitchin tan" contest), left many of the Punk purists wondering what the hell Brendan Mullen, the concert organizer, was up to. At the same time the Whiskey management decided that Punk was not doing good business for its club and replaced the sympathetic Michele Myers with the dire David Forest, who immediately cancelled all Punk bookings and tried to pull in some nice, clean disco acts.

Once again things were deteriorating. The Rock Corporation was never the right place to be, and the bikers were not happy having their living room invaded by crazy-color. The Canterbury was beginning to get especially ugly. The halls smelled like shit, someone constantly pissed in the elevator (right on the wall where someone had spray-painted "Pirannas eat lesbian shit"), one girl was raped at gunpoint, cockroaches were everywhere, and another girl had an angry neighbor throw a pot of boiling soup on her face. Racial tensions were high. The basement rehearsal room had been padlocked, little fires were breaking out and the punks started to flee. What had been envisioned as L.A.'s equivalent of the Chelsea Hotel was no longer hospitable to kids playing Wire and Sham 69 full blast at four in the morning.

Paul Greenstein was a designer of guitar-pin jewelry who had an interest in preserving historic L.A. sites. Greenstein liked to take dates to a funny old pseudo-Polynesian restaurant/bar in Chinatown. One day he asked its owner, Madame Wong, if she would like to try having live rock bands play in her restaurant. Wong turned the idea down at first, but Greenstein persisted, and started shows with some of the older generation Hollywood pop bands like 20/20 and the Zippers. Greenstein liked the Punk bands, but didn't want to push things at the conservative club, though the Plugz managed an early Wong set. Once again there was the problem of not having a dance floor, but the intrepid Greenstein tried an X/Bags show. Like the Germs, the Bags had been banned from most venues due to intense audiences turning over furniture or wrecking bathroom appliances. The show was a disaster. Kids turned over tables and chairs during the Bags set, and someone stole Billy Zoom's guitar, preventing X, who were due to go to New York the next day, from doing their set. After similar incidents occurred during an Alleycats show, Madame Wong decided, in her inscrutable wisdom, that the problem was with bands having girls in them. X, the Bags, and Alleycats all had female rock and roll creatures that obviously provoked unstable males to acts of carnal violence. Wong fired Greenstein, a new booker would appear, and the club would become the home of safe, commercial groups like the Motels, the Pop, Oingo Boingo, 20/20, Code Blue and that most famous of one-shot power-pop bands, the Knack.

NO magazine appeared around this time, featuring sex and disfigurement pictures along with provocative graphics and interviews with X and the Go-Gos, who mentioned, even at that early stage of their career, that they wanted to be on AM radio. However, given the Go-Gos' repertoire of angry songs either seeming to advocate the overthrow of the government or blasting L.A. *Times'* music critic Robert Hilburn, it didn't seem like the musically inexperienced Go-Gos were Top 40 material at the moment. The Flyboys flew in from Arcadia, bringing

42.

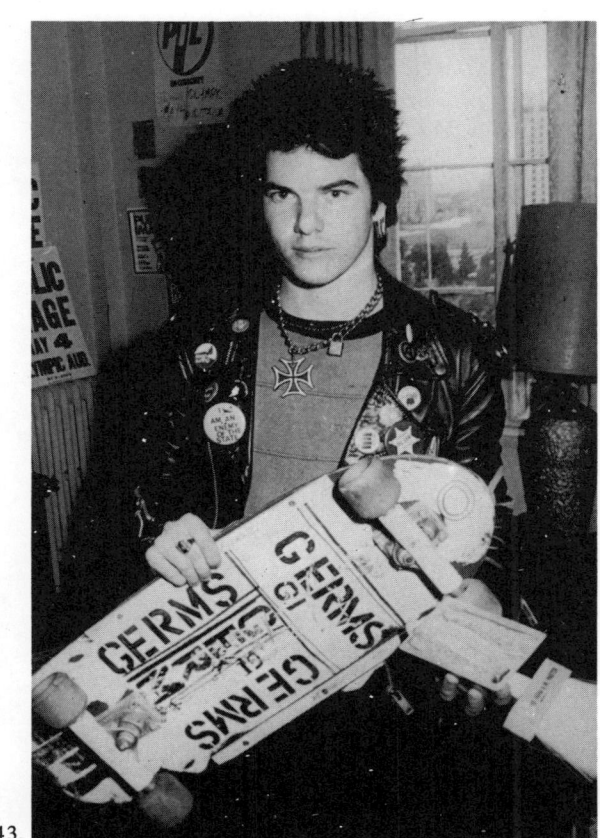

43.

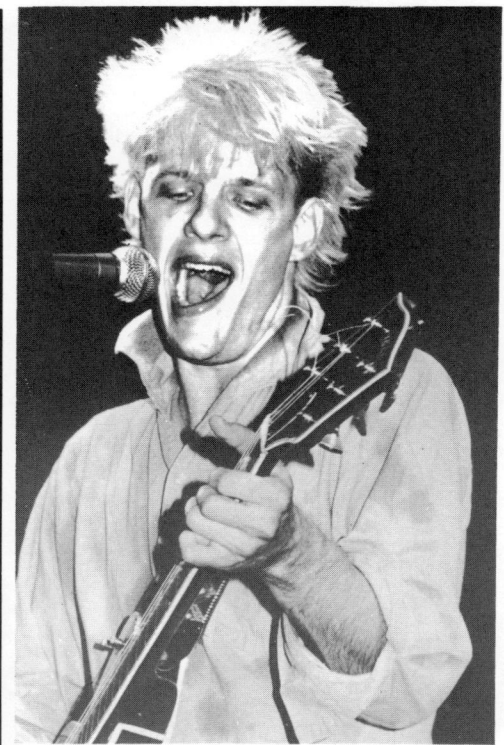

44.

42. OINGO BOINGO. Photo: Craig Dietz.

43. DARBY CRASH of the Germs, April, 1980. Photo: Gary Leonard.

44. JOHN of the Flyboys. Photo: Lynda Burdick.

bright, day-glo clothes and Buzzcocks-derived Pop-Punk. They offered a colorful alternative to an increasingly grey, sedentary scene filled with internal squabbles. Dangerhouse Records, in particular, was getting its fair share of vicious rumors and innuendo. People claimed Black Randy was ripping off the bands on the label, though everything was on such a minute business scale at that point that it seemed unlikely that any profit could have been diverted.

Another venue, Club 88, was discovered by the Extremes and Bags, and occasionally hosted strong shows, though a 21 age limit inhibited a lot of fans. Though 1978 had lost a lot of the crazy spark that ignited the L.A. scene, Dangerhouse felt positive enough to release a sample of local groups called *Yes L.A.*, featuring the Germs, X, Alleycats, Black Randy, the Eyes, and the Bags. It seemed like a good way to end the year.

January, 1979

The New Year started with the "New" Masque. Brendan Mullen had found a large warehouse, formerly a seedy disco. There was nothing to wreck in the place, making it the perfect Punk showcase. Ex-football jock turned conceptual artist Bob Biggs was financially involved with the New Masque, and later Biggs would take over *Slash* magazine. Former editor Steve Samiof had become bored with Punk and began putting out a free art and boutique ad mag called *Stuff*.

1978 had been the year of small hall shows. The Whiskey and Starwood, Hollywood's major clubs, were still closed off to Punk, so bands sought out unknown venues, throwing sporadic gigs at places like Lazaro's, the Azteca, Larchmont, and Baces Hall. Fear was starting to get a reputation for its very abrasive humour and wild hammer-headed walls of sound.

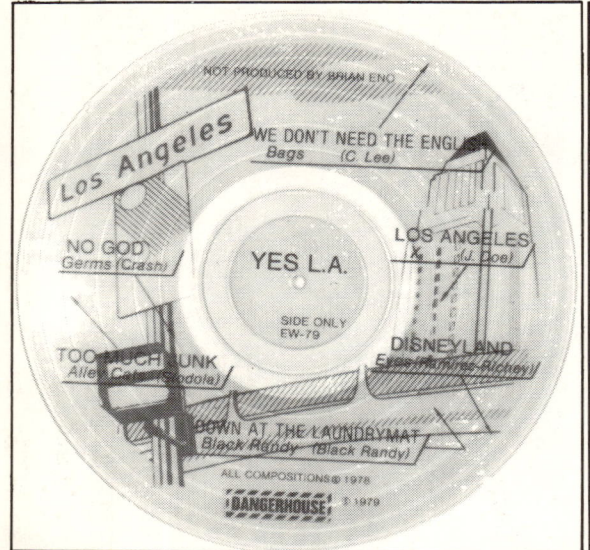

Fig. 17.

45.

Fig. 18.

Fig. 17. *(Facing page)* YES L.A., various artists. *Courtesy of Bomp Records.*

Fig. 18. *(This page)* FEAR, THE RECORD, Fear. Package: J. Ruby Productions. *Courtesy of Slash Records.*

45. *(Facing page)* Elks Club Hall Riot. Lead singer of Middle Class with his girl friend display their bruises and cuts inflicted by police during the "Elks Club Riot", March 1979. Photo: Ann Summa

46. *(This page)* LEE VING of Fear. Photo: Ed Colver.

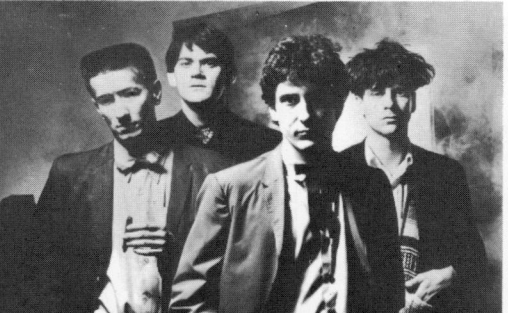

47.

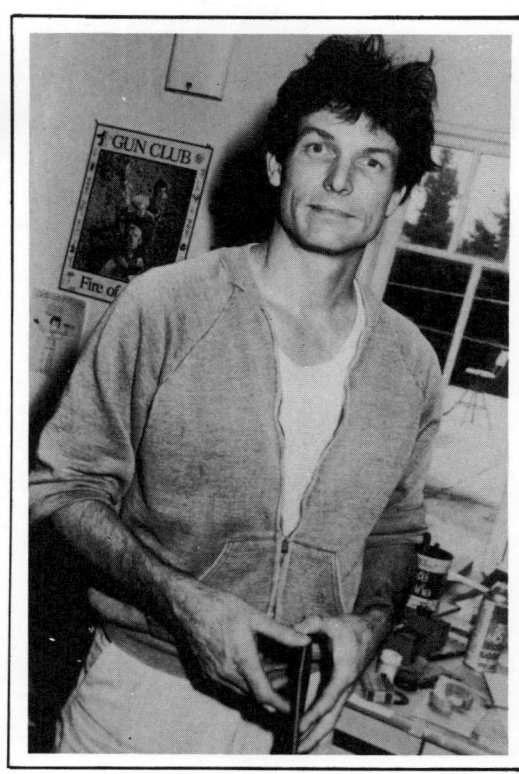

48.

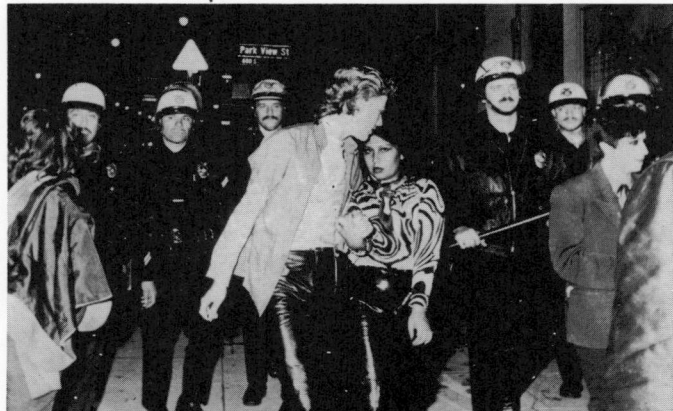

49.

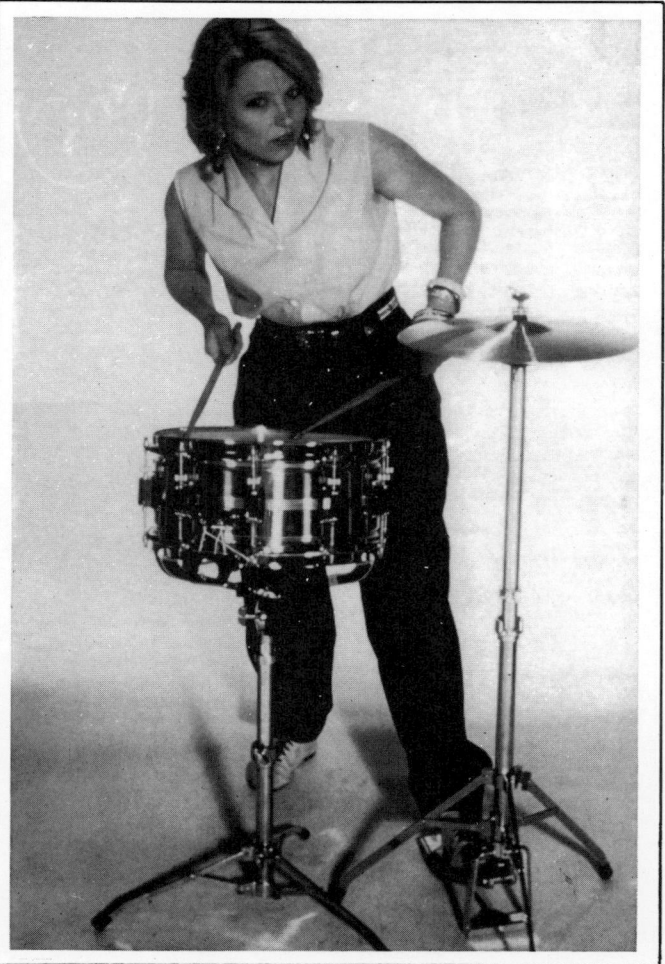

50.

47. WALL OF VOODOO (l-r) Joe Nanini, Chas T. Gray, Stan Ridgway, Marc Moreland. Photo: *Courtesy of IRS Records and L.A. Personnel Direction.*

48. BOB BIGGS of Slash Records. Photo: Gary Leonard.

49. Elks Club Riot. A couple being herded down 6th Street, March 1979. Photo: Ann Summa.

50. GINA SHOCK, drummer of the Go-Gos, 1982. Photo: Craig Dietz.

February, 1979

wo important visitors came to town. The Clash played (with the Dils opening), but the band was even more anticlimactic than the Pistols. The group's set was unfocused, featuring songs from the uninteresting second album. More significant was the appearance at the New Masque of Levi & the Rockats. Suddenly girls were trading in bondage pants for poodle skirts. Though the Rockats never lived up to their initial hype, a strong devout Rockabilly cult was maintained and grew to the point where today's Rockabilly shows swarm with fans.

March 17, 1979

hings seemed to be going rather routinely at the Elks Lodge. Inside the theater a great concert was going on, featuring the top bands of the day: The Alleycats, the Plugz and the increasingly popular Go-Gos. The Go-Gos had moved away from their early, angry punk diatribes towards a more pop-inflected sound, singing with canny harmonies about "London Boys." The Wipers, a group from Oregon, played. The Zeros, who were playing L.A. less and considering a move to San Francisco, made an appearance. There was a fairly calm mood in the crowd. The English proprietors of the new clothing store, Poseur, were telling the soundman to change his music (not Punk enough for these fashion dilettantes). Outside the steps leading to the lobby dozens of punks, tourists, and music fans idly lounged about. Certainly nothing was as severe as the first Elks Masque benefit a year ago when Bruce Barf (of the Weirdos, Controllers, Skulls, Wall of Voodoo, and Masque infamy) pissed on the crowd from the balcony.

So it was a bit surprising to see a chorus line of helmeted riot cops march into the Elks building. It didn't seem to make sense — there was nothing really going on. Maybe a glass was broken, but it was no more violent than some of the fights that erupted at weddings held in the Elks building.

When the police suddenly turned and walked out, people laughed and jeered at what looked like an incredible waste of cop-power.

Then suddenly it happened. The cops came charging into the building, swinging their clubs, and knocking down helpless kids. Pandemonium broke out. There had been no spoken order to leave the building, but now angry cops were chasing angrier punks. I was sitting next to Jeff Atta and his girlfriend Dorothy when the cop charge came. I immediately ran, but Atta, not understanding what was wrong, held his ground. The next time I saw him, Jeff Atta had a huge wound in the middle of his forehead with several stiches in it, and Dorothy had a black eye and cuts all over her face. Her sister, furious at this police brutality, had been seen at the riot swinging a board at a cop. Other kids were seen throwing bricks through police car windows.

Elks Lodge created an immediate media furor. An obvious misuse of police power, it was the first major incident of police brutality since the Vietnam War era, where the cops had instigated a mini-riot for NO REASON. The original Masque basement became a temporary center for helping victims of what was called "The Saint Patrick's Day Massacre."

It set a precedent. In the old days the cops might have shown up when the Plunger parties got

51.

53.

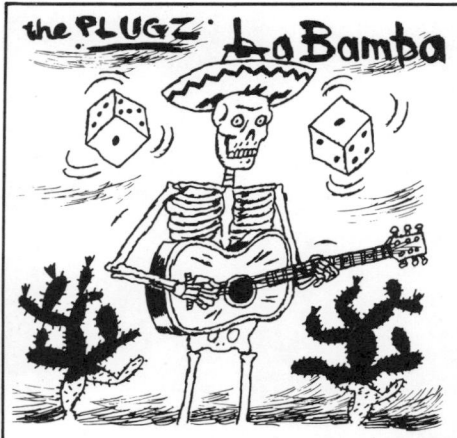

Fig. 19.

too wild, or when a show spilled out into the street, but basically the cops left the punks alone. Who cared if a bunch of weird-looking kids were drinking, fake-fight dancing and listening to ear-shattering music? After Elks Lodge the police became a genuine menace and started appearing at shows with increasing regularity.

The New Masque prospered with shows by the Go-Gos, the Fly Boys, X, the Plugz, and Fear. New bands started showing up. The Simpletones were like a punk cross between the Beach Boys and the Supremes with three male singers chanting "I Like Drugs", while Suburban Lawns were from Long Beach and featured a bizarre, off-kilter singer named Su Tissue. Visitors from San Francisco like the Mutants, Negative Trend, the Offs, U.X.A., and the original Dead Kennedys all made appearances.

Though the old Masque was still used for rehearsal space by bands like the Go-Gos and Motels, the New Masque was the introduction to Punk for a lot of new people coming into the scene. Following the familiar pattern, city authorities and greedy property owners shut the place down by May. The new Masque went out in a blaze of glory with a show

52.

54.

Fig. 19. Cover art for the Plugz *La Bamba* 45. Art by Gary Panter. *Courtesy of Fatima Records.*

51. BELINDA CARLISLE, vocalist of the Go-Gos. 1982. Photo: Craig Dietz.

52. KATHY VALENTINE, bassist of the Go-Gos. 1982. Photo: Craig Dietz.

53. JANE WIEDLIN, guitarist of the Go-Gos. 1982. Photo: Craig Dietz.

54. CHARLOTTE CAFFEY, guitarist of the Go-Gos. 1982. Photo: Craig Deitz.

55.

featuring the Cramps, Pure Hell from Philadelphia, a mysterious, experimental combo called Wall of VooDoo (with former members of old Masque bands like the Model Citizens and Skulls), and ending in the most burned-out, fitting way, with the Germs.

The Plugz had evolved into a solid trio with pure Punk drive and sharp social commentary. The members gave a nod to their Spanish heritage with a super charged version of *La Bamba*. Having released a single on the infant Slash label (before Biggs took over), the Plugz became one of the first L.A. Punk groups to record and release their own album, *Electrify Me*. F-Word released a live LP in June of 1978. The Dickies had their first album, *The Incredible Shrinking Dickies*, released on A&M. They would go to England, be thoroughly roasted by critics, and accumulate a huge adolescent following.

June, 1979

id Vicious was dead and the Hong Kong Cafe was open. Sitting in the courtyard across from Madame Wong's, the Hong Kong booked those Punk bands banned by Wong's. It also opened the way for new bands, because all of a sudden dozens of new groups were popping up. But *not* in Hollywood. The suburbs were ready to take over.

The first flashes of a suburban scene took place at a church rented by members of Black Flag in Hermosa Beach. Among the groups that were part of the Church scene were the youngest punks of all, Red Cross, whose bass player was 11 when the group formed. Other church inhabitants included some veterans from the initial Masque days, the Last, who played a combination of psychedelic, surf and pop music that attracted the attention of Bomp Records. Another group, the Descendents, were a hilarious, hickish three-piece that would later develop into a fine group.

Further down the coast a scene was growing in the wake of the first wave created by the Crowd. Bands like the Screws, Outsiders, Slashers, and later, China White, were forming in Huntington Beach and inland Orange County communities like Fullerton, Anaheim, and Garden Grove. The first and foremost of these bands was Vicious Circle from Long Beach who started playing shows at a barn-like heavy metal hall, the Fleetwood, in Redondo Beach.

The first of the Orange County bands, Middle Class, released an EP, *Out of Vogue*. Chris D. released an essential compilation album, *Tooth and Nail*, featuring the Controllers, Germs, U.X.A., Negative Trend, Flesheaters, and Middle Class. The Hollywood scene was starting to be filled with dark, grey junkies mouthing off various anti-semitic policies.

Among the other developments the Hong Kong instigated was a new breed of group known (for lack of a better term) as "art bands." Though the musicians in these bands hated the term (after all, very

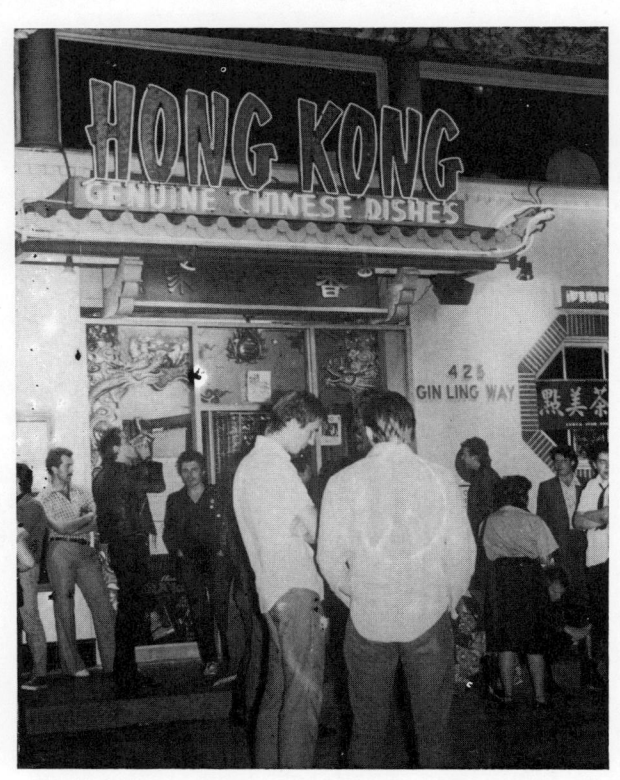

56.

few of them were visual artists and most had a very non-pretentious attitude towards what they were doing), these groups were taking a more imaginative, less strait-jacketed approach toward communication. The groups included the bouncy, winsome, techno-pop of Human Hands, the introspective orchestral textures of the moody B-People, the blaring synthesizer torture of Nervous Gender, and the slightly mysterious, science-fiction sound of the reclusive and fascinating Monitor. Nervous Gender had an angry androgynous lesbian singer named Phranc, who later became L.A.'s first Punk folk singer.

Black Flag released their first EP, *Nervous Breakdown*. While some old punks went to the art

57.

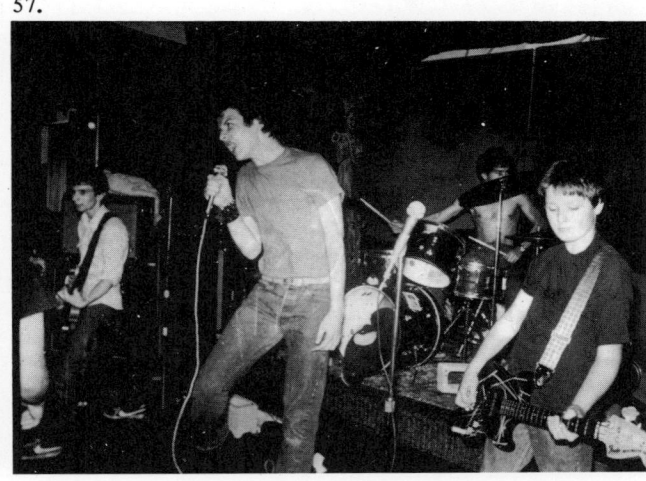

55. The Church in Hermosa Beach. Photo: Al Flipside.

56. Hong Kong Cafe in Hollywood. Photo: Al Flipside.

57. RED CROSS (l-r) Greg Hetson, Jeff McDonald, Ron Reyes, Steve McDonald. Photo: Al Flipside.

58. *Facing page.* STAN RIDGEWAY of Wall of Voodoo. Photo: Lynda Burdick.

58.

59. Crowd at Black Flag concert. Photo: Frank Gargani.

60. *(Facing page)* JOHANNA WENT. Photo: Frank Gargani.

61. *(Facing page)* JOHANNA WENT. Photo: Ann Summa.

62. & 63. *(Facing page)* JOHANNA WENT. Photos: Ed Colver.

camp, others went to Rockabilly and still others went to sleep, Black Flag reminded one of what the original energy and intent of Punk was. But Black Flag, unlike the original Masque crowd, was not into fashion credibility. They were basically Joes off the street. This underlined a separation between the South Bay working-class kids and the post-glitter Hollywood punks. The Hollywood kids didn't stand a chance. The new breed of suburban Punk was physically tougher, angrier and more immediately REAL about their intention than the original party people.

September, 1979

Black Flag gained notoriety by shocking unaware families at a free concert in Polliwog Park in the South Bay. Outraged letters to the local paper decried the band's obscene lyrics and the violent dancing of fans. The police began a steady persecution of the South Bay punks, who already had enough trouble coping with local long hairs and red-necks. When Keith of Black Flag sang ,"I'm going to EXPLODE," he meant it.

As a sign of the changing times, the original Masque was finally shut down after a party with U.X.A., and Mad Dog from the Controllers played

59.

60.

61.

62.

63.

Fig. 20.

64.

Fig. 20. Cover of *Slash* magazine. Vol. 2 no. 9. Drawing of Su Tissue of Suburban Lawns by Vallen. *Courtesy Slash Records.*

64. B PEOPLE (l-r) Paul Cuttler, Pat Delaney, Tom Recchion, Alex Gibson and Fred Nilsen. Photo: Ed Colver.

65. EDDIE AND THE SUBTITLES (l-r) unknown, Chas, Eddie, unknown. Photo: Ed Colver.

66. SU TISSUE of Suburban Lawns. Photo: Ann Summa.

67. JOHANNA WENT as Sister DeNiro. Photo: Frank Gargani.

65.

around with a fuck-band called the Blackhearts (some of whose members would later turn up with Joan Jett!). But in a spiritual sense, the Masque had been gone long before it was closed.

The Mau-Maus discovered yet another unlikely venue, a black bar called King's Palace, which staged some exciting shows, including the comeback of the Weirdos who had been off the circuit for a while. When the Weirdos blasted into their first song, all hell broke loose in the King Palace's subterranean room. It seemed as if the old Weirdos mania would be reactivated, but the band could never recapture the sheer intensity of the early days when they were

66.

67.

L.A.'s Punk Beatles. Anyway, there were a lot of bands doing what the Weirdos did at that time. And most of them were younger, faster and louder.

Huntington Beach kids were doing an absurd dance called the "Worm" that resembled an epileptic fit. Eddie, of Eddie and the Subtitles, had received a $5,000 inheritance, and was using it to support and promote bands from Fullerton and outlying areas.

November, 1979

Slash Records released *Germs, G.I.*, an ultimate statement of Hollywood hardcore sensibility. The Germs' hard, fast, brittle and terrifying songs showed how far the band had come musically since the days when Darby Crash was called Bobby Pyn. Posh Boy was starting to document the suburban scene, putting out a compilation, *Beach Blvd.*, and signing teen punks Red Cross.

It was also around this time that a pretty red haired woman from Washington State first appeared in Los Angeles. Her name was Johanna Went. Her performances defy categorization, but could be explained as costume changes choreographed to the drone of the industrial music of her sidemen, Mark and Brock Wheaton. She unleashed a barrage of images that included anything from giant dildos to oozing concoctions of unknown origin dripping from the effigies she mutilated on stage.

—*Craig Lee*

Fig. 21.

Fig. 21. Cover of *Slash* magazine featuring Dave Vanian of the Damned. May, 1977. Photo: Melanie Nissen. *Courtesy of Slash Records.*

Fig. 22. *(Page 42)* Panel from Gary Panter's "Jimbo" comic strip which appeared in the pages of *Slash. Courtesy of the artist.*

Fig. 23. *(Page 43)* NO QUESTIONS ASKED, The Flesheaters. Cover art by Chris D. *Courtesy of Slash Records*

Fig. 24. *(Page 44)* CH3, Cover photo: Ed Colver. *Courtesy of Posh Boy Records.*

41

NO QUESTIONS ASKED
FLESH EATERS

CH3

FEAR OF LIFE

In 1978 the suburbs of Los Angeles (Anaheim, Fullerton, Garden Grove, Huntington Beach, Redondo Beach, etc.), were still a home for Disneyland, Movieland Wax Museum and a place to grab a Bob's Big Boy Burger on the way to Mexico. Punk rock, underground music, or alternative music was a Hollywood commodity with an airtight incrowd and a tiny network of bands and clubs. For the record — there were bands formed by "defectors" and cool-dudes from the suburbs: Middle Class, the Crowd, the Flyboys, and the Simpletones. With the exception of the Crowd, these bands didn't carry a *scene* with them, and Orange County was still drowning in mucho macho heavy metal. But, in a couple of months the Hollywood scene would fizzle, crumble, and decentralize, and the Punk rock suburbs would be the talk of the town.

The first flashes of a suburban scene took place at a church rented by members of Black Flag in notorious Hermosa Beach. Black Flag, who almost always seem to be at the skinned head of L.A. Punk, had just lost their mega-beer-drinking yowler Keith Morris to the Circle Jerks. He was replaced by Puerto Rican muscleman Ron Reyes. The unimpressive church was the first focal point of the scene. The tiny tots of Red Cross played *Tiger Beat* teen punk, the wiry rhythmic Last (whose Joe McNulty was a church live-in and party organizer), and the hilarious, almost hickish Descendents who would later rise to bigger and goofier things, all debuted there. For three to five months gigs were held at this "big ole thang," until the landlord brought the festivities to an end.

Just along the coast, in soon-to-be-infamous Huntington Beach, a tiny scene of about seven bands (Screws, Outsiders, Slashers, Crowd, Klan, and later China White and the Blades) was spreading faster than herpes in Hollywood. The first and foremost band of the hour was Vicious Circle who started doing shows at the Fleetwood in Redondo. The Fleetwood was the club of the hour for second generation punks in Orange County and the South Bay: Hollywood contingent bands (Weirdos, Fear, X, Bags) as well as the even newer one-song-wonders. This provided the first major meeting place for the two previously stranded scenes. What the Fleetwood lacked in glamour — it was something of an old supermarket — it made up for in pure frightening tension. The dancing at the Fleetwood was not the paltry arm waving, sneer-on-the-face "slam" practised these days by kids introduced to the scene through television. The violent dancing at the Fleetwood was the kind where midway through a Vicious Circle set, twelve ambulances with twenty four stretchers would pull up outside. Beach kids, whose lives revolved around heavy physical prowess, were out to kick ass. Soon Vicious Circle would disband because of the fights. Many of the jocks went on to become soldiers as soon as blood wasn't chic on the scene.

Fig. 25. Poster for Black Flag concert, August, 1981. Art by Raymond Pettibone.

Fig. 26. Poster for Black Flag concert, October, 1980. Art by Raymond Pettibone.

68. GREG GINN of Black Flag. Photo: Ed Colver.

69. DEZ CADENA of Black Flag. Photo: Ed Colver.

70.

Fig. 27.

Fig. 27. Poster for Circle Jerks concert, March, 1981. Art by Shawn Kerri.

70. HENRY ROLLINS of Black Flag. Photo: Rooh Steif.

71. CHUCK DUKOWSKI of Black Flag. Photo: Glen E. Friedman.

72. CHUCK BISCUITS with Black Flag. Also played with D.O.A. and the Circle Jerks. Biscuits is Punks answer to Keith Moon.
Photo: Ed Colver.

71.

Despite the somewhat apathetic audiences at the Fleetwood, (where ten or eleven punkettes would sit on the stage gossiping with their backs to the musicians), a strong network of bands popped up in the inland area thanks to the help of heavy metal madman Eddie of the Subtitles. Eddie promoted bands with a $5,000 inheritance. Under his wing were: the crazed, fantasmic Adolescents with lanky singer Tony, whose voice set standards for a million small-town Punk bands; the surf-crazy Agent Orange, whose recorded work is some of L.A.'s best to date; and the powerful Social Distortion's Mike Ness whose inland party apartment was immortalized in the Adolescents' song, *Kids of the Black Hole*.

In the minor league were the Ruins, Sexually Frustrated, Dead Skin, Der Stab, the Negatives, and Eddie's own acid-metal band, Iron Lung, which included a member of Middle Class. But actually, anybody could play in Iron Lung. Eddie owned a big black van and would transport inland kids to the shows and watch the havoc. By the summer of 1980 Eddie had become so important to the inland scene that it was dubbed "the Eddie Empire."

Closer to home (if Hollywood was your home), in Chinatown at the Hong Kong Cafe, a year and a half of crowded gigs occurred catering to all that was good in L.A. Starting in the summer of '79, muscle Punk, voodoo art, and anything else was showcased seven-nights-a-week at the Hong Kong. Down the street at the geek capital of the world, Madame Wong's Punk was being banned ruthlessly. This is how the story goes: A tape was left for Wong. It was supposedly a gift from Dwight Twilley. When the tape was played over the p.a. at one of their heady new wave nights, a recorded voice screamed for all patrons to move down the street to the Hong Kong and hear some "real music." Exit Punk.

Club 88 in West L.A. picked up on Punk and their charming manager, Wayne, booked some fab shows. Then early in the summer of '80, just after 999 and the Dead Kennedys had successfully played L.A., Patrick Goldstein, a writer with the L.A. *Times*, ran an article called "The SLAM!" This freely exploited and made media-meat out of the suburban Punk scene, citing that punks (especially Orange County kids) were criminal, vicious, and *dangerous*. Naturally this drew a whole new wave of fungus out of places too placid to even *be* suburbs, who read "Punk rock" as "drawing blood." It was a disaster for such bands as Black Flag, the Circle Jerks, Fear, China White, etc. It banned them from clubs, jeopardized any party they played, flyer they put out, and even fans that wore their stickers. The Huntington

72.

73. ROGER ROGERSON of the Circle Jerks.
 Photo: Ed Colver.

74. CIRCLE JERKS (l-r) Roger Rogerson, Lucky Leher, Gregg Hetson, Keith Morris.
 Photo: Ed Colver.

75. SOCIAL DISTORTION (l-r) Dennis Danell, Derric, Brent, Mike Ness. Photo: Ed Colver.

76. KEITH MORRIS of the Circle Jerks.
Photo: Glen E. Friedman.

Beach PD began to refer to bands as "gangs". So naturally a person with a Blades sticker was a member of the Blades gang. Not helping matters were various news exposes on "beach punk killers and whores."

On the other end of the spectrum X's album, *Los Angeles*, a classic in every right, was greeted by phenomenal reviews. Shortly after, the Whiskey A-Go-Go, always hip, cool, and expensive, booked them for three straight nights.

The Starwood began an intense booking schedule of hardcore Punk around this time. By mid-summer Darby Crash, the biggest tangible idol for suburb Punk, left the Germs and debuted a new band at the Starwood. It flopped. . .badly. The ruthless spirit of the Germs was a goner, and Darby knew it. Nevertheless the show was packed, proving how strong a force Hardcore Punk had become. Soon Eddie and the Subtitles put out their monumental "American Society" single. It was played to death on Rodney Bingenheimer's Saturday and Sunday night shows. With the help of Rodney's airplay the Subtitles became the band of the moment.

At this time the URGH show was organized at the Santa Monica Civic Center, featuring X, Dead Boys, Dead Kennedys, Chelsea, Oingo Boingo, Magazine, and the Cramps, among others, in a live show captured on film. For Punk purists it was a disaster, but successful with every sub-hippie and punk-with-perfectly-clean-boots. Eddie's Empire, always ready for action, put on a late summer show at La Vida Hot

48

Springs. Twelve bands from the inland area and the beach were highlighted by Middle Class and the struggling, overproduced psycho-pop of Geza X and the Mommymen. So massive was this day-long outdoor event that a biker gang decided to drop in and wreak havoc. The police followed. It was not violent, but at the time police/punk clashes were rare. This would change fast.

At the end of the summer of '80 two men who owned a cutsey New Wave shop wanted to put on a Punk show at a cheap hall called the Hideaway. The show was to have Black Flag, the Circle Jerks and the best new bands including Mad Society (five kiddies from the Starwood parking lot scene). Three hundred punks showed up. They were greeted by one door with an endless line, a hot club, and a cheezy sound system. What do packs of angry punks do when greeted with stress? RIOT. A car was pushed into the club, and one of the club's walls was effortlessly knocked over by the frustrated fans. Not a week later Black Flag and D.O.A. played the Whiskey and halfway through the show it seemed there would be no problems. But the police showed up and told the line of people waiting for the next show that only two hundred people would be admitted. They then proceeded to rip up the tickets of people IN LINE! Someone threw a bottle at a cop car and like lightning the strip was closed off. Within an hour a riot was happening. The police who worked this beat must have been thrilled with this throwback to

77. **SOCIAL DISTORTION** (l-r) Brent, Derric, Mike Ness, Dennis Danell. Photo: Ed Colver.

77.

the days of Buffalo Springfield and *For What It's Worth*. It seemed like Black Flag would never play again. However, being the businessmen that they were, they booked a super gig at Baces Hall with the Screws from Huntington, the Adolescents, and San Francisco's Punk pride and joy, U. X. A.

Baces Hall had been the home for many memorable Punk shows featuring S.F.'s Mutants, Dils, and Avengers as well as Fear, X, and the Bags, among others. But that had been in a different era, and when hundreds of intense, aggressive kids showed up for a Black Flag show, the owner got cold feet and called in the cops. More than ready, the police cordoned-off the street, creating a riot atmosphere that was conveniently captured on film. Rona Barrett would later show this film and interview Chuck from Black Flag and Daphne, Mad Society's mentor and manager, on the *Tomorrow* show. The spirit in the air in late 1980 wasn't comfortable, but it was as inspiring as anything in rock 'n' roll or politics yet.

In late 1980, Los Angeles disintegrated musically. The Bags, long-time crossover hardcore band from Hollywood, and loved by the beach crowd, broke up. The Germs broke up. Media misrepresentation became a weekly event to be explained to disbelieving parents and authorities. And the gigs just weren't happening. Soon, however, Black Flag played the

Starwood, and the Circle Jerks released their first LP *Group Sex*. The Marina Skatepark punks held a marriage benefit for *Flipside* gossip columnist Gerber and ex-Germs drummer Rob Henley. The Vex, a new club in East LA, opened and fast became, along with the Starwood, the cat's meow in punkarama. At the Vex a strange and untimely Chicano Punk scene formed, combining hardcore beach punk (the Undertakers, the Stains), plop pop (Los Illegals, the Brat), and cuckoo orchestral art by Wild Kingdom. The Vex was the best place for the hardcore to congregate and listen to the bands.

Only the news story made a difference in December of '80: The final Germs smash at the Starwood and the suicide of Darby Crash aka Bobby Pyn aka Jan Paul Beam. If the L.A. underground had a leader, it was Darby. Darby's close friends and various incrowders from the Skinhead Manor (a house for punk loners near Hollywood High), fell apart in grief. It seems grief has no place in the music scene. Darby took living on the fringe seriously. But, his timing was off in a most ironic way. John Lennon died hours later. Even so the Starwood came alive for the next seven months. Every Tuesday was Punk night, and if the band was scummy, at least the parking lot was full and as social as a high school prom. Down the street was the Oki Dogs heartburn scene, popularized in the now dead *Slash* magazine by hipster Phast Phreddie. If you were still bored, there was Errol Flynn's burned out mansion and massive field way up in the Hollywood Hills where in the

78. FEAR (l-r) Philo Cramer, Derf Scratch, Lee Ving, Spit Stix. Photo: Ed Colver.

79. THE BRAT. Photo: Craig Dietz.

80. STEVIE METZ of Mad Society. Photo: Frank Gargani.

81. LEE VING of Fear. Photo: Ed Colver.

Fig. 28. Poster for Germs concert, January, 1980. Art by Gary Panter.

82. DARBY CRASH of the Germs shortly before his death. Photo: Ed Colver.

83. JENNIFER a character from the film *The Decline of Western Civilization.* Photo: Courtesy Penelope Spheeris Films.

84. PENELOPE SPHEERIS producer of the film *The Decline of Western Civilization.* Photo: Frank Gargani.

85. Hollywood Blvd. at the premier of the film *The Decline of Western Civilization.* Photo: Ed Colver.

Starwood/Vex heyday punks painted "welcome to hell" on the destroyed floor of the tennis court. Imagine 200 punks being chased out of a complicated maze of bush and forest by police.

It was around this time that brilliant and outspoken Penelope Spheeris released her film, *The Decline of Western Civilization.* Now every valsurfer and insecure suburbanite could see those nutty far-out punks. It was around this time Black Flag threw a wild bloody show at the timeless Stardust Ballroom with the Circle Jerks, Fear, and China White. Fear bassist Derf Scratch was left with a severely damaged face from a brawl with a monster sized skinhead. It was around this time that Robbie Fields of Posh Boy, always the charming conman with the Brit accent, began to release a horde of classic Punk discs. Also around this time the Cuckoo's Nest in Costa Mesa (a two hour drive from anywhere), got a reputation for pushy security guards and urine pool bathrooms. It was around this time that record companies were popping up to make real vinyl discs of L.A. punkitos: Frontier, SST (an old company now held together by Black Flag), and a host of other independents. In the definitive words of Circle Jerks drummer Lucky Lehrer — "Face it . . . punk's the happening thing."

From the land of fish and chips a new kinda beat, new kinda eyeliner/dresscode, and new kinda

promotional package sailed ashore to America snapping up trendies like a clam: enter the New Romantics. Its biggest, most marketable item, Adam and the Ants, were the first. At their appearance at Tower Records on the Sunset Strip they were greeted with quite a surprise, truckloads of punks with "Black Flag kills ants on contact" stickers heaving Safeway eggs at them. While a few bald kids weren't going to stifle a New Wave sensation, it certainly had Adam befuddled. That night he angrily smashed his precious cane on the wall at KROQ before Rodney's show.

Following Adam came hordes of lush crooners in lace with Casio machine drumbeats like Human League, Human League, and, of course, that other band, Human League. As a mass movement NewRo had little to offer. But L.A. picked up on it, and fast, with the warbling of bands like Kommunity FK and Aphoticulture. Vinyl Fetish, the best record store west of Istanbul, began sponsoring a weekly night of dressers-up and import plastic at the Cathay in the porn section of Hollywood. Dubbed "The Veil" by its creators Joseph Brooks and Henry Peck, the Monday night event created a mini-fashion revolution that lasted a couple of months. The idea of a club that only played records, a Post-Punk discotheque, was quickly seized on by opportunists with a lot less taste and a lot more money. Suddenly, there were New Wave discos, playgrounds for middle class namby-pambys too scared by the dread "P-rock." Fed on a cultivated diet of cutesy new wave novelty tunes by converted KROQ, dozens of sweetly vapid Noo Wavesters deserted clubs with live bands and started shaking their spandex asses in the very same disco environments that Punk rock had hoped to eliminate.

The Horror Rock scene arose, picking up on the grim side of NewRo fashion with L.A.'s own well earned sense of black humor and surfcrutch sound. What this group of tightly associated bands produced in two years (many of the groups had pulled up out of the graveyards as early as mid 1980), Black Sabbath couldn't've done in seven bird eatings. At the forefront of the scene was 45 Grave, formed from the ashes of the Canterbury apartment scene and fronted by beautiful batgirl Mary Sims (aka Dinah Cancer). Other members were ex-Germs drummer Don Bolles, ex-Bags bassist Rob Graves (aka Rob Ritter), and Paul Cutler, ex-Consumers guitarist. 45 Graves' members in a different form were also the wonderfully stupid and terribly great Vox Pop. Also formed from ex-band members and scene makers were the passionate goofball Boneheads. Best of all, though short lived and sporadic, were the voluptuously frightening Castration Squad. Their songs like *A Date with (dead) Jack (Kennedy)* chilled the soul and tickled the funny bone, in a sick Don Rickles way.

Horror Rock brought some much needed bands out of the woodwork, such as the Cramps who put out their best and sleazient record yet, *Psychedelic Jungle*, and the re-formed Fleshaters with a super-

86.

Fig. 29.

Fig. 29. Cover art for 45 Grave single. Anonymous. *Courtesy of 45 Grave.*

86. 45 GRAVE (l-r) Dinah Cancer, Rob Graves, Don Bolles, Paul Cutler. Photo: Ed Colver.

87.

88.

87. MARY SIMS a.k.a. Dinah Cancer of 45 Grave and Vox Pop. Photo: Ann Summa.

88. VOX POP (l-r) Mary Sims, Don Bolles, Paul Cutler, Jeff Dahl, Kelly, Mike Ochoa, Del Hopkins, unknown. Photo: Ed Colver.

89. PAUL CUTLER of 45 Grave, Vox Pop, The Consumers and the B People. Photo: Ed Colver.

54

89.

rock-star lineup featuring members of X and the Blasters. There were even crossovers from the skinhead scene like the HB/Long Beach band TSOL. Their punk rock EP on Posh Boy and their terror/dark dance disc on Frontier sounded so disparate you'd think they were two different bands. Whatever TSOL picked up, they did it with finesse and musclebound grace.

Also semi-underground and mostly a party band, Sexsick took to the streets for a spurt of intense, romantically hateful rock'n'roll. Gerber, by this time sporting her birthname, Michelle Bell, carried Sexsick with her passive/aggressive voice. A former *Slash* writer and Blondie fan club prez, Jeffrey Lee Pierce, began packing 'em in with black-beauty-inspired, slide guitar swamp blues. His band was called the Gun Club, and their albums *Fire of Love* on Ruby and *Miami* on Animal are among L.A.'s glowing moments. Horror Rock spawned some awfully lame imitators and "wannabe's" who thought hanging a glowing skull across your body made it all legitimate. Some of these bands, such as Voodoo Church and the originally messy Christian Death (who would go on to be much more), held up for only as long as the traffic would allow.

By the time summer of '81 rolled around, the Cuckoo's Nest, the Starwood, and the Vex were having problems. The Cuckoo's Nest's docile neighborhood finally closed the club after several court battles with the help of the Costa Mesa authorities. The Starwood was in a similar situation, but was pulling through, until a bouncer was stabbed by an angry maniac during a Fear show. The Starwood tried to bury the story quickly, but the owner was allegedly caught with a shoebox full of cocaine shortly after the stabbing. The media interpreted the Starwood's closing as the fault of punk violence. This didn't help matters for Joe Vex and his club in East L.A. where (near his third rented hall) a young Mexican male was murdered. Rumors spread that a Mexican Chicano had shot a punk in the head at his club. Shortly thereafter, the Vex ran out of money and closed after a fantastic *Flipside* benefit with the Circle Jerks and the Adolescents. Once again hardcore speedrock was clubless.

With no place to go some punks, mods, skins, teds, and members of Hollywood's Masque crowd could find nothing to do but go to Disneyland for a Ventures show. Assorted venues happened briefly, as they always do, but they were few and far between. Most, like Campus Theater and Polish Hall, got destroyed in a few shows. One hall, Bard's Apollo, lasted half a

90. T.S.O.L. (l-r) Ron Emory, Jack Greggors, Francis Gerald Barnes, Mike Roche. Photo: Ed Colver.

91. JACK GREGGORS of T.S.O.L. Photo: Ed Colver.

92. GUN CLUB (l-r) Pat Bag, Ward Dotson, Jeffrey Lee Pierce, Terry Grahan and Ann. 1982. North Beach, San Francisco. Photo: Ed Colver.

93. THE MINUTEMEN (l-r) D. Boon and Mike Watt. Photo: Glen E. Friedman.

summer, spawning a new circuit of Punk bands including: Youth Brigade (members of the Better Youth Organization who tried to promote Punk rock in a fair, unadulterated way); Circle One (whose speed is unmatched to date); L.A.'s Wasted Youth (old Oki Doggers with a gnawing sense of humor); Overkill (featuring the illustrious, almost performance-like Merril on vocals); Symbol Six (the only band who can truly call themselves Pop-Punk) and the slambam Siagon. Red Cross made one of their comebacks at the Apollo after two years of personal hassle. Fear, China White, TSOL, and others all did the club regularly. The one-year-old Bad Religion played Bard's and made a name for themsleves. Weeks later at the Apollo, with Wasted Youth and others on the bill, 40 police began kicking, grabbing and throttling innocent money-paying punks.

While many of the original horror bands disintegrated (including Castration Squad, whose bickering and drugged sloppiness *buried* them), two new ones bolted out from garages and occult shops. They were Christian Death, whose sincerely rabid, sometimes transvestite singer, Roz Williams, howled loose poetry over synthesized chaos, and the Superheroines, whose punchy rhythm didn't have much to do with their dark mystique. Legal Weapon, fronted by screaming cuckoo-girl Kat, belted out toughrock for neurotics. In the kiddie bin Unit 3 with Venus played drumbox toy music for pre-adolescents. Venus, the cute singer, was no older than nine herself. The majors (Black Flag, Circle Jerks, Fear) pulled off fantastic tours of the States and then returned home to their roots and the fans who made them. Black Flag put out the single of the summer, *Six Pack*, and secured themselves tough Henry Rollins from SOA, one of the many Washington, D.C. bands on the rise.

For those with hair and something under it, Al's Bar, the Brave Dog and the nearby Atomic Cafe were at the bespeckled head of an art damage noise and torture scene in Downtown L.A. Gigs would feature Afterimage, made up of *Contagion* magazine writers whose 50 cent rag was filled with poems about slicing people's heads off and places to eat good tacos; 110 Flowers, who would destroy a million Velvet Underground cliches and make it all sound ready for AM radio; Phoenix, Arizona's Meat Puppets; the B-People and the Strong Silent Types.

Some Masque veterans hung around the downtown scene. Al's and especially the Brave Dog had a feeling of community that had not been felt in L.A. since the initial days of the Masque. When Red Wedding debuted at the Brave Dog, half the audience already knew the band, who had previously played the club as Hey Taxi. The Brave Dog's shows were called "private parties" since the club hadn't gotten the necessary official permits. When an underage kid was caught drinking by an undercover cop, the party was over, ending a memorable year at an intimate, fun club.

94. JEFFREY LEE PIERCE of the Gun Club. Photo: Karen Filter.

95. DANNY of L.A.'s Wasted Youth. Photo: Ed Colver.

96. JACK GREGGORS of TSOL, Elite Club San Francisco, 1982. Photo: Stanley Greene, *Courtesy of Punk Globe.*

97. SHANNON WILHEM of Castration Squad. Photo: Lynda Burdick.

THE BLASTERS

RANK and FILE

Fig. 30. *(Page 57)* JEALOUS AGAIN, Black Flag. Cover art by Raymond Pettibone. *Courtesy of SST Records.*

Fig. 31. *(Page 58)* THIRD FROM THE SUN, Chrome. Artist unknown. *Courtesy of Faulty Records.*

Fig. 32. *(Page 59)* THE BLASTERS, The Blasters. Artist: Custav Alsina. Design: Steve Bartel. Package: J. Ruby Products. *Courtesy of Slash Records.*

Fig. 33. *(Page 60)* SUNDOWN, Rank and File. Artist: Sam Yeates. Design: Jeff Price. Package: J. Ruby Products. *Courtesy of Slash Records.*

Fig. 34. SIX PACK, Black Flag. Cover art: Raymond Pettibone. *Courtesy of SST Records.*

98. HENRY ROLLINS of Black Flag. Photo: Ed Colver.

99. HENRY ROLLINS of Black flag. Photo: Karen Filter.

100. THE FIBONACCIS. Photo: Ed Colver.

101. BAD RELIGION. (l-r) Jay, Jay Z. Bret, Greg. Photo: Ed Colver.

102. ROZZ WILLIAMS of Christian Death. Photo: Ed Colver.

103. SHRON, a friend of Christian Death with crucified cat at a performance. Photo: Colver

104. *Facing page.* DAVE ALVIN of the Blasters. Photo: Ann Summa.

105. *Facing page.* PHRANC. Photo: Frank Gargani.

106. *Facing page.* THE BLASTERS on *American Bandstand* (l-r) Phil Alvin, John Bazz, Bill Bateman, Dick Clark, Dave Alvin, Gene Taylor. Photo: Gary Leonard.

107. Facing page. THE BANGLES formerly the Bangs. (l-r) Susanna Hoffs, Vicki, Annette Zilinskas and Debbi. Photo: Karen Filter.

Al's Bar had a different problem: Art. Even though such important groups as the Dream Syndicate, Fibonaccis, 45 Grave, the Shadow Minstrels, the Bangs, Salvation Army, the Boneheads, and Christian Death graced Al's stage, the club was shut down. Neighboring visual artists complained that the noisy clientele violated their sacred Downtown art retreats. It was sad to see one group of so-called artists' invalidate another group of so-called artists' form of expression. But the complaints reached City Hall, and pressure finally caused Al's to stop its live music shows.

The massive Florentine Gardens booked X on the hottest night of the summer. Naturally, the backstage ventilation was mysteriously stolen. Shortly thereafter, the Dead Kennedys with TSOL and 45 Grave also made an appearance. After catcalls from "too lame for prime time" valley punks, 45 Grave subjected the audience to fifteen minutes of feedback hell. The next night's show with the Circle Jerks broke out in a riot highlighted by a sixteen-year-old skinhead being pushed face-first through the glass doors. So much for Punk at the Florentine Gardens.

Punk rock was nothing underground. Au Contraire! It was the biggest thing to hit Westwood, Beverly Hills and the likes since pizza. Posh Boy Records released the first Punk tape compilation including the very best of San Pedro's split-second songsters, the Minutemen, the aching melodies of Saccharine Trust, Black Flag, TSOL, the powerful CH3 and the rumbling Shattered Faith. The tape, *The Future Looks Bright Ahead*, sold like hotcakes and vanished in a week.

Twisted Roots, five people who didn't find out about punk on Eyewitness News, debuted at the Whiskey and played semi-terrific happy music. The Roots, ex-Screamer Paul and ex-Germ Pat, received some heavy criticism and went under for a few months before returning a summer later.

In September of '81 the Whiskey began extensive booking of the best of the underground including Middle Class, Aphoticulture, and the simply marvy Phranc, a Jewish lesbian folk singer. With the popularity of Phranc came a series of acoustic nights at the Whiskey in which skins slammed to the Circle Jerks doing a non-electric version of *Red Tape*, and Phranc speaking out against Nazi punks and men. Black Flag put out an eventless (not boring, not bad, just eventless) show at California State University at Northridge (CSUN) with Fear, the Stains, Youth Gone Mad, and Caustic Cause. There were thousands of punks, geeks, jocks, and inhibited observers at this Valley college hall, Devonshire Downs, that resembles an ugly barn. Seeing Black Flag at CSUN is like seeing Sinatra at the Masque. It just don't fit.

By Halloween the city was alive. CSUN held a "Cramps Horrible Halloween" celebration with the Cramps and Panther Burns. The *Texas Chainsaw Massacre* was shown on a cheap high school movie projector. The show was a sweatbox, and the only way to spend trick-or-treat night. The Better Youth Organization started a club "for the kids, by the

104.

106.

105.

107.

63

kids" called Godzilla's in Hollywood off the San Fernando Road. Their furious booking schedule included the better Punk rock noise improvisational clamor. The club was always crowded and the atmosphere anywhere from pleasant to bloody. But the feeling was gone. The antics that had been pulled at the Fleetwood and the Starwood only a year earlier were the Bible of L.A. punk. Anything, any attempt at rowdiness that came off, came off poseur-like. As one Starwood punk said at a Godzilla's show, "That isn't aggressive, they look like a bunch of amputated dicks being wobbled around in a bucket." When Godzilla's closed, for monetary reasons, the Better Youth Organization promoted a major show with the Adolescents (minus singer Tony who went on to form the Abandoned), Social Distortion, and a host of others at the Hollywood Palladium.

On a different level the Club Lingerie, which had been around since early 1981, changed its simple Veil dance structure and began booking the best trendy bands, Underground, and R&B. Though the Lingerie had a pointless 21 age limit, their booking schedule is as creative as anything L.A. has produced except maybe Kelbo's Tropical Drinks. The reason for it is Brendan Mullen, the man who made the Masque. He books the joint with precision and cleverness. One example of the Mullen method: Fear played the Lingerie as a Valley Gay Men's Violin Quartet with a hilarious ad of the boys in suits holding violins. Scummy chic and classy tackiness, the Lingerie has it all and the world knows it. This leads us to the next big thing, the Rockabilly Revival.

The Blasters from Downey could pack the Whiskey with Hollywood nocturnals and teenybopper losers. But until the end of the year Rockabilly was a word that sounded like Elvis Presley, and reeked of old movies for suburban television rats. With the introduction of Jimmy and the Mustangs, the onslaught of weekly Top Jimmy and the Rhythm Pigs shows at the Cathay, and some enthusiastic write-ups in the most available papers, everybody got a quiff and did the Bop Bop Bop! Many kids too restrained to become punks broke loose with Rockabilly, and bands from Orange County, such as the young Red Devils, Rockin' Rebels and the Whirlybirds formed. The stand-up basses and cute dolly-like singers were packin' in "goils" more than, pardon the expression, "cats". (Possibly attracted to the less violent atmosphere.) The Blasters released their second and most professional album on Slash and before you could say "GO-CAT-GO" the single *I'm Shakin'* was a national hit and marching up the Billboard chart in badass shiny shoes. On New Year's Eve the Blasters played with Fear and Black Flag in one of the strangest booking concoctions of the '80's. It was one fine shindig with the punks dancing Blasterwise and the Rockabilly-lovers bopping to the punk bands. This party-like event took place downtown at the New Olympic Auditorium. Chalk one up for diversity.

1982 brought a fresh cohesive scene labeled Post-Punk. Fear released a classic smooth album on Slash. The Dickies returned rarin' to roar with songs about their sex organs. The air of something big was cutting through the smog and exhaust of the Big Smoke. You could sense it in the tingly perfection of Red Cross's teen quack rock, the "all-babe" Bangs' rambunctious sixties rhythms, the Dream Syndicate's underground velvety sound, and the multi-language Fibonaccis.

The summer of '82 was the bastard summer of L.A. music. It was typified by uncrowded shows and few important disc releases (with the possible exception of the Salvation Army and Christian Death LPs) and the debuts of few bands. The craze was import discs, and backdated Motown nonentities played in dark smoky rooms with singles flirting. Yes, that's right — dance clubs: the Seven Seas, the Fake Club, the Lingerie, and the too cool for human life, Zero Zero. The Whiskey was closed and became a disco, while the Roxy went in and out of phases, none of them discernible.

By the end of 1982 clubs were closing left and right while many punks were retreating into reactionary, revivalist movements. The Mod scene, safer, cleaner, and more accessible than punk, became a social affair, with The Untouchables able to pack major clubs like the Roxy simply because they had the right two-tone look. Rockabilly became hugely popular in Orange County with ex-skinheads sporting

108. MIKE MAGRANN of CH3. Photo: Ed Colver.

109. TOP JIMMY AND THE RHYTHM PIGS at Berkeley Square, Berkeley, December, 1981. Photo: Gary Leonard.

110. LEGAL WEAPON. Photo: Ed Colver.

quiffs and bopping to James Intveld, Rockin' Rebels, Red Devils with their talented singer Emmy Lee, the Gyromatics and a dozen Stray Cat imitators. Most of whom were better than the Cats themselves.

Possibly the most artistically rewarding bands could be loosely classified as "psychedelic." The Dream Syndicate was the next best thing to the Velvet Underground. The Salvation Army became The Three O'Clock, combining captivating flower power themes with post-thrash pop. The Bangs sparkled as the re-named Bangles and avoided the obvious comparisons to the Go-Gos.

The Anti-Club opened, providing a testing ground for Savage Republic and the bizarre electronic bagpipe player Jimmy Smack. A notorious leather bar in Silverlake, The One Way, began having Sunday afternoon parties called Theoretical, that featured the most exhuberant audience/band interaction since the initial Masque days. Though the hardcore leathermen often intimidated some of the music fans, the Theoretical offered exciting sets by groups like Red Wedding, Funhouse, the Shadow Minstrels, New York's Bongos, and Mnemonic Devices while giving a properly strange setting to off-beat performers like Edith Massey, Phranc, and Lotus Lame.

The problem was that many people didn't seem to care anymore. Apathy had set in. The Music Machine in West L.A. was starting to book great shows by the end of 1982, but more people were interested in going to bland New Wave discos and dancing to insipid novelty numbers by Missing Persons and Toni Basil. People became so hungry for the next thing that they lost sight of the original intense energy that had fueled the band revolution in L.A.

Optimistically, there are still a lot of valuable groups making essential meaningful statements. The Minutemen, Redd Kross (formerly Red Cross), and the Descendents are at the peak of their playing power, but it's becoming increasingly difficult for these groups to be heard or seen. What was once so hard to do (form a Punk band) is now done "by the numbers" with kids settling for style over content. This is always the imminent danger in new music movements. It has to keep a check on itself, lest it become the thing it originally sought to replace.

—*Shreader*

111. THE THREE O'CLOCK formerly the Salvation Army. Photo: Ed Colver.

112. THE BLASTERS in concert at the Old Waldorf, San Francisco, 1982. Photo: Vicki Berndt.

113. CHINA WHITE. Photo: Ed Colver.

114. STEVE WYNN of the Dream Syndicate. Photo: Bobby Castro.

115. REDD KROSS formerly Red Cross, (l-r) Janet Brady, Tracy Lea, Steve McDonald, Jeff McDonald. Photo: Ed Colver.

65

SAN FRANCISCO

TEXT BY PETER BELSITO

Whether the Sex Pistols were meant to be a nine-month wonder garnering laughs and money for their situationist manager Malcom McLaren or "a force to set the world on its ear,"[1] it is clear that they were perceived as the latter in California from their inception to their final disintegration. Johnny (Lydon) Rotten's last words from the stage at Winterland, Jan. 14, 1978, were "HA-ha-ha!! Ever get the feeling you've been cheated?" The audience had been cheated that night in grand rock and roll style. Rotten had been heard to say before the show, "Let's really fuck it up tonight. We'll fuck up these fucking hippies. We'll turn the tables, make and do something they haven't read about in the music press." Even McLaren was quoted afterwards saying "Fuckin' awful show, wasn't it? They were just like any other rock band."[2]

Without a doubt the Pistols' final concert in San Francisco brought to a close the formative period of California Punk subculture. Not that San Francisco is unaccustomed to such things. After all, similar energies had been bloated into oblivion during the fifties and sixties by sudden mass popularity. The Pistols concert made it clear that Punk had become the "next big thing". But it had taken a long time getting here. The myth had been propagated since the fall of 1976 by a battalion of musicians, scenesters, entrepreneurs and managers beginning when Mary Monday touched down at San Francisco airport in a friend's private plane.

When Mary arrived in "hippie" San Francisco from Montreal via Vancouver, she already had the Punk look. "This was just me since forever. I dyed my hair green when I was fourteen just for fun. I had my first clear plastic space suit when I was sixteen. I already had the black leather jackets, the leather boots, the whole trip. It was just me, who I am. When I hit S.F. people couldn't handle it at all... they would just back off."[3]

Within three months Mary had found herself a band, the Britches. "I started taking BART to every high school in the East Bay to find musicians young enough to relate."[4] She also found an audience and a club to perform in.

The Mabuhay Gardens was as unlikely a place to find rock and roll as a Jewish synagogue. The club had hosted occasional theatrical successes but its primary source of income was a supper show of dancing Filipino girls, and a Filipino Presley impersonator called Eddie Mesa, which is to say that business was not good, in spite of the club's location on San Francisco's neon-flashing, sexplosive Broadway strip. A small sign out front read "Theater for Rent".

Ness Aquino, the lease holder of the Mabuhay Gardens, wanted $75 a night to rent his club — enough to pay the waitresses. Mary sensed his conservative attitude. "It would have never worked at that point if I had gone in there and been totally Punk Rock, because he wouldn't have understood. So what I agreed on with him was that I'd put on a 'show' with costumes and props and skits. The deal was I could come in on a Monday evening to try it out... the show ran for three weeks and kept building until Ness was so happy about it that I could do whatever I wanted."[5]

Dirk Dirksen had been searching for an "organic living nightclub" in which others would do their trip and he could attempt to document contemporary music. Dirksen, the nephew of Senator Everett Dirksen of Illinois, was a Hollywood exile. Within a week of his arrival in San Francisco he investigated the Mabuhay and realized the free-standing structure wouldn't transfer sound to the surrounding area. Dirksen began booking "The Mab" on Mondays and Tuesdays with the Nickelettes, an all-woman cabaret, and Ducks Breath Mystery Theater, an all-man comedy troup. His productions outgrossed the weekends. The "Nicks" ran for nine months and began production on a new show, leaving an opening for Ms. Monday.

About the time of Mary's first show, a tabloid called *Psyclone* released its first issue. *Psyclone* was an arts and music rag that originally had nothing to do with Punk. Editor Jerry Paulsen's interests tended more towards graphics and film. Dirksen picked up a copy of "The Magazine money can't buy" and after reading it sent Paulsen an invitation to Mary Monday's next show. Mary's shows had by now become an Aquino-Dirksen presentation and shifted to Friday and Saturday nights. Ness Aquino had big-

Fig. 35.

117.

118.

Fig. 35. Poster for Mary Monday concerts (1976) Artist: Alain Maranda. *Courtesy Dirksen Miller Productions.*

116. *(Page 66)* THE NUNS (l-r) Dietrick, Mike Varney, Jennifer Miro, at Winterland, S.F., 1978. Photo: Richard McCaffrey.

117. The Mabuhay Gardens (streetlevel) and the On Broadway (second floor), North Beach, San Francisco. Photo: William Sigfried.

118. MARY MONDAY (foreground) performing at the Mabuhay Gardens, San Francisco. Background: Vermillion, 1977. Photo: James Stark.

Fig. 36. Poster for the Nuns. Photo: Chester Simpson. Design: Edwin Heaven and C. Johnson. *Courtesy Edwin Heaven.*

Fig. 37. Poster for Damned appearance at the Mabuhay Gardens, San Francisco, 1977. *Courtesy of Dirksen-Miller Productions.*

Fig. 38. Poster for Miners Benefit show at the Mabuhay Gardens, San Francisco, 1978. Artist: Rico. *Courtesy Dirksen-Miller Productions.*

THE RESIDENTS PRESENT THE THIRD REICH 'N ROLL THIS SIDE EXPLAINS WHY HITLER WAS A VEGETARIAN RALPH RECORDS A DIVISION OF THE CRYPTIC CORPS PRODUCED BY RESIDENTS, UNINC. JACKET BY PORNO/GRAPHICS

THE RESIDENTS PRESENT THE THIRD REICH 'N ROLL · THIS SIDE EXPLAINS WHY CENSORED! WAS A VEGETARIAN · RALPH RECORDS IS A DIVISION OF THE CRYPTIC CORP · PRODUCED BY RESIDENTS, UNINC. · JACKET BY GRAPHICS

SNAKEFINGER

MANUAL OF ERRORS

ger problems than a nearly empty Filipino supper club. He had also run up a tab with a number of liquor companies and the IRS. His conservative attitude was broadened by the dollars rock and roll brought to his box-office. Because of Mary's popularity, other groups attracted to the club's bizarre atmosphere began to approach Aquino and Dirksen for a chance to play. The first was the Nuns, who borrowed some money to rent the Mabuhay late in 1976.

The Nuns have been alternately described as the perfect platinum blonde surrounded by four street punks or "one Peggy Lee with four Sal Mineos."[6] They were fronted by three singers: Dietrick (a former roommate of Dee Dee Ramone), Jeff Olner, a street poet, and Jennifer Miro, a 19-year-old blond bombshell who played keyboards. When asked about Jennifer's keyboard artistry in an interview, Olner, who co-founded the group remarked "she knew how to play and everything." The rest of the band didn't, at least not in the beginning. The group started when Olner and Alejandro Escovedo were making a film about a kid who wanted to be a rock star, but couldn't cut it. They were unable to find a band trashy enough, so they became the band themselves and called themselves the Trashcans. "We were probably the worst band that ever played the face of the earth"[7] was Olner's description of the early Nuns. Miro's initial impression was, "This is the most repulsive band I ever saw. It's just perfect." And so the unlikely marriage of beauty and the beasts. After a year of driving organic types to the streets with songs like *Decadent Jew*, the Nuns melded into a three-chord wonder that caused lines to form on Broadway.

After the Nuns' early Mabuhay appearances, Dirksen arranged to have a videotape of them made and aired locally. In it the band cruised down the coastal highway in a Mercedes Benz puking to their song *Suicide Child*.

Opening for the Nuns' first Mab show, to an audience of 40 people, was a Los Angeles-based group called the Dils who debuted their fast and physical sound to the San Francisco audience. The nucleus of the group was two brothers, Chip and Tony Kinman from Carlsbad, California, just outside San Diego. Shortly afterwards they moved to San Francisco and established in their music and interviews a political consciousness that would set standards for other Bay Area musicians to either emulate or rebel against.

By January, 1977, Dirk Dirksen had entrenched his Dirksen-Miller Productions as the sole booking agents of the Mab. He had also established a short-lived alliance with Jerry Paulsen to publicize the bands playing the Mab in *Psyclone*. Paulsen had assembled the talents of writers like Michael Snyder and reviewer Howie Klein, among others. They filled the pages of his tab with ultra-hip jargon extolling the talents of the vanguard American new wave bands like Blondie, the Ramones and, of course, the Nuns, plus features like Punk of the Month. As quickly as *Psyclone* had gathered its support, it lost it. In desperate need for capital to keep the rag afloat, Paulsen, who doubled as the Mab's ticket collector, attempted to extract a tariff from bands who'd been featured in its pages. This set the talent to grumbling. Add to this a distasteful incident involving the firing of a .45 caliber pistol at a Mab party and the demise of *Psyclone* was ensured. It sputtered to a stop in June of 1977.

The spring and summer of 1977 saw a blaze of activity that was unmatched at any other time during this era. The arrival at the Mabuhay of bands like Devo, Blondie, the Dead Boys, the Screamers, the Zeros (three young Chicanos who'd eventually migrate to S.F.), the Weirdos, the Ramones and the Damned from England precipitated a fallout of local fans and later talent that exploded the scene into the public eye. The Damned in particular captured the imaginations of the locals.

In the void left by the departure of *Psyclone*, Mary Monday convinced her producer, one Edwin Craven, to finance a magazine called *New Wave*. *New Wave* published its first and only issue in August 1977. It was primarily a hype vehicle for Ms. Monday and the Nuns, but it also introduced some of the new bands like the Dils, the Avengers and Crime.

Crime had not been far behind the Nuns in

120.

Fig. 42.

Fig. 39. *(Page 70)* THIRD REICH 'N ROLL, The Residents. (American edition.) *Courtesy of Ralph Records.*

Fig. 40. *(Page 71)* THIRD REICH 'N ROLL, The Residents. (German edition.) *Courtesy of Ralph Records.*

Fig. 41. *(Page 72)* MANUAL OF ERRORS, Snakefinger. Cover art: Mark Beyer. *Courtesy of Ralph Records.*

Fig. 42. Cover of *Psyclone* magazine. *Courtesy James Stark.*

119. THE NUNS (l-r) Jeff Raphael, Alejandro Escovedo, Mike Varney, Jeff Olner, Jennifer Miro and Dietrick. Photo: Jonathan Postal. *Courtesy of Edwin Heaven.*

120. THE DILS, (l-r) Chip Kinman, Tony Kinman, Rand McNally. Photo: James Stark.

119.

Fig. 43. Poster for Crime concert, 1978. Artist: James Stark.

121. THE AVENGERS in concert at the Mabuhay Gardens, 1978. Photo: Richard McCaffrey. *Courtesy of BAM magazine.*

122. CRIME (l-r) unknown, Frankie Fix, Ricky Williams, Johnny Strike, 1977. Photo: James Stark.

123. PENELOPE HOUSTON of the Avengers, 1978. Photo: James Stark.

approaching the Mabuhay in search of the elusive gig, which had until late 1977 been nearly impossible to root out in S.F. There were no appropriate venues. They had scored their first at the Old Waldorf, which was then a neighborhood bar located in the Fillmore district, on Halloween, 1976. They were scheduled to go on between two gay acts dressed as fruits and vegetables. A banana even knocked over guitarist Ron Ripper's stack of Marshalls. When they finally did go on, the plug was pulled after two songs. All seven customers had left with their ears ringing. Crime was difficult for audiences to comprehend musically, but they more than made up for it stylistically. Their shows were introduced with sirens and search lights and they wore police uniforms on stage. In the words of one journalist ". . . they pull off the job with a calm and smoothness that is the antithesis of most punk bands." [8]

The Avengers, on the other hand, didn't fare as well with the press early on. . . "They are so self-consciously New Wave and so serious about their punky image that you want to unfasten their safety pins near an activated electro-magnet. . .Penelope, the porcine lead singer, is like Judy Garland, overweight and downed-out in *Judgment at Nuremburg*, after a regulation Army crewcut. Can style be this clumsy?"[9]

The Avengers were initially clumsy, and a tad predictable with their style, but their music was, and remains, legendary. Their approach, if self-conscious, was courageous. Songs like "I Believe in Me," "The American in Me," and "We Are the One" reek of a durability that set them apart from the standard fare. Before their breakup in early 1979 they managed, with the help of ex-Sex Pistol Steve Jones, to set the record straight on vinyl. In 1983 a posthumous LP was released on Go! Records solidifying their role in shaping the early S.F. Punk sound.

WE ARE THE ONE
We are the leaders of tomorrow
We are the ones to have fun
We want control, we want power
Not gonna stop until it comes
(chorus)

We are not Jesus (Christ)
We are not fascist (Pigs)
We are not capitalists (industrialists)
We are not Communists
We are the one!

We will build a better tomorrow
The youth of today will be the tool
America's children made for survival
Fate is our Destiny and we shall rule.

I am the one who brings you the future
I am the one who buries the past
A new species rise up from the ruin
I am the one that was made to last.
© 1977 Avengers

A new sense of style swept over the Punk community in June 1977 when CBS aired a documentary on English punks. Up until that time only a few individuals who'd visited the UK had a sense of the English momentum. The scent of change was thickening. The Pistols "Anarchy in the UK" could be heard rumbling from the warehouses South of Market, and along the alleys of North Beach. The documentary made Punk a movement. The formula had become public knowledge, and overnight the trappings sprouted in the form of spike hairdos, torn clothes and studded leather jackets.

This TV documentary sent the news desk at S.F.'s

CBS affiliate, KPIX Channel 5, scurrying for a story on local punks. Reporter Dave McElhatton made a surprise visit to the Mabuhay where a group called Leila and the Snakes were performing a musical comedy routine. Leila, in the person of comedienne Jane Dornacker, and her Snakes were a Tubes spin off and decidedly *not* a Punk band. One sequence of their act featured a mock cat fight between Dornacker and Pearl E. Gates. This "fight" was taped by the news crew and summarily replayed on the evening news, sensationalizing Punk "violence" in S.F. A classic case of inflammatory television journalism. Naturally, hordes of sensation-seeking outsiders instantly descended on the Mab, increasing business, vandalism and violence. Simultaneously a wave of obligatory items on Punk violence began dotting the journalistic landscape calling for law and order to be enforced on those anarchistic kids.

The young scene's thirst for a radical but informed source of information and a suitable graphic style was quenched in June with the premier issue of a fanzine called *Search and Destroy*. The name was

124. CRIME (l-r) Hank Rank, Frankie Fix, Johnny Strike and Ron the Ripper. Photo: Roberto Morrison. *Courtesy Dirksen-Miller Productions.*

appropriately enough borrowed from a tune by the grandfather of Punk, Iggy Pop. Eschewing slick typesetting for common typewriter print, replacing headlines with scrawled calligraphic titles, *S&D* devolved over eleven issues into a style all its own. What's more, it was free of affiliations to any club or previously existing clique of artists and writers. The first issue focused on the Mabuhay, criticizing the booking policy and wondered aloud where all the cash from the "overcrowded" shows was disappearing to. Everyone had their personal explanations, but the fact remained that the headliners as often as not felt underpaid. Publisher ("pilot and plane owner") Vale had fired the first salvo in the "Battle of Mabuhay". Dirksen countered with an ad in *Search and Destroy* number two bearing the message "Mabuhay to you! What else can we say? Signed, Some of the Staff," accompanied by a photo of himself greedily gnawing some greenbacks.

Since he had taken over the booking at the Mab, Dirksen had consciously developed a Jack Benny-esque "tightwad" stage personality which he used while introducing acts. He was loud, brash, insensitive and prone to wearing a pair of glasses with a penis nose attached. This stage personality enhanced the rumors concerning the club's paying policy. His appearance on stage would inspire the audience to a round of drunken shouts like, "Get off the stage faggot," and flying beer cans. Dirksen's response would be a scathing appraisal of the offending audience member's taste. How much taste could they have if they were at the Mad Mab?

Dirksen was San Francisco's first punk entrepreneur. He was the first to realize that suburbanites and tourists from the hinterlands might find punk rockers and their "scene" exciting to look upon. For this, and some questionable booking policies, Dirksen won the undying disrespect of most punks, prominent among them the increasingly vocal Dils and the editors of *Search and Destroy*. For a while in 1978, bands and fans began to boycott the Mabuhay in protest.

By the end of 1977 the initial influx of bands had been reinforced by a flock of newcomers. The Nuns and Avengers had established themselves as the big draws. Bands such as Skidmarx, Tuxedo Moon, the Mutants and Negative Trend all made their Mabuhay debuts in late 1977. Added to this was the announcement that the Sex Pistols would be making their American tour which culminated in S.F.

Bill Graham Productions secured the rights and privileges of producing the Sex Pistols show at Winterland, an ice arena in the Fillmore section of San Francisco. Graham, of course, is a man of estimable talents as a rock music programmer. He had operated

125. LEILA AND THE SNAKES (l-r) Jane Dorknacker, Pam, Pearl E. Gates a.k.a. Pearl Harbor. Photo: Cooksey Talbott.

126. VALE, editor and publisher of *Search and Destroy* magazine. Photo: Ruby Ray.

127. DIRK DIRKSEN sitting on the steps of City Hall in San Francisco during a "Jello for Mayor" rally. In the background are Mickey Creep with "Vote Jello" sign and Chi Chi with "Kill Myself" sign. Photo: Stefano Paolillo.

the two most prestigious rock clubs of the sixties: the Fillmores East and West. The original Fillmore lay a scant few blocks south of Winterland. Neither Graham nor any other promoter has ever been a favorite with punks. His reputation with them could be described as shabby at best. Regardless, the announcement of the Pistols gig went up on the marquee along with the next gig, an evening with Styx. Still it wasn't nearly as incongruous as Merle Haggard following the Pistols in Dallas.

Winterland was by far the biggest stop on the Sex Pistols tour; in fact, the show was the best attended of their career. San Francisco was lying in wait for them, having gobbled up the 6,540 tickets in a single day. The Avengers and the Nuns had been ordained to open the show. The doors opened at 5 pm and the bands began at 9:30 with the Pistols coming on at midnight. The crowd ogled open-mouthed as Rotten delivered his last "Tell us what it's like to have bad taste" to their adoring faces. Winterland security efficiently heaved the Pistols' American tour manager out of the hall while he screamed, "I'm the fuckin' manager!" When it was over Rotten headed for his hotel in San Jose: Saint Sidney camped out with some punkettes in the Haight, a perfect choice, where he managed to get in a West Coast OD; and guitarist Steve Cook with drummer Paul Jones wandered around town peering through boutique windows at displays commemorating their visit. Danny Furious, the Avengers' drummer, later remarked: "The Pistols have been the only band to make a dent in the establishment — they exploited the media, they ripped off the record companies, and now they're over with. In a lot of ways punk rock is over with — at least in its innocence, in its fashionable yet non-threatening violence and all that shit! I mean it was obvious at Winterland — everyone knew how to behave, everyone knew how to spit, how to dress — everyone knew how to pack the place. But it was just sensationalism, a spectacle."[10]

128. HELLIN KILLER and SID VICIOUS in San Francisco. Photo: Ruby Ray.

129. JOHNNY ROTTEN a.k.a. Johnny Lydon, of the Sex Pistols at Winterland, San Francisco, January, 1978. Photo: Jill Von Hoffman.

130. THE IMPOSTERS who opened many shows during the Mabuhay's early days. Photo: Richard McCaffrey. *Courtesy of BAM magazine.*

... the style no doubt made sense for the first wave of selfconscious innovators at a level which remained inaccessible to those who became punks after the subculture had surfaced and became publicized. Punk is not unique in this: the distinction between originals and hangers on is always a significant one in subculture. Indeed, it is often verbalized (plastic punks or safety-pin people, burrhead rastas, or rasta bandwagon, weekend hippies, etc. versus the "authentic" people... [11]
—Dick Hebdige

With the passing of the Sex Pistols came an influx of energy and a short-lived sense of social obligation which was typified by the "Miners' Benefit" on March 20, 1978. The benefit was the brainchild of Howie Klein, the aforementioned reviewer for *Psyclone*. He helped pioneer Punk music on Bay Area radio when he joined Chris Knab to produce a show called the "Outcast Hour" on KSAN. The name was later changed to "The Heretics". Klein had toured England with the Clash in 1977 and returned to S.F. full of idealism about how the music could raise social consciousness. With the support of the Dils, who by this time made their home in S.F., the idea of throwing a show to benefit striking coal miners in Appalachia caught on quickly. Everyone consented to play, with one glaring exception: Crime. "It was the kind of benefit that was easy to play and equally difficult to decline. Crime's refusal signalled their clear rejection of the S.F. scene's new spirit of solidarity, with its cutesy-pie political consciousness rooted in the long discredited but ever hopeful quagmire of '60's new left politics."[12]

Another viewpoint would suggest that egos had come into play and the real reasons behind Crime's refusal to participate was the question of who would be the headliner. S.F.'s young musicians were learning some difficult lessons about the music industry which were best summed up by Alejandro of the Nuns: "... a lot of things have been brought out into the open with the Pistols—we've learned how fucked up the record industry is and how bands treat each other. It's a shame to see it happen to you after seeing it happen to everybody else—to still be in competition ... We just want to help, and I want to see the bands stop all the bullshit. I don't give a shit about being top of the heap here in San Francisco..."[13] Alejandro left the Nuns a short time later and moved to New York, where he helped to form the C&W band, Rank and File.

The Miners' Benefit went on regardless of anyone's reasons for participating and introduced some new bands that had previously lacked press exposure and large crowds. Among them were the Mutants, Negative Trend, Seizure, the Sleepers, Tuxedo Moon and U.X.A.

The Mutants and Tuxedo Moon were the only two bands from this group that managed to survive. The others flared up significantly and then faded, sometimes into oblivion, sometimes to reform under new names.

The Mutants are a five-guy, two-girl ensemble fronted by the irrepressible Freddie (Fritz) Fox, a video-burnout and the world's longest running art project; Sally Webster, a pint-sized, polka-dot Mona Lisa; and Sue White, whose frizzed blonde locks conjure images of a suburban housewife that likes to stick her fingers in wall sockets. Their early notoriety centered around this threesome's unpredictable stage antics which could include anything from ritualized TV destructions to squabbling over the one remaining operable microphone. Because most of the band members emanated from various art schools, the Mutants were originally labeled an "art" band. This misnomer was put to rest by one journalist who wrote... "When you see the band on stage, the only concern they seem to have with art is with its complete and gleeful ruination."[14] In 1982 the Mutants released a long awaited album called *Fun Terminal*.

131. SUE WHITE of the Mutants, 1980. Photo: Stefano Paolillo.

132. THE MUTANTS (l-r) Brendan, Fritz Fox, John Gullak, Sue White, Paul, Sally Webster, Dave. Photo: Liam Cutchins. *Courtesy of the Mutants.*

133. FRITZ FOX singer of the Mutants. Background (l-r) Brendan and Paul. Photo: Ed Colver.

NEW DARK AGES

*You're all afraid to look ahead
You'd rather live in the past instead
You took your mind and put it to bed
Wake up before you're dead—*

*We're living in the New Dark Ages
Read about it on magazine pages
Wearing clothes of the latest rages
These are the New Dark Ages...*

©1978 Mutants

Tuxedo Moon, on the other hand, left no questions as to their pursuit of artiness. Their first performance at the Mab late in 1977 thrust them into a totally alien Punk world where their angst rock blended telepathically with the nihilist attitudes of

134. THE MUTANTS (l-r) Sue White, Sally Webster, Fritz Fox (face), John Gullak and Paul. Savoy Tivoli, San Francisco. Photo: William Sigfried.

135. SALLY WEBSTER of the Mutants. Photo: Ruby Ray.

79

Punk. The group was founded when members Steve Brown and Blaine Reininger met in a San Francisco City College class on electronic music. They enlisted guitarist Michael Belfer, who was later replaced by Peter Principle, and Chinese performance artist and vocalist Winston Tong, who would later win an Obie Award for his performance *Bound Feet.* At their height Tuxedo Moon was the most revered group in the Bay Area, to the point where even their alleged use of heroin was widely mimicked.

Negative Trend was a no-holds-barred, balls-out band based on the philosophy that the point of life is to break all the rules and limits. S.F. artist Bruce Conner, who was among the small early Mab clientele, described lead singer Rozz by saying: " His very first gesture on the first night as the first chord was struck was to run full speed off the stage, land on the tops of the front tables, grab drinks out of peoples hands, throw 'em down on the floor, and kick the chairs over."[15] Rozz's reasoning for being in a band was "If I wasn't in a band I'd probably be in Portland being useless...I'd be using drugs, there's not much else."[16] After three months Rozz did return to Portland with a broken arm and smashed up knees.

The Sleepers came from Palo Alto, a quiet college town south of San Francisco. Their early press points out that one of the names they had considered for the band was "Flipper," a name that would later be put to good use. The Sleepers' sound was primarily a blend of Ricky Williams' vocals (Crime's original drummer) and the neo-psychedelic melodies that echoed from the guitar of Michael Belfer. Head somnambulist Williams' demented lyrics (he walked out of an institution shortly before he began playing drums for Crime) were delivered in an emotionally convincing, sometimes deep, sometimes soaring, sometimes insane voice that accompanied you home from the club along with your buzzing ears. Drug culture played no small part in the development of the Sleepers' sonorous sound.

Another band that made an early appearance during the Miners' Benefit was U.X.A. (United Xperiments of America, X meaning the unknown.) U.X.A. was the creation of Michael Kowalsky, a writer and filmmaker who had taken up residence at the Mabuhay early on. Kowalsky wrote U.X.A.'s songs with his girlfriend, vocalist Dee Dee Troit. Michael had been a clearing house of Punk information. He had early access to recordings from New York and England and influenced many of the new bands like the Sleepers and the Offs. Among his other notable acts were the destruction of the Mab's

136.

137.

136. TUXEDO MOON (l-r) Steve Brown, Winston Tong, Blaine Reininger, Peter Principle, Olga Gerrard. The Victoria Theater, San Francisco, February 1981. Photo: Erich Mueller.

137. THE SLEEPERS, (l-r) Ricky Williams, Tim Mooney, Paul Draper and Michael Belfer.

138. WINSTON TONG of Tuxedo Moon. Photo: Erich Mueller.

138.

cash register one evening and getting the Nuns kicked off a bill with Blondie at Jeffrey Pollack's Old Waldorf which had moved downtown. The Nuns' response was to throw a jam-packed free show at the Mab that all but wiped out the audience at the Blondie gig. Later that night, the "Blondie's" showed up at the Mab, where they had made their first S.F. appearance, wanting to jam with the Nuns.

U.X.A.'s contribution to S.F.'s scene was cut short by Kowalsky's untimely death from a cocaine overdose. But songs like *Innocent Bystander* accurately transmit American Punk's growing rage; burning desire for public unity versus "the system" which had no room for punks; and a hands-tied hopelessness concerning the possibilities for change.

INNOCENT BYSTANDER

Give me a reason a reason for grief
I know it's just a bad case of being deceived
I'll give you a reason when you're feeling upset
It's the time to react instead of regret.

Twenty years left and you want to hide
You want revenge to ease the pain inside
Nine to five and a TV set
Is all the excitement frustration can get.

©1978 U.X.A.

San Francisco punks were very conscious of their image as "rebels without a cause" in the eyes of the English prototypes. Julie Burchill and Tony Parsons, in their book, *The Boy Looked at Johnny*, summed up the American dream as "the vision of accumulating enough money to permit them (the Americans) to give the problems of the huddled masses a derisive finger."[17] This was something that the English, primarily their beloved Sex Pistols, had been doing for some time. How else could one interpret Malcom McLaren's "extracting cash from chaos" slogan? Does the admission make it politically correct, or does the cash justify the means?

The American Punk attitude was better represented by groups like the Dils, who summed it up like this: "America is pacified by irresponsible media distortions and falsifications such as: 'American punks aren't political because there's nothing wrong here' and 'Punks here are just middle class, well-educated kids.' But that doesn't necessarily invalidate revolutionary integrity. You don't have to be poor, black or on welfare to know it stinks." [18]

The first infusion of the Rockabilly sound began with the appearance of Ray Campi and the Rockabilly Rebels at the Mabuhay. Campi, a middle aged high school teacher from California's Central Vally, had plenty of showmanship to teach S.F.'s urban punks. The Rebels played with gut level energy, authenticity and fire that would spawn many imitators a few years later.

139. RICKY WILLIAMS of the Sleepers. Photo: Ruby Ray.

140. MICHAEL KOWALSKY and DEE DEE TROIT of U. X. A. holding a tally sheet from a Mabuhay Gardens performance, 1978. Photo: Ruby Ray.

141. DEE DEE TROIT of U. X. A. Photo: Ruby Ray.

142. RAY CAMPI AND THE ROCKABILLY REBELS (Campi far left). Photo: Ruby Ray.

143. NEGATIVE TREND (l-r) Will Shatter, Craig Grey, Rozz, and Steve, at the Mabuhay Gardens, San Francisco, 1978. Photo: Ruby Ray.

Fig. 44. JOHNNY TOO BAD, The Offs single. Anonymous.

144. THE OFFS (l-r) Billy Hawk, Don Vinil, Bob Roberts, Fast Floyd, Bob Steeler, at the Mabuhay Gardens, San Francisco. Photo: Elaine Vestal.

145. ZEV at the On Broadway, San Francisco, 1982. Photo: Erich Mueller.

146. DON VINIL of the Offs. Photo: Richard McCaffrey. *Courtesy of BAM magazine.*

Another performer who wandered into the Punk scene around this time was a mad percussionist named Zev, whom Dirksen would throw in between acts at the Mabuhay. Zev would then proceed to excite the crowd by pounding a magical cacaphony of sound out of pots, pans, metal barrels, springs, kitchen sinks and nearly anything else imaginable.

Three new groups made their appearance in early 1978. They were Noh Mercy, KGB, and the Offs. The Offs were fronted by charismatic vocalist Don Vinil, an ardent audiophile, who found his inspiration in Negro spirituals and reggae. Vinil's dismal first attempt at a band had been called Grand Mal, and his second attempt with the Offs didn't begin very well. Vinil could be best classified as a "screamer" early on. He was joined by Billy Hawk on guitar, who initially couldn't play his instrument. The rest of the group kept changing as if caught in a revolving door until the appearance of Bob Steeler, the former drummer for Hot Tuna. His professionalism and solid tempo inspired Vinil and Hawk, saving the group from anonymity. Add to this core saxphonist Bob Roberts, a tattoo artist from N.Y.C., and the intrepid Fast Floyd on bass, and the Offs emerged as a prime musical attraction in the city. They were the first Punk/Reggae fusion band.

The Offs' bassist, Fast Floyd, became notorious due to several accusations of assault with a deadly weapon. No court ever convicted Floyd, but one evening during the crashing finale of an Offs set he felt threatened enough to leave his bass humming on stage and disappear without a trace for nearly a year. When he reemerged he worked with two bands: Fast Floyd and the Fabulous Firebirds and the Spiders.

KGB was a quartet led by an eighteen-year-old vocalist known as Johnny Genocide. Genocide had been caught in the Offs' revolving door for a while until he spun off and started his own Anglopunk sounding KGB. He was joined by Jeff Rees on bass, Canadian drummer Zippy Pinhead, who would later defect to the Dils, and guitarist Ron Ramos.

147.

148.

147. BOB STEELER of the Offs, 1980.
Photo: Stefano Paolillo.

148. FAST FLOYD AND THE FABULOUS FIREBIRDS (top row l-r) Linwood Land, Lance Romance, (bottom row l-r) Franko St. Andrew, Bobby Mack and Fast Floyd, 1982. Photo: Harold Adler, *Courtesy Fast Floyd.*

Noh Mercy was a two-woman group that was introduced as an *entr'acte* at a Tuxedo Moon/Dils show in a new venue called 330 Grove Street. They were originally called On The Rag because as drummer Tony said, "Every time we played it was that time of month."[19] The other half of Noh Mercy was lyricist/vocalist Esmerelda, whose roots were primarily in the theater. That was it. Tony on drums, and Es blasting the audience with songs like *Caucasian Guilt*. It may have been minimal, but the audiences went wild. Noh Mercy is no more, but Esmerelda has built a successful career as a soloist, performing with taped accompaniment.

CAUCASIAN GUILT

I don't want to be politically correct
I don't need no Caucasian guilt
I never cooked no Jews
I never took no Indian land
I never made no Black my slave
I never dug no Latino grave
Never made no Chinese build me a Rail road
I never put no Jap in a camp
I don't care if faggots call me a cunt
I don't care if they take me out to lunch
I don't mind high heels on a dyke
Just don't knock me off my bike
Hey!

I don't need no Caucasian guilt
I'm ready for a brand new race
One concerned with the way you move
Not the arrangement of your face
Need no Caucasian guilt (2 times)

©1978 Esmerelda

The opening of 330 Grove Street, which was the Gay Community Center to Punk music, signified the end of the Mabuhay Gardens' reign as center of S.F.'s Punk scene. The Grove Street venue was basically an empty warehouse, but its U-shaped balcony, separate lounge and authentic-feeling back street location near City Hall attracted the bands and their fans whose numbers had now swollen enough to support more clubs. The first shows at 330 Grove were organized by Linda Nakamura and a group called the Maniacts. They also published a xerox fanzine called *Village of the Dumbed*. Shortly after the original gigs, which drew upwards of 500 punks, the Maniacts lost their booking privileges because of some damage to the sound system, and another promoter named Paul (Rat) Backovitch began programming. Rat had previously booked gigs at the Pit, a club in a South of Market residential warehouse called Project One. There he had put on four shows with groups like the Nubs, who served as a clearing house for emerging Punk musicians, and a legendary show with KGB, the Mutants and the Dead Kennedys. At this show a new dance called "the Biafra" was born when audience members climbed up on stage to copy Kennedy vocalist Jello Biafra's antics. That gig OD'ed the Pit. The residents of Project One, a hippie artist commune, objected to the massive crowd. Rat recalled: "It was the first time we put an ad in the paper, cars were swarming around the building and there were people I'd never seen before."[20] So Rat shifted to 330 Grove where he did a rapid succession of shows that ended in early 1979 when the city bought the building for demolition. A parking lot replaced it, which remained unfinished three years later.

The popularity of the Dead Kennedys was immediate and awesome. The initial appeal of the band was the lure of their admittedly sensational

Fig. 45. Poster for a show at 330 Grove Street, 1979. Anonymous.

Fig. 46. *(Page 85)* IN GOD WE TRUST, Dead Kennedys. Cover art: Winston Smith, Fallout PRoductions and Biafra. *Courtesy of Faulty Products and I.R.S. Records.*

Fig. 47. *(Page 86)* FUN TERMINAL, The Mutants. Design: The Mutants. Photo: Liam Cutchins. Litho Assistant: Michael *Courtesy of M.S.I. Records and the Mutants.*

Fig. 48. *(Page 87)* NOT AVAILABLE, The Residents. Cover art: Pore-know Graphics. *Courtesy of Ralph Records.*

Fig. 49. *(Page 88)* CALIFORNIA BABYLON, Factrix. Camera art and Design: Joseph Jacobs. *Courtesy Subterranean Records.*

149. NOH MERCY (l-r) Tony Hotel, Esmerelda. Photo: Lig.

150. ESMERELDA, September, 1982. Photo: Marshall W. Rheiner.

151. DEAD KENNEDYS (original line-up l-r) Klaus Flouride, Jello Biafra, East Bay Ray Glasser and Bruce Slesinger on the occasion on the Bay Area Music awards. Photo: f-stop Fitzgerald.

DEAD KENNEDYS

IN GOD WE TRUST, INC.

MUTANTS

Fun Terminal

OPPOSITE WORLD • LESSON IN TIME • COLOR OF IMAGINATION • TRUE STORY • NEW DRUG • MAN FROM OMICRON • TWISTED
THING • GIVE AND TAKE • YOU WAIT • STRANGE NIGHT • WAR AGAINST GIRLS • EMOTIONAL READ OUT • PERFECT TARGET

THE RESIDENTS
NOT AVAILABLE

California Babylon

Factrix Cazazza Live

name. But Colorado-born singer Jello Biafra's stage presence was a slice of Iggy Pop topped with surreal protest lyrics.

In the early days, Jello would spice up the act by letting the crowd shred his clothing, leaving him naked in their midst. Eventually, he grew tired of this and once refused to continue a show when a member of the audience absconded with his shoe. Instead he sat stubbornly on the edge of the stage in front of 1500 people while the DKs roared through instrumental versions of their songs.

The Kennedys were originally a quintet with two guitars, bass, drums and Jello, but the guitarist known as 6025 left the band early in their career. This left Biafra with the power trio of Klaus Floride on bass, East Bay Ray Glasser on echoplex guitar and Bruce Slesinger on drums. Slesinger later left to form his own band, the Wolvarines, and was replaced by Darren Peligro, who had toiled with the Nubs, Speedboys, Hellations, and a group called SSI from time to time.

Early Kennedys songs included titles like *Kill the Poor*, *Kidnap* (about Patty Hearst's kidnapping), and the ever popular *California Uber Alles*, a hilarious black lampooning of former governor Jerry Brown's presidential aspirations.

CALIFORNIA UBER ALLES

I am Governor Jerry Brown
My aura smiles & never frowns
Soon I will be president
Carter power will soon go away
I will be Fuhrer one day
I will command all of you
Your kids will meditate in school

(chorus)
California Uber Alles
Uber Alles California

Zen fascists will control you
100% natural
You will jog for the master race
And always wear the happy face

Close your eyes can't happen here
Big Bro on white horse is near
The hippies won't come back you say
Mellow out or you will pay

Now it's 1984
Knock knock at your front door
It's the suede/denim secret police
They have come for your uncool niece

Come quietly to the camp
You'd look nice as a draw-string lamp
Don't worry it's only a shower
For your clothes here's a pretty flower.

©1978 Dead Kennedys

Biafra's antics on stage included grimacing, Nazi salutes, tantric prayer posturing and, of course, the usual table-demolishing, drink-dumping rock and

152.

153.

154.

155.

152. DEAD KENNEDYS, Jello Biafra (with microphone). Photo: Richard Mc Caffrey, *Courtesy of BAM magazine.*

153., 154., and 155. EAST BAY RAY GLASSER, KLAUS FLOURIDE and DARREN PELIGRO respectively. Photos: Glen Friedman.

Fig. 50.

Fig. 50. CALIFORNIA UBER ALLES, Dead Kennedys single.

156. JELLO BIAFRA of the Dead Kennedys. Photo: Erich Mueller.

Fig. 51. NAZI PUNKS FUCK OFF, Dead Kennedys single.

Fig. 52. Poster for a show benefitting *Ripper* magazine, 1982. Artist: Tim Tonooka.

157. JELLO BIAFRA of the Dead Kennedys. Photo: Ed Colver.

158. JELLO BIAFRA of the Dead Kennedys at the On Broadway Theater in San Francisco on the occasion of the Maximum Rock and Roll record release party. 1982. Photo: Erich Mueller.

roll shock tactics. As he put it, "...shock is a way of unglueing the insides of peoples' heads."[21] And shock is what the Dead Kennedys are all about.

During the summer of 1978 the Mutants and Crime both played unusual gigs outside San Francisco's city limits. In June the Mutants performed for the patients at the State Mental Asylum in Napa where it was difficult to tell the members of the band from those of the audience. In an equally ironic gesture Crime took their show, complete with cop uniforms, inside the walls of San Quentin prison on September 4th.

A fanzine called *Punk Globe* appeared in August of 1978. *Punk Globe* was, and still is published and edited by Ginger Coyote, and prominently features Ginger herself. Each issue was sure to present at least one photo of Ginger posed with anyone from Debbie Harry to Ed Asner. The *Globe* had none of the high seriousness, aspirations or intellect of *Search and Destroy*. It was put together with only one thing in mind: fun. Inside you'd find a lively gossip column that served as a Who's Who of local punks, a Punk of the Month award complete with runner up, brief interviews, news, lots of pictures, and all for a buck. During the next few years several other fanzines came and went. They included Mickey Creep's *Creep Magazine*, Tim Tonooka's *Ripper* and the *Revolutionary Wanker* among others.

In November 1978, out of sheer necessity, San Francisco's first independent record label catering to Punk was born. The Nuns, who had been courted, wined, dined—everything but signed by a major record company, released a single on Chris Knab and Howie Klein's fledgling 415 Records. The disc, which included the songs *Decadent Jew, Savage,* and the Nuns' most popular tune *Suicide Child*, was an overwhelming success.

November also saw the murders of San Francisco's mayor George Moscone and gay supervisor Harvey Milk by former cop and supervisor Dan White. White's lawyers would later argue his famous "Twinkie Insanity" plea (White claimed diminished mental capacity because of junk food), getting him only a five-year sentence for the twin "manslaughters." Shortly after the murders, 900 people belonging to the San Francisco-based Peoples Temple committed suicide in Guyana. The mass suicide further enhanced San Francisco's reputation as "capitol of the kooks" in the eyes of the watching nation as the media labored over the sight of the 900 bloated bodies of Jim Jones' suicidal cult.

Fig. 53. Cover of *Punk Globe* magazine featuring Dirk Dirksen. Photo: Julie Stein.

Fig. 54. Poster for shows at the Deaf Club. Anonymous.

159. GINGER COYOTE of *Punk Globe*. Photo: Stanley Greene, *courtesy of Punk Globe*.

160. 415 RECORDS (l-r) Howie Klein of 415, Hillary Stench of Pearl Harbor and the Explosions, Beverly Wilshire of KSAN radio, Butch Bridges of 415, Sally Webster of the Mutants, Pearl E. Gates of Pearl Harbor and the Explosions, Charlie Hagan the Mutants original bass player, Chris Knab of 415 and John schuster, 1979. Photo: Richard Mc Caffrey. *Courtesy BAM magazine*.

Valencia Street in the Mission District of San Francisco is an unusual thoroughfare. At the north end of the street are numerous motorcycle shops, a Ba'Hai temple, a thriving Greek community, the American Indian Center, a black-dominated housing project and a growing lesbian community. Further down the road as you pass 16th Street in an area infested with burrito stands, a Communist book store, a crater left by a burnt building where twelve died, and an empty-shelved pharmacy, hangs a small white sign with black lettering which reads "San Francisco Club of the Deaf Inc." It was here in a dim second floor social club for deaf people that the most memorable series of punk shows to rattle San Francisco's ear drums took place.

Robert Hanrahan (the manager of the Offs and Dead Kennedys at the time) had been impressed by the Maniacts' regular venue, and during his daily business about town he always had one eye open for a place where he could produce shows. "...and then I was on Valencia Street one day and saw a 'Hall for Rent' notice. I went up and there were three guys watching TV without the sound on. They pushed a pad and pencil toward me, we started exchanging notes, and the next thing we were doing a show on December 2."[22] Hanrahan rented a cheap $50 public address system, booked the Offs and Mutants, printed up some pink fliers, distributed them and waited to see what would happen. At eleven o'clock on December 2nd, as if they were migrating birds, punks began appearing along the sleazy Valencia burrito strip headed for the Deaf Club. The place was reminiscent of Beat novelist Jack Kerouac's description of the underground jazz clubs in Frisco nearly three decades earlier. The crowd face to face with the band in a tiny, smoky, steam box of a room, pogoing, screaming, drinking, drugging, necking, pressed together, throbbing like one big heart to the loony bin-inspired Mutants and the ever improving Offs. It was so loud that speech was as useless for the punks as it was for the deaf people who always came to the gigs.

In the ensuing months the entire spectrum of bands that were emerging in the city played to overflow houses at the Deaf Club. New bands like the Units, a synthesizer combo, the art rockers Pink Section, and Pearl Harbor and the Explosions appeared. The Explosions were a snappy pop foursome featuring vocalist Pearl E. Gates, Peter Bilt on guitar and a rhythm section comprised of the Stench Brothers, Hilary and John. The Humans and JJ 180 (also briefly known as the Realtors) from Santa Cruz appeared, as well as VS., the first all-girl bondage rock band, and the Urge, another all-girl outfit featuring drummer Jean Caffene. D.O.A. with guitarist-singer Joey Shithead came south from Vancouver to play. There was also a pop band with four bespectacled brothers and a drummer called No Sisters; the Mummers and the Poppers, a zany cover band featuring Billy Bastioni, Debora Iyall and Rachel Weber, MX 80 Sound, the Mondellos, the Touchtones, Snuky Tate; the Readymades, fronted by ex-Avenger Jonathan Postal; the Belfast Cowboys, the Situations, Levi and the Rockats from England, the Vktms, headed by gutsy vocalist Nyna (Napalm) Crawford; X, the Germs, the Bags and Alleycats from L.A., as well as S.F.'s Blowdryers whose caustic witted singer Jennifer would out rank anyone in the house between songs like *Suicide Line* and *A Mexican Has Feelings Too*.

The Deaf Club became synonymous with Punk. What better name for a club featuring this kind of music? It wasn't long before the club was exposed in the media and became public knowledge, which spelled its downfall. It became the victim of fire codes and maximum occupancy laws in the end. Hanrahan attempted to improve the venue and adhere to the law, but by the end of the summer of '79 the Deaf Club had been effectively closed to Punk shows. Two documents did emerge from its brief but fiery life. They are Richard Gaikowski's film *Deaf Punk*, filmed by Joegh Bullock, and a compilation album called *Can You Hear Me?* produced by Hanrahan.

Radio exposure for Punk bands was virtually nonexistent in the Bay Area aside from occasional

161. BILLY BASTIANI of Ultrasheen, the Spiders, and the Mummers and the Poppers. Photo: Stefano Paolillo.

162. PINK SECTION (l-r) Carol Detweiler, Steve Wymore, Judy Gittelsohn, Matt Heckert. Photo: *Courtesy Judy Gittelsohn.*

163. THE BLOWDRYERS (l-r) Timmy Spence, Jennifer Blowdryer with microphone, Judy Parks, Gordon and Susie H at the Deaf Club, San Francisco, August 1978. Photo: Vestal.

164. *(Facing page)* VS. (l-r) Jeorgia Anderson, Olga de Volga, Carola Anderson, Amy Linden, and Kathy Sanford. Photo: Ruby Ray.

165. *Facing page.* NO SISTERS (l-r) The Barrett Brothers, Dave, Tim, Tom, and Peter. Photo: Michael Jang, *Courtesy Tim Barrett.*

166. *Facing page.* THE UNITS (center l-r) Scott Ryser, Jabari Allen, Rachel Webber, Mark Henry and David Allen, 1983. Photo: H. D. Moore, Jr., *Courtesy of the Units.*

164.

165.

166.

95

hour slots carved out by jocks like Knab and Klein and a show called "Maximum Rock and Roll" on the non-profit Berkeley station KPFA. Maximum Rock and Roll was founded by Tim Yohannan, who acquired a Tuesday night slot, during which he and compatriots Jeff Bale, Jello Biafra, Ruth Schwartz and Ray Farrell would play local releases and underground music from around the world. The show, which is currently syndicated on ten other stations around the country, remains the sole exclusively hardcore program in the area.

By 1980 KUSF, the station of the Jesuit-operated University of San Francisco, began rock programming and quickly migrated to the Punk/New Wave camp. KUSF presented daily programming with a number of shows dedicated to new music hosted by deejays like George Epileptic, Del Taco, Denise Demise, Alan Paxton, Kim Danders and the ubiquitous Mr. Klein. Another station to open the airwaves to the new music was Berkeley's KALX which featured dj's like Christine Lowry and Johnny Myers.

In mid-January of 1979 a communally based "family" of Rastafarians began a company called Olufumni Presents, which was headed by a man called Ashiya Odeye. Olufumni had gotten control of an auditorium located at 1839 Geary Street near Fillmore that they called "The Temple Beautiful." The Temple Beautiful was a pre-earthquake Jewish synagogue (Temple Beth Israel) with elaborate stained glass windows, a vaulted ceiling, a huge U-shaped balcony that seated hundreds, and, as Olufumni proclaimed on their posters, "San Francisco's largest dance floor". The Temple, which had formerly been called The House of Good and used for rock shows promoted by Janos Kovacs in the early seventies, lay between the buildings that formerly housed Bill Graham's original Fillmore and Jim Jones' Peoples Temple, on a block just across from San Francisco's Japantown Center. The area was dark and isolated, and initially crowds were reluctant to visit the Temple. Until February 8th, that is. Six days after Sid Vicious made his pact with the devil official, hundreds of posters went up around town bearing the message "White Riot" next to a picture of the Clash. That's all that was needed to send every punk from Santa Rosa to Santa Cruz, 1500 strong, in the direction of the Geary Temple for an essentially unannounced show. The enigmatic announcements covered the fact that the Clash played the show in violation of a contract they had inked with mega-promoter Bill Graham. The show turned out to be a benefit for a non-profit group of punks called New Youth who were raising cash with the Clash to get a permanent clubhouse for punks. Admission was three dollars, the show was great and New Youth pocketed about four grand. But the clubhouse never materialized and New Youth was assailed with a quagmire of queries about the dough. A year later New Youth published a "punk directory" with the proceeds. Known as "the little pink book," New Youth's directory had an international listing of independent, non-aligned creators and promoters of music and visual arts.

Shortly after the Clash played, the Avengers announced that they were disbanding. Their farewell concert at the Temple drew a capacity crowd that clambered up on stage, diving into a giant pile of humanity with singer Penelope at its core.

Punk crowds had always been integral to the makeup of each show, but as the scene progressed the crowds became more and more daring in the absence of a hard-line security corps. They sometimes grabbed the microphones out of the hands of the performers to sing their own version of a song, or pulled performers into the crowd, carrying them across a sea of heads. But it was around this period that a new twist

167.

169.

Fig. 55. Poster for the Clash concert at the Temple Beautiful. *Courtesy Elaine Vestal.*

167. THE CLASH at the Temple Beautiful, San Francisco, February, 1979. Photo: Ruby Ray.

168. Inside the Temple Beautiful at a concert for Rock Against Racism, San Francisco, June, 1979. Photo: Richard Mc Caffrey, *Courtesy BAM magazine.*

169. Altered billboard, North Beach, San Francisco, June 1979. Photo: Jill Von Hoffman.

168.

Fig. 55.

96

170.

was introduced. Members of the audience would climb up on stage, strut and swagger star-wise for a few moments, then race to the edge of the stage and dive onto the crammed front lines of the crowd. In the minds of many members of the first wave of scenesters this was a violation of some unwritten code. They retired themselves, claiming the scene had become too violent and that football mentality had encroached on polite Punk society. Another development was the so-called Slam Dance, which was the first cousin to the Pogo. The Slam, like the Pogo, made everyone fair game to be bounced off of, and though to an outsider it appeared to be a drunken brawl, it was essentially harmless. As long as everyone understood that they were *supposed* to get pushed around there was no problem. This didn't always happen and occasionally there were violent results.

S.F.'s Punk institution, if there could be such a thing, self-destructed in March, 1979, when *Search and Destroy* announced, almost as an afterthought, that its mission had been accomplished. They ceased publication after eleven issues. Another tabloid, the Oakland-based *Another Room*, began publishing a short time later. *Another Room* was edited by Mutant guitarist John Gullak and Lucy Childs. It remains the Bay Area's longest-active underground tabloid. Decidedly not a fanzine, *Another Room* is a by-artists-for-artists publication with a New Wave slant.

Another news source began circulating around town a few months before *S&D*'s demise. A woman named Ivey with friends Ruby Ray and Mark McCloud began publishing an events calendar. The calendar could be had for an SASE and was indispensable for serious scenesters. It came to be known simply as Ivey's Calendar and was published every month for nearly two years.

While the Deaf Club and Temple Beautiful were providing plenty of alternative entertainment for San Francisco punks, Dirk Dirksen at the Mabuhay had kept alive his policy of booking Punk bands seven nights a week. The Mab has pursued this policy longer than any other West Coast venue.

On May 21, 1979 the Dan White "Twinkie Verdict" was handed down. White was convicted of voluntary manslaughter rather than murder for the deaths of Mayor George Moscone and Supervisor Harvey Milk. That night, hundreds of irate citizens gay, straight and punks, took the law into their own hands. They gathered at City Hall where they rioted, smashing windows (in the building), looted nearby stores, and burned eleven police cars. Police retaliated hours later with a riot of their own. They stormed a bar in the gay Castro neighborhood, brutally beating customers and passersby. Some individuals were arrested and a defense fund was organized. Groups like the Offs and the Blowdryers played benefits to raise money for the cause. Later a photo of the burning cop cars would become the cover art for the DK's first album.

1979 was the year of the altered billboard in San Francisco. Literally hundreds of billboards all over the city were defaced by guerrilla art attacks. Some attacks were simply heaved paint balloons, for the abstract riot approach, while others were precise alterations that appeared official while in fact they bore a message that was sexually perverse or political. One artist, Mark Pauline, pasted his own poster, which pictured two cats copulating, on the side of a bank in North Beach. Beneath it he added a note to the bank officers warning that removal of the poster before the deadline determined by the artist would result in a "counterattack" against the building. The poster came down shortly after the time limit expired.

Fig. 56.

Fig. 57.

Fig. 56. Sample of Ivey's calendar, September, 1979.

Fig. 57. Cover of *Another Room* magazine, October, 1981.

170. IVEY, creator of Ivey's calendar. Photo: Ruby Ray.

Fig. 58. LOVE CANAL/HA HA HA, Flipper.
Courtesy of Subterranean Records.

171. THE PETER BILT BAND (l-r) Dan, Darren, Peter Bilt. Photo: Stanley Greene, *Courtesy of Punk Globe.*

172. PEARL E. GATES, singer for Pearl Harbor and the Explosions. Photo: Cooksey Talbot.

The Mutants released their first single, *Insect Lounge*, backed with *New Dark Ages* and *New Drug*, early in 1979, and shortly afterwards Pearl Harbor and the Explosions released their 45 "Drivin". 415 Records had pressed both discs which disappeared as quickly as they got to the racks. The Explosions were signed by Warner Brothers and released an album. But shortly afterwards internal differences caused the group to disintegrate and Pearl left town with the Clash. The inability of this group to survive has until recently caused major labels to shy away from S.F. groups. After the Explosions' collapse, Peter Bilt founded another band called the Expressions, and later the funky-sounding Peter Bilt Band. The Stench Brothers migrated from one band to another, working with the Soul Rebels and later settling in with Chrome, a group mixing electronics, Punk, tape collage and *musique concrete* to create a primitive holocaust sound that has popularized them in Europe and at home.

Brad Lapin was a copy writer for CARE, creating direct mail advertisements to solicit donations for the charity. He lived in a spacious Russian Hill flat which smelled of gas that leaked from the heater in his entrance hall. Lapin was a Hollywood transplant. He had come to S.F. to take advantage of its relaxed social attitudes. He was also an avid reader and music fan, and when *Search and Destroy* dismantled itself he was out of a fanzine. So, in the DIY tradition of Punk, he created *Damage* magazine. On June 1, 1979, the first issue of *Damage* was released bearing a George Westcot photo of Jello Biafra on the cover, containing interviews with Dirksen, Hanrahan, Noh Mercy, L.A.'s Bags and a centerfold of Sally (Webster) Mutant. Lapin continued to publish *Damage* through eleven issues, ending in 1981 when he, hopelessly in debt, left S.F. for his old L.A. haunts. Over its life-span *Damage* provided "an outlet for the most exotic types of critico-literary style, and helped in its own way to create an actual literature expressive of Punk aesthetics". [23] Among the writers and artists who published in *Damage* were Marian Kester, Jonathan Formula, Shoshana Wechsler, Max Sentry and Stephano Paolillo.

By mid-year another school of bands had established themselves in the city. Foremost among them was Flipper. Flipper consisted of Vietnam vet and ex-art teacher Ted Falconi on guitar, vocalist Bruce Loose (whose destructive nature nominated him as most likely to be found in a muddy ditch with a bullet in his head), Will Shatter, formerly the bassist with Negative Trend, and Steve DePace, an ex-fan turned drummer. Their motto was "Flipper Rules . . . OK?" They even had a new rock and roll category for themselves called "Pet Rock". " 'Pet Rock' is not a joke, and if it were, it wouldn't be funny." Add to that their logo, which was relentlessly graffitied around town, and the considerable writing talents of Shoshana Wechsler behind them, and you had the best publicity of any band since the Dead Kennedys.

Flipper was named by Ricky Williams (who was their original vocalist), and predictably the band did everything backwards. If the other bands were playing faster, Flipper played at a crawl; if the other bands songs were shorter, Flipper was ponderously long; if the other bands were political, Flipper had this to say: "What? Politics? Politics are fucked! Who wants to talk about government or something like that?"[24] It wasn't long before adoring adolescent fans were referring to them as "those perky porpoises". Flipper's music was not pop, and it didn't fit the Punk mold too well either, essentially because it was a reactionary acid-hybrid spiked with Will Shatter's (who left the band in early 1983) poignant poetry.

One by One

Each moment

Each road

174.

Fig. 59.

Fig. 59. Cover of *Damage* magazine no. 1, June, 1979. Photo: George Westcot. Design: Peter Belsito.

173. FLIPPER (l-r) Ted Falconi, Bruce Loose, Steve De Pace, Will Shatter, 1981. Photo: Julie Stein.

174. BRAD LAPIN editor of *Damage* magazine. Photo: Julie Stein.

*Every wall
Shall cease to exist*

*One by one
The waves crash
Onto rock
And the rock will fall
The rock will fall.*

©1981 Flipper Insect Music Company
lyrics by Will Shatter

The chances of Flipper landing a record deal with a major label or even pop-oriented 415 Records were nil. Fortunately for Flipper and other expressionist art bands like Minimal Man, which border on the Punk world, Subterranean Records was formed in late 1979 by ex-New Youth member Steve Tupper. Subterranean's first release, financed late in 1979 by Tupper's machinist job, was a 45 r.p.m. compilation featuring Flipper and three other bands: the Tools, a tight metalish group featuring guitarist Mike Fox; the Vktms, hardcore-rock darlings of Ginger Coyote's *Punk Globe*; and a new band called No Alternative.

No Alternative was the KGB band with head honcho Johnny Genocide, whose hair color was weekly in duration, playing guitar with bassist Jeff Rees. Together they, with a constantly changing line-up of drummers, released a three chord anthem called *Johnny Got His Gun* on the sampler. They also opened nearly every show at the Temple Beautiful, which had been renamed the New Wave A Go Go by the new booker, Paul Rat. The foppish Genocide had a knack for eliciting a beer can response from his audience and on several occasions the music became secondary to the spectacle of 50 Budweiser cans being launched into the air.

Another band to debut in '79 was a three piece female unit called the Contractions. Their guitarist Mary Kelley is easily amongst the most accomplished players in the Bay Area. She, with comely bassist Kathy Peck, drummer Debbie Hopkins and for awhile keyboard artist Kim Morris, comprised one of the

Fig. 60. S.F. UNDERGROUND, various artists. Pictured is the entrance to the Deaf Club. Photo: Stefano Paolillo. *Courtesy of Subterranean Records.*

Fig. 61. *(Page 102)* MINIMAL MAN, Minimal Man. Artist: Patrick Miller.

Fig. 62. *(Page 103)* NOT SO QUIET ON THE WESTERN FRONT, various artists. Cover art: Tim Yohannan, Winston Smith, Thought Crimes and RE/SEARCH. *Courtesy of Maximum Rock and Roll.*

Fig. 63. *(Page 104)* CLUB FOOT, various artists. *Courtesy of Alterboys International.*

175. THE CONTRACTIONS (l-r) Mary Kelley, Kim Morris, Debbie Hopkins and Kathy Peck, Summer 1982. Photo: Neal Ewenstein.

176. FLIPPER (l-r) Bruce Loose, unknown fan, Will Shatter at the On Broadway, San Francisco, 1982. Photo: George Sera.

177. NO ALTERNATIVE (l-r) Jeff Rees and Johnny Genocide at the Mabuhay Gardens, San Francisco, February, 1980. Photo: Elaine Vestal.

178.–188. *(Facing page)* Stills from 1982 Target Video tape. Photos: Joe Rees.

184.– 194.

MINIMAL MAN

MAXIMUM ROCK N ROLL PRESENTS

not so QUIET ON the WESTERN FRONT

GEN. DOZIER PLUGS HIS EARS AT POST-KIDNAPPING NEWS CONFERENCE
His Red Brigades captors forced him to listen to Maximum Rock and Roll, he says

CLUB FOOT

finest all woman politico-pop bands in the States. They released a self-produced single called *Rules and Regulations*.

September 1979 marked Target Video's arrival in San Francisco from Oakland, where Joe Rees along with Sam Edwards, Jill Hoffman and a swarm of volunteer workers had spent 1978 documenting the scene on video tape. Target covered every band from the Avengers to the Zeros. The group moved into a three-story warehouse located in the Mission District. Because of the low rents and the lure of institutions like the Deaf Club, Target Video, and later Tool & Die, the Mission was fast developing a Punk bohemia nestled among the indigenous Spanish-speaking population. A few months later Target began a series of after-hours events that culminated in a police raid and court action. The crime: having a good time late at night. Eventually, the charges were dropped but the popular after-hours parties were finished.

The first of these after-hours parties was organ-

189. MARY KELLEY of the Contractions.
Photo: Neal Ewenstein.

ized in conjunction with the first Western Front Festival in October 1979. The Western Front was a week-long event utilizing every available Punk venue in San Francisco. By this time the Savoy Tivoli, an elegant and long-standing night club on upper Grant Avenue in the same North Beach neighborhood that had spawned the Beats, had begun an eclectic booking schedule ranging from Pop to Reggae and art-oriented bands like Tuxedo Moon, Pink Section, Noh Mercy, and Indoor Life, a mombo-combo with Jorge Scarras vocalizing. Even the Deaf Club was re-opened for the Western Front. The festival drew talent from all over the U.S., England and Canada. The Germs, Weirdos and Catholic Discipline came from L.A., Pointed Sticks from Canada, Feederz from Phoenix and the Clash arrived from London. New groups from San Francisco included the promising power-pop Punts, who'd later change their name to the Wild Combo, led by Bonnie Hayes; the Woundz; the rythmic industrial pop of Los Microwaves; and the drug Dadaists Minimal Man. *Damage*, which had moved to the Target building, released a free issue to celebrate the festivities. On the back cover was an announcement for Jello Biafra's candidacy for mayor of San Francisco.

Biafra's campaign rocketed the sharp witted vocalist into the public eye and united the Punk communities self-appointed leaders in a way that even the Western Front failed to do. While attending a gathering at Target, *Damage* editor Lapin loudly proclaimed, "We have our own paper, our own television station (Target) and our own candidate for mayor," to the raucous applause of everyone present. Jello's campaign was built on a landmark platform worthy of Pat Paulsen. Policies like hiring laid off city workers as panhandlers at 50 percent commission to replace funds lost through Proposition 13 (an unpopular property owners' tax break that eventually sent California's state treasury plummeting from a three billion dollar surplus to a one billion dollar deficit) were introduced; requiring police to be elected; legalizing squatting in vacant buildings; and the erection of Dan White statues around town

190. THE WOUNDZ (l-r) Anthony, Paul, unknown and Jay, at the Sound of Music, S.F., September 1980. Photo: Elaine Vestal.

191. LOS MICROWAVES (l-r) Todd Rosa, Meg Brazil, David Javolas, 1981. Photo: Alex Waterhouse-Hayward. *Courtesy of Posh Boy Records.*

192. SAM EDWARDS of Target Video. Photo: *Courtesy of Sam Edwards.*

193. THE PUNTS (l-r) Mark Pollard, Charles Hornaday, Bonnie Hayes and Steve Savage. Photo: f-stop Fitzgerald.

194. MINIMAL MAN (l-r) Hitoshi Saski and Patrick Miller. Photo: MACHINE. *Courtesy of Patrick Miller.*

106

(while having the Park Department open up concession stands dealing eggs and tomatoes to throw at them) were all discussed. Dirksen hosted a benefit at the Mabuhay to raise the $400 campaign budget, and a whistle-stop subway speechmaking tour culminating at City Hall was booked. The media attention mounted after the local papers quoted appointed mayor Dianne Feinstein as saying that Biafra "made the race more interesting."[25] Jello was not elected mayor, but he did collect 6,591 votes (coming in fourth) and earned more press coverage than any local punk rocker.

It was no accident that the next few months would see a plethora of new clubs opening up, including The Sound of Music in the Tenderloin, the Hotel Utah, (South of Market), X's in North Beach, the Roosevelt on Market Street, Le Disque in the Haight, The Palms on Polk Street; the Back Dor, Rock City and the Stone, all on Broadway; and the "art clubs."

In the winter months of 1980, with uncanny synchronicity, six underground venues opened their doors to the public. *Cover* magazine of New York would later call them the "Fashionist" clubs, accusing their perpetrators of being "the carpetbaggers of the art world". Hardly "carpetbaggers," the art clubs were kept open out of their founders' pockets. Rarely were there any profits to be bagged. Bearing the brunt of this indictment were these six vanguard clubs: the A-Hole, A.R.E. (Artists for Revolution in the Eighties), Club Foot, Club Generic, Jet Wave and Valencia Tool and Die. Each set about producing performance, video, film, painting and of course music events. During the following eighteen months, San Francisco experienced the birth of a visual scene that complemented the musical frenzy. Performance artists like (Richard) Irwin Irwin, the Scientists, Jim Pomeroy, Michael Peppe, Pons Maar (who had been in a band called Bob), Ondyn Herschelle, Arturo Galster, Tony Labat, Karen Finley, JoJo Planteen, Bruce Pollack (co-founder of the A-Hole), Debora Iyall (currently the lead singer-lyricist of Romeo Void) and many others performed in these clubs. Painters like Irene Dogmatic, Lisa Fredenthal, Pamela Rome, Doug Roesch, Peggy Simon and John Whitehead exhibited; and filmakers like Mark Heustis (*Whatever Happened To Susan Jane?*), Richard Gaikowski (*Deaf Punk*), Mindy (*Louder, Faster, Shorter*, a documentary on the Miners' benefit), and Karl Hinz *(Loud and Lewd)*.

On any given weekend there was sure to be an after-hours gathering. It could be Crime and the Speedboys in A.R.E.'s spacious third floor gallery,

195. THE PUDS (center) Philip Hyser at the Savoy Tivoli, San Francisco, 1980. Photo: William Sigfried.

196. THE BLACK DOLLS (l-r) John Surreal, Jerri Bionda, Stan Fairbanks and Sinthya (seated). Photo: Glenn, *Courtesy of the Black Dolls*.

197. DOG a.k.a. David Swan of the Longshoremen. Photo: Stefano Paolillo.

198. VINCE of Animal Things. Photo: Jeanne Hansen.

199. THE INFLATABLE BOY CLAMS (l-r) Genvieve Boutet de Monvel, Judy Gittelsohn, JoJo Planteen and Carol Detweiler. Photo: Richard McCaffrey. *Courtesy of BAM magazine*.

200. THE INVERTEBRATES (l-r) Mort Shaperio, Jeffrey Skoller, Pat McLaughlin, Bill Wheeler, Guy Geduldig, Linda Nathanson and Tom Wheeler. Photo: Mitch Linden. *Courtesy of Tom Wheeler*.

201. RICHARD KELLY AND J.C. GARRETT (l-r) two of the founders of Club Foot. Photo: Stefano Paolillo.

202. ANDY PRIEBOY of Eye Protection and Susan. Photo: Stefano Paolillo.

203. KIPPY of the Rockadiles. (Formerly the Dickheads.) Photo: Carl Hoffman.

Billy Bastioni's Ultrasheen at Club Foot, Philip Hyser of the Puds " with a 45 r.p.m. pegged on his pecker" at the A-Hole or ancient poet Allen Ginsberg fronting a group called the Job at Tool and Die. Club Foot and Tool and Die were also rehearsal studios and began spitting out groups. The Alterboys, Animal Things, the popabilly Dickheads (who would later change their name to the Rockadiles), the Longshoremen, Arkansaw Man, the Invertebrates, Naked City, and Bay of Pigs all rehearsed at Club Foot. The Appliances, Units, Tommy Tutone, The Peter Bilt Band, Bad Posture, Black Dolls and Undersongs practiced their craft at Tool and Die. Club Foot eventually released an LP on Subterranean featuring a standout cut by the Longshoremen's vocalist Dog, a.k.a. David Swan, a used car salesman turned beatnik, titled *What Does It All Mean?*. Another highlight of the Club Foot LP was J.C. Garrett's (co-founder of Club Foot along with Richard Kelley) crooning on the Alterboys' song *Ray Orbit's Son*.

The art clubs were in constant conflict with city authorities and landlords. One by one they were closed. The A-Hole was busted during an after-hours party when an envious gay disco called the police in an attempt to eliminate competition. This was quickly followed by Jet Wave and A.R.E. which were evicted from their adjacent Market Street lofts. A.R.E. moved across town to Valencia at 16th and still exists, but only as a gallery. Club Generic was busted for after-hours assembly, and Club Foot semi-retired. Tool and Die continued to operate openly only three blocks from the Mission police station and was even joined on the same block by a club called The Offensive in 1981. But, the Die was busted in late 1982 when an overflow crowd at a D.O.A. gig became too conspicuous for the cops to ignore. The Offensive was popped a week later. Club Foot and Tool and Die now open only for sporadic events. The Offensive has closed permanently.

In March 1980 the Kinman brothers decided to break up the Dils, Punk's original "red rockers," much to the chagrin of their ardent followers. Chip Kinman travelled to N.Y. and there together with ex-Nun Alehandro put together a C&W group called Rank and File. Tony Kinman joined them later when they moved again, to Austin, Texas. There, drummer "Slim" Jim Evans was added to round out the group whose music is sometimes called "punkry." The turn to C&W seemed like a natural one to the Kentucky-born Army brat Kinmans, but the transition took their fans by surprise. The group has persisted, however, winning over some old fans and adding an army of new ones who find no contradiction in the once hard-driving Kinmans playing an occasional acoustic set. In 1982 they released their first album on Slash called *Sundown*.

In March 1980 the Temple Beautiful was closed after a church group purchased the building. A week-

204.

Fig. 64.

Fig. 65.

Fig. 64. HE WHO FALLS / SHE WAS A VISITOR, Minimal Man single. Artist: Patrick Miller.

Fig. 65. Poster for a concert at Valencia Tool and Die, 1981. Artist: Peter Belsito.

204. RANK AND FILE (l-r) Alejandro Escovedo, Slim Jim Evans, Tony Kinman and Chip Kinman, Sunset Strip, Los Angeles, May, 1982. Photo: Gary Leonard.

end of farewell concerts was planned but never materialized. The new owners had them cancelled because they feared that the already heavily vandalized synagogue would not be left standing. Undaunted, Paul Rat quickly rounded up a new group of venues, which he began rotating to avoid harassment. They were Rats Palace, the 10th Street Hall (both in the South of Market area); the Elite Club, formerly the original Fillmore; and the Russian Center (both in the Western Addition).

Tenth Street Hall survived one of the hardest of hardcore evenings ever presented when L.A.'s Circle Jerks and Black Flag opened for the Dead Kennedys. That particular night, Biafra, always the showman, pulled a young skinhead wearing a swastika T-shirt out of the audience, to help introduce the Kennedys' new song *Nazi Punks Fuck Off*. The swastika had long been used by punks for its shock value. For example, when one English punk was asked in 1977 why she wore a swastika, she replied, "Punks just like to be hated." [26] The new DKs' song submitted that the swastika was still a fascist symbol, contradicting the simplistic anti-establishment interpretation given by the original punks. Indeed, in Germany this symbol is officially banned. (In California it is a felony to draw it.) When San Francisco's experimental synthesizer group, The Residents, tried to market their *Third Reich and Roll* album in Germany they were forced to censor every swastika, Hitler image, and the word "Reich" that appeared on the cover art.

The closing of the Savoy Tivoli was commemorated on an album called *Savoy Sound Wave Goodbye* which was produced by the club's promoters Jerry and Olga Gerrard, on their independent Go! Records. Cuts by Tuxedo Moon, Ultrasheen, the Sleepers and Mutants are on the disc. New bands continued to flow from the seemingly infinite reservoir of musicians in the Bay Area. Pop was the domain of groups like the demented, half-taped, half-live Barry Beam (who would score a top ten disco hit in 1982 called *Jump Shout* with ex-Nub Lisa Fredenthal singing); the Varve, (an all-girl unit from Boulder, Co.); the Lloyds; the melodramatic Wolvarines; the always stylistic Chrome Dinette (who would later add famed percussionist Mingo Lewis); and the extremely danceable Symptoms. Art bands abounded. They were led by the likes of Indoor Life, the "Pet Rockers," Amimal Things, jazz-damaged Red Asphalt and feminist rockers Wilma. Rockabilly converts began to appear, led by Silvertone (which was quickly signed to produce a demo by Warner

205.

206.

207.

Fig. 66.

208.

Fig. 66. & 67. Drawings for backdrops used in the Residents' *Mole Show*, 1982. *Courtesy of the Residents.*

205. THE RESIDENTS in the background with dancers in the foreground. From the *Mole Show*, Kabuki Theater, San Francisco, 1982. Photo: f-stop Fitzgerald.

206. SNAKEFINGER. Photo: *Courtesy of Ralph Records.*

207. Vivian Ridenhauer, a fan, outside the Sound of Music, S.F. Photo: Bobby Castro.

208. THE RESIDENTS. Photo: *Courtesy of Ralph Records.*

110

Fig. 67.

Brothers and included ex-Avenger Jimmy Wilsey). Another LP that appeared around this time was the Sleepers' *Painless Nights*, on Adolescent, which qualified as the group's last will and testament. Ricky Williams, the brilliant voice with the erratic temperment, had wandered off to help found Flipper and then into another group called the Toiling Midgets. The Midgets with Ricky released an album in 1982 called *Sea of Unrest* which has been described by critic J. Neo as a "brilliant set of terminal brain damage rock."[27]

With Ricky gone, Sleepers guitarist Michael Belfer and drummer Brian MacLeod put together the Clocks of Paradise with singer Kelly Brock. The Clocks of Paradise were an instant success. They opened a show for the British group New Order at a hit-and-run venue called The Cinema, rendering the headliners totally forgettable. (The Cinema was booked by a maverick Graham employee, Ken Friedman, who would shortly return to the fold to help book Graham's newly acquired Old Waldorf and later the Kabuki Theater in Japantown Center.) The Clocks were hit-and-run too and broke up shortly after the gig. Belfer has since wandered through a series of bands going by names like the Passengers and Mondo, searching for a combination that unlocks the alchemy he controlled on *Painless Nights* — a landmark San Francisco recording.

The Residents are the world's most popular unknown musicians. They strictly adhere to a policy of anonymity. Under this policy The Residents have never revealed their identities, granted an interview, or, until late 1982, performed live. They founded Ralph Records which released their own discs as well as those by Tuxedo Moon, MX 80 Sound, and multi-talented guitarist/songwriter Snakefinger. At their Grove Street studios they also produced many brilliant promotional video tapes, directed by Graeme Whifler. In 1982 the Residents produced and performed *The Mole Show* which incorporated their music, theatre, dance, and graphics in a live multi-media presentation. Throughout they remained disguised and anonymous as they do to this day.

The Sound of Music, scene of many a drag show, took a step up and opened its doors to Punk music during 1980. At the time it seemed like the last remaining refuge for the low-life underground Punk scene. The closing of the Temple, the Roosevelt, and the Savoy Tivoli during 1980; the Mabuhay's increasing resistance to hardcore (which would eventually lead to a split between Dirksen and Aquino that caused Dirksen to open his On Broadway venue in a theater

209.

210.

211.

212.

209. ARKANSAW MAN (l-r) Patrick Lovullo, Steve Clarke, and Glen Sorvisto. Photo: *Courtesy of Alterboys International Studios.*

210. SILVERTONE (l-r) Jim Wilsey, Jamie Ayres, John Silvers and Chris Issac. Photo: f-stop Fitzgerald.

211. JOANNE GOGUE of the Varve. Photo: Julie Potratz.

212. VKTMS. (l-r) Steve, Nyna (Napalm) Crawford. Photo: Bobby Castro.

213. *(following page)* TOILING MIDGETS. (l-r) Ricky Williams, Tim Mooney, and Jonathan Hendrickson. Photo: George Sera.

214. *(Following page)* NYNA CRAWFORD of Murder. Photo: George Sera.

215. *(Following page)* J. SATS BERET (with mircrophone) of the Lewd, San Francisco, 1981. Photo: Erich Mueller.

216. *(Following page)* THE SYMPTOMS. Photo: Richard McCaffrey. *Courtesy of BAM magazine.*

217. *(following page)* RED ASPHALT (l-r) Steve DiMartis, unknown, Scott Iguana, Trina, and unknown. Photo: Julie Potraz.

213.

214.

215.

216.

217.

112

and newcomer vocalist Brian Marnell. The release was followed by another album in October by the synthi-pop Units, called *Digital Stimulation,* and a single shortly afterwards by the Vktms called *100% White Girl*. In 1982 the Vktms uncompromising vocalist Ms. Crawford left the band to form a group called Murder.

These releases paralleled the second and last Western Front Festival during October of 1980. The previous year's festival had produced the usual amount of squawking and slagging among the moody Punk elite as to whether or not the festival had had any impact. Whatever the '79 festival had to offer, the '80 version had more of it. A steering committee had been created in April to plot and manage the event, and if one *had* to find fault, it would be that Punk and organizations do not by their very nature mix. In any case, eleven venues participated in the festival, among them A.R.E., Club Generic and Valencia Tool and Die as well as the gay disco the I-Beam and Berkeley Square, which had a decor that inspired *Damage*'s Jonathan Formula to dub it "Barbie's lunchbox." A special issue of *Damage* served as a program with descriptions and pictures of all the

just upstairs from the Fab Mab); and the general unreceptivity at the time of the art clubs made it difficult to find a place to perform. Bands like Flipper, the Lewd, the Woundz, Animal Things, the Tanks, the Undead, Arkansaw Man, the Ghouls, and the Saucers began calling the seedy, dirty little Tenderloin Club home.

415 released their first album during July 1980. It was by a band called SVT which featured former Jefferson Airplane and Hot Tuna bassist Jack Cassidy

Fig. 68.

Fig. 68. Poster for the first Western Front Festival, October, 1979. Artist: Winston Tong.

218. SVT (l-r) Paul Zahl, Brian Marnell, Nick Buck and Jack Casady. Photo: *Courtesy of MSI Records.*

219. FACTRIX (l-r) Cole Palme, Bond Bergland, Joseph Jacobs, Monte Cazazza, Tana Emmolo-Smith, at Kezar Pavillion, San Francisco, December, 1980. Photo: Jim Jacoy. *Courtesy of Joseph Jacobs.*

Fig. 69.

Fig. 69. Poster for the film *Loud and Lewd*, 1981. Artist: Karl Hinz.

220. THE LEWD (l-r) J. Sats Beret and Olga deVolga. Photo: William Sigfried.

bands, floor plans of the venues, and a schedule. Highlights of the festival included S.F. debuts of the Young Marble Giants, Stiff Little Fingers, Cabaret Voltaire and the English Beat, all from the U.K.; the B-52s, DNA, Our Daughters Wedding and Talking Heads from the East Coast; and the Go-Go's, Black Flag, Nervous Gender and Weirdos from L.A. Newcomers from San Francisco included the "quasi-classical neo-Broadway rock" of Eye Protection who were fronted by Andy Prieboy. Other highlights were the industrial music of Factrix, Bob (whose graffiti read "Where Bob goes, dogs smell"), the Hoovers, the Neutrinoz, and the macabre Mr. E. and the Necromantics. Minimal hardcore arrived from suburbia with Hayward's Social Unrest. And Seattle transplants the Lewd recruited bassist Olga deVolga, formerly of the Offs and VS., to put down a bottom for mad thrasher J. Sats Beret.

But it wasn't just a music festival. Both Club Generic and Tool and Die had film screenings, and Tool and Die presented a retrospective Punk poster show of over 500 posters originating in S.F. Later a book based on the show, called *Streetart* was released. It wasn't San Francisco's first book about Punk culture. Earlier in 1981 photographers Ray Santos, Richard McCaffrey, and f-Stop Fitzgerald self-published *X-Capees*, which documented the early years of S.F. Punk.

B y 1981 most of the original enthusiasm for Punk had been drained from the scene. Most of the initial wave of characters had either dropped out or disappeared. Some of these disappearances came out of success, as in the case of the Dead Kennedys and Target, who put together highly popular tours in Europe. But, there is something about success that isn't digested well by the nihlistic Punk metabolism. Bands who succeed at the rock and roll game are as suspect as clubs with too clean a decor or fans with long hair. People began saying Punk was dead when dinosaur groups like the Who and Stones began making painfully contrived attempts at Punk aesthetics. People began saying that Punk was dead when studded leather wristbands appeared in downtown shop windows rather than in the back rooms of gay bars, and people began to say that Punk was dead when every secretary and 35-year-old vegetarian began showing up at the office with a splotch of crazy-colored hair. They were right. Punk was being castrated in the marketplace.

221.

Fig. 70.

Fig. 70. Poster for a show at Valencia Tool and Die, 1982. Anonymous.

221. BOB NOXIOUS of the Fuck Ups with (l-r) Victoria, Leslie and Virginia or the Fuckettes. Photo: Erich Mueller.

222. *Following page.* THE HUNTINGTON BEACH SHUFFLE. Photo: Gary Robert.

115

223.

Fig. 71.

Fig. 71. "The Skank Kid". Drawings of the "Huntington Beach Shuffle" by Shawn Kerri.

223. THE UNDEAD. Two of the original members (l-r) Dave Vacant and Sid Terror. Photo: Julie Stein.

224. THE FUCK UPS (l-r) Joe Dirt, Sean Tuohy, Bob Noxious and Ricky. Photo: Erich Mueller

225. JOE REES of Target Video. Photo: *Courtesy Joe Rees.*

224.

Damage floundered through its final issues in an attempt at gaining an international audience by hyping English and L.A. based groups while ignoring the local talent. Bands who had survived the early Mab days, like Tuxedo Moon and the Offs, relocated in Belgium and N.Y.C., respectively. Meanwhile, members of other bands began switching their styles to Rockabilly in an effort to beat the ennui that had set in. On the surface everything appeared divided and malnourished. But beneath the surface something was brewing that paralleled the suburban hardcore explosion happening in Orange county. "Thrash" music had been born. The three most prominent San Francisco bands in this category were Bad Posture, Code of Honor and the Fuck Ups. They, along with survivors like the Lewd, Dead Kennedys, Flipper, and the Undead, embodied the original energy and attitudes that those who were saying "Punk is dead" were trying to escape.

Thrash was a term which could be loosely applied to any music that used jackhammer tempos which effectively turned the beat into a hum. The vocalist delivered a similarly paced diatribe about anything from McDonalds hamburgers to murdering bus drivers. Thrash was inherently political. The audience

225.

118

members, who were mostly skinheads or mohawked males, dived from the stage or formed a circle where they'd dance the "Huntington Beach Shuffle." The "Shuffle" was a mutation of the Slam Dance, best understood by Shawn Kerri's illustrations for the Circle Jerks. Dress was obligatory black leather for those who could afford it, while torn jeans and plaid shirts sufficed for others. Headbands, leather wristbands with threateningly pointed studs, black motorcycle or combat boots and tattoos rounded out the look.

The Fuck Ups were a four piece Thrash band Headed up by ex-Undead member Bob Noxious, Punk's answer to primal therapy. When Bob wasn't whining into a microphone, he could be found diving off stage at shows. He was known to knock out the singers of other groups while they were playing. The Fuck Ups were a raw, nasty, uncontrollable quartet with enough energy to claw their way through any icons set in their path, including those of their politically correct detractors. The Fuck Ups were not politically correct. Their lyrics were often racist, sexist or just in poor taste, but their intensity was frightening. For example, drummer Joe Dirt submitted to a two-month medical experiment to raise cash to fund the group's 45. The band was often accompanied by a group of three hardened females called the Fuckettes who did backing "vocals" on some songs.

Fig. 72. Poster for a show at the Sound of Music, 1982. Anonymous.

226. SAL PARADISE drummer for Code of Honor, 1982. Photo: Erich Mueller.

227. THERESA SODER and JELLO BIAFRA at their wedding in a San Francisco cemetery, Halloween, 1981. Photo: f-stop Fitzgerald.

Fig. 73. Poster for a Romeo Void concert. Anonymous.

Code of Honor was a righteous group of knitters who advocated that California secede from the Union. Vocalist Johnithin Christ would growl lyrics like "better to die than to live a fucking lie" and deliver Morrisonesque monologues about never deserting your buddies in need. Code of Honor's guitarist was Mike Fox, who metal influences were abundantly apparent and as slick as the veneer on his Les Paul. Dave Chavez handled the bass and Sal Paradise was the drummer.

Bad Posture was a demented metal machine fronted by seven-foot tall screecher Jeff (4-Way) Miller. The band was paced by the considerable drumming talents of John Surreal (who doubled as drummer with the Black Dolls) and the sociopathic-sounding rip-chord guitar assaults of Steve DeMartis (both ex-Nubs). Finishing out the group were bassist Emilio and guitarist Eddie, a couple of Brownsville transplants who left home because nobody played

228.

229.

120

their kind of music. Their music ranged from Link Ray covers to their immortal *GDMFSOB*, on the Maximum R&R album. This band did not have to bite the head off a snake to get attention.

By mid 1981 Tool and Die had begun to book hardcore Thrash shows featuring three bands for three bucks, a policy which had disappeared years before. The Die was a street-level storefront with a semi-sound proof basement, a seven-foot ceiling crossed with pipes, and brick walls. The bands stood on the same floor face to face with the crammed sweltering audiences. Beer could be had for a buck, and gigs would last till the wee hours when bands like L.A.'s Social Distortion or the DKs would appear unannounced. Upstairs people would drink, smoke, socialize, graffiti the walls, scream, fight or curl up for some sleep. Outside on the sidewalk there would inevitably be a dozen or two skulking kids in the

228. ROMEO VOID (l-r) Peter Woods, Larry Carter (drums) Debora Iyall, Frank Zincavage and Ben Bossi at the Roxie, Hollywood. Photo: Lynda Burdick.

229. CODE OF HONOR at Valencia Tool and Die, 1982 (l-r) Mike Fox (guitar) and Johnithin Christ. Photo: Erich Mueller.

230. BAD POSTURE at the On Broadway, S.F., 1982. Photo: Erich Mueller.

231. DEBORA IYALL of Romeo Void. Photo: f-stop Fitzgerald.

232.

nearby doorways or leaning on parked cars while catching a breath of smokeless air.

Other Thrash bands to make an appearance around this time were X Mas Eve, Free Beer, the Fear-influenced Scapegoats from Santa Cruz, and Toxic Reasons.

The Dead Kennedys (because of their longevity and Biafra's talent for keeping in stride with the moment) and Flipper became the unofficial leaders of Thrash. On Halloween of 1981 Biafra married Therese Soder, formerly of the Situations, in a graveyard while a squad of photographers recorded the ceremony for posterity. Biafra had also formed his own label called Alternative Tentacles.

Romeo Void exploded onto the San Francisco music scene in February 1982 when they released their first LP on 415 called *It's a Condition*. The band featured vocalist Debora Iyall, whose sultry sex talk coupled with Benjamin Bossi's screaming sax solos rocketed the album onto the national charts. *It's a Condition* was followed later in the year by an EP called *Never Say Never*, featuring a hit song of the same name, ("I might like you better if we slept together"), that scent CBS Records scrambling to San Francisco for a visit with 415. After a year of negotiations a package was worked out for joint Columbia/415 ventures, the first of which was Romeo Void's *Benefactor* album in 1982, followed by the release of Translator's *Heartbeats and Triggers*.

Romeo Void was obviously not a Thrash band. Their music is packaged for dance club play, which is where ex-punks tend to migrate. A flock of clubs designed for dancing have emerged to fill this need,

232. JELLO BIAFRA of the Dead Kennedys.
Photo: Ed Colver.

233. BAD POSTURE at the On Broadway, 1982.
Photo: George Sera.

234.

235.

including the I-Beam in the Haight, the Trocadero Transfer, Echo Beach, the Stud (which had been playing good music since the mid-seventies), the 181 Club (which had previously been a hangout for black transvestites), and memorable parties at the Club Anon. The Anon would feature cameo appearances by local luminaries like saxophonist extraordinaire Norman Salant, Snakefinger, Indoor Life, Esmerelda or Zev. It was not uncommon for stars like Iggy Pop to be spotted upstairs at the Anon while several strip-tease acts or a magician performed on one of the several stages of the third floor club.

The notoriety of Country/Rockabilly/Punk spinoff bands like Silvertone and Rank and File had begun to send ripples through the Punk world. Johnny Genocide traded in his spiked hair for a pompador and his last name for Patterson when he switched to his Rockabilly combo The Swinging Possums. Other bands like the CF (Club Foot) Country Players, the all-girl trio The Stir Ups, and the Memphis G-Spots (featuring a transvestite, Artie Galster, singing Patsy Cline tunes) seemed to indicate the makings of a Rockabilly trend. They attracted audiences avoiding the slam-bang orientation of Thrash bands like M.D.C. (Millions of Dead Cops), Free Beer, those mohawk leatherboys Crucifix, Impatient Youth, or Los Olvidados (The Forgotten), a San Jose band that took their name from a Luis

234. TRANSLATOR (l-r) Dave Scheff, Steve Barton, Robert Darlington and Larry Decker. Photo: f-stop Fitzgerald.

235. CRUCIFIX (l-r) Sothira, Chris, Matt and Jimmy. Photo: Ed Colver.

236. BONNIE HAYES of Bonnie Hayes and the Wild Combo. Photo: Lynda Burdick.

236.

Bunuel film. Simultaneously the Pop bands like Bonnie Hayes and the Wild Combo (whose album *Good Clean Fun* was released by Slash), the New Jersey transplants Pop-O-Pies, and No Sisters had begun pumping records into the MOR market and receiving some rotation airplay.

In 1982, the Maximum Rock and Roll show released a Thrash-oriented compilation album featuring "deprogramming by 47 Northern California and Nevada bands" called *Not So Quiet on the Western Front*. The back cover of the album bears the message "If Punk Is Dead, What The Hell is This?" What it is is an index to nearly every hardcore Thrash band in the area with the exception of the Fuck Ups. Maximum Rock and Roll also began printing a bi-monthly magazine that updates its readers as to the latest developments on the Thrash scene as well as providing its political conscience. Other magazines to emerge in 1982 were *EGO*, *BraveEar* and *Puncture*, all of which introduced quality writing and criticism back into the zine scene in San Francisco.

As always groups that defy categorization streamed out of the woodwork. They included the moody Fade to Black, the Black Athletes, Paris Working, Umbrella Defense, and Beast, a new vehicle for ex-Cramp Brian Gregory; B-Team, the Reggae/Punk two-piece Burnt Offering, the Lifers, the Looters, the teenaged Uptones, and the Renegades.

Fig. 74. Poster for a show at the Hotel Utah, 1983. Anonymous.

237. PAULETTE DENIS of Fade To Black. Photo: Wynn Richards.

238. BENJAMIN BOSSI of Romeo Void. Photo: Carl Hoffman.

Fig. 75

The eighties are not grounded in any one style. Musically, visually and in the fashion world there are camps promoting the predominance of the various Post-Punk styles: Thrash, Industrial, New Romantic, Rockabilly, Neo-Psychedelic, Ska, Reggae, mainstream Pop, etc. etc. It is truly an eclectic period to be alive: the melting pot of the second half of the twentieth century. It is an era when the line between radical and conservative has been blurred, and when the media and numbers have created a "pop underground". The eighties will be the time when the nostalgia cycle finally collides with the present and we are forced to invent the future.

FOOTNOTES

1. Greil Marcus, " Anarchy in the U. K.", *Rolling Stone History of Rock and Roll*, 1980, Rolling Stone Press, pg. 451.
2. Article on the Sex Pistols' San Francisco appearance, *Punk* magazine, vol. 1, no. 14, May/June 1978, pg. 46.
3. Interview with Mary Monday, unpublished, by Peter Belsito, July 1982.
4. Ibid.
5. Ibid.
6. Interview with Edwin Heaven (manager of the Nuns), unpublished, by Peter Belsito, December, 1982.
7. Michael Snyder, article on the Nuns, *New Wave*, no. 1, pg. 5.

240.

239.

8. Jonathan Formula, "I Drove the Fun Bus", *Damage*, no. 8, August, 1980, pg. 24.
9. Michael Snyder, "Rock Around the Bay", *Berkeley Barb*, vol. 26, no. 13, issue 634, October 7-13, 1977, pg. 10.
10. Vale, Interview with the Avengers, *Search and Destroy*, no. 6, pg. 13.
11. Dick Hebdige, *Subculture, The Meaning of Style*, Methuen, London and New York, pg. 122.
12. Jonathan Formula, "I Drove the Fun Bus", *Damage*, no. 8, August 1980, pg. 22.
13. Lynnx, Interview with Alejandro Escovedo, *Search and Destroy*, no. 6, pg. 3.
14. Annex, " The Mutants", *Damage*, no. 6, pg. 26.
15. Mia Culpa, "Interview with Bruce Conner", *Damage*, no. 2, pg. 8.
16. Negative Trend, self interview, *Search and Destroy*, no. 6, pg. 7.
17. Julie Burchill and Tony Parsons, *The Boy Looked At Johnny*, Pluto Press Limited, 1978, pg. 59.
18. Vale, "Dils Didactics", *Search and Destroy*, no. 5, pg. 21.
19. Anonymous interview with Noh Mercy, *Damage*, no. 1, pg. 34.
20. Jennifer Waters, Interview with Paul Rat, *EGO* magazine, no. 4. pg. 28.
21. Anonymous interview with the Dead Kennedys, *Search and Destroy*, no. 9, pg. 5.
22. Mia Culpa, "Robert Talks", *Damage*, no. 1, pg. 6.
23. Marian Kester, *Streetart: The Punk Poster In San Francisco*, Last Gasp, 1981, pg. 60.
24. Tony Rocco, "Biafra 6, 591 Votes (3%)", *Damage*, no. 4, pg. 18.
25. M. O. David, "San Francisco Fashionism", *Cover* magazine.
26. Dick Hebdige, *Subculture, The Meaning of Style*, Methuen, London and New York, pg. 117.
27. J Neo, "Toiling Midgets : Sea Of Unrest", *EGO* magazine, no. 2, pg. 16.

Fig. 75. Cover of *EGO* magazine, August 1982. Design: Peter Belsito.

Fig. 76. Poster for a concert by the Toiling Midgets. Artist: Kim Seltzer.

239. TODD STADTMAN of B Team, 1982. Photo: Vicki Berndt.

240. NORMAN SALANT, May, 1982. Photo: Alan Grosso.

241. BEAST (l-r) Carlos, Greg, Andrela, Mark and Bryan. Photo: Paulette Denis.

242. *Back Cover.* Fans at a Los Angeles concert. Photo: Ed Colver.

CRAIG DIETZ

Born: Hollywood '52.
Education: Alley between Main and Spring, L.A. '72.
Goals: To be famous for more than fifteen minutes.
Live: Central City, California.

LYNDA BURDICK

Having survived the sixties, Lynda Burdick alternates between photography and an affection for Afghan hounds and the guitarist for a prominent L.A. band. In her spare time, she runs a modern equivalent of the proverbial crash pad, a video parlour for miscellaneous homosexuals. The major emphasis of her work to date has been the photo documentation of the L.A. music scene. Her work appears in various local and national publications as well as on numerous album covers.

GLEN E. FRIEDMAN

I've been taking pictures and getting them published all over the world for the last six years. I enjoy catching the most intense or emotional moments in a unique manner. The excitement of achieving this is what keeps me going along with the appreciation I get from the subjects who let me know they enjoy the photographs as much as I do. Shooting skateboarding and bands, where the emotion and action is overwhelming, while I'm enjoying the music and energy, make this art very gratifying.

ANN SUMMA

Ann Summa began her career in photography in Toyko in the early seventies where she lived for four years working for a French-Vietnamese photojournalist. When she returned to the U.S. in 1977 she was totally bored with music until stumbling across the vibrant "punk rock" scene happening in L.A. Hooked on new music and the tension (and fun) surrounding it, she has continued to photograph its participants for local, national and international publications. She is currently at work on a book on modern Japanese pop culture.

BOBBY CASTRO

An S.F. native, Bobby has spent over 18 of his 30 years capturing the political, musical, and street scenes of his city. A contemporary of the punk rock, "new wave " movement, his photos depict this history in it's many varied aspects. Staff photographer for KUSF *Wave Sector* his work has also appeared in many other local and some national periodicals.

ED COLVER

ERICH MUELLER

I have been photographing bands and people in the San Francisco punk scene since early 1979. In order to capture the energy and actions at a gig I had to develop different techniques, since a straight forward flash picture usually doesn't show the excitement I feel and see through my camera lens. Most of my photos in the book succeed, I think, in illustrating my point of view in a visually exciting way.

RUBY RAY

Ruby Ray is now living in NYC where she continues her photographic and esoteric studies and search for fun. In addition to portraiture, she more recently has been working with projected imagery, experimenting with methods of visually expressing interlapping dimensions and time frames.

f-stop FITZGERALD

f-stop Fitzgerald a.k.a. Richard Minissali is curator of the widely traveled photography show "Coast to Coast: New Wave and Punk Rock Imagery." Winner of many awards he has received a Polaroid Film Grant, a Light Work Photographers Grant, and a grant from the Eyes and Ears Foundation. Between 1977 and 1979 he collected the material that became the book *X-Capees*.

More recent book credits include editing *Dead Kennedys: The Unauthorized Version* with text by Marian Kester and *Weird Angle* a book of his own photographs, both published by Last Gasp of S.F.

GEORGE SERA

PHOTOGRAPHERS

The editors regret that, in spite of their efforts some names of band members, and photographers have been omitted. Any additional information which might aid us in making future editions of this book more complete should be sent care of the authors to:

HARDCORE CALIFORNIA
c/o Last Gasp
2180 Bryant Street
San Francisco, CA 94110

HAROLD ADLER , Photo: 148, VICKI BERNDT , Photos: 112 , 239, LYNDA BURDICK , Photos: 9, 25, 27, 30, 44 , 58 , 97 , 228 and 236, BOBBY CASTRO, Photos: 114, 207, 212, ED COLVER, Photos: 4, 6, 19, 32, 33, 37, 40, 46, 62, 63, 64, 65, 68, 69, 72, 73, 74, 75, 77, 78, 81, 82, 85, 86, 88, 89, 90, 91, 92, 94, 97, 100, 101, 102, 108, 110, 111, 113, 115, 133, 157, 232, 235, 243, LIAM CUTCHINS, Photo: 132, CRAIG DIETZ, Photos: 42, 50, 51, 52, 53, 54, 79, PAULETTE DENIS, Photo: 242, NEAL EWENSTEIN, Photos: 175, 189, KAREN FILTER, Photos: 94 , 99, 107 , f- stop FITZGERALD, Photos: 2, 151, 193, 205, 210, 227, 231, 234, AL FLIPSIDE, Photos: 11, 31, 34, 55, 56, 57, GLEN E. FRIEDMAN, Photos: 41, 71, 76, 153, 154, and 155, FRANK GARGANI, Photos: 22, 36, 59, 60, 67, 80, 84, 105, STANLEY GREENE, Photos: 96, 159, 171, ALAN GRASSO, Photo: 241 , JEANNE HANSEN, Photo: 198, CARL HOFFMAN, Photos: 203, 238, JIM JACOY, Photo: 219, MICHAEL JANG, Photo: 165, GARY LEONARD, Photos: 7, 13, 39, 43, 48, 106, 109, 204, LIG, Photo: 149, MITCH LINDEN, Photo: 200, MACHINE, Photo: 194, RICHARD McCAFFREY, Photos: 29, 116, 121, 130, 146, 152, 160, 168, 199, 216, H. D. MOORE, JR., Photo: 166, ROBERT MORRISON, Photo: 124, ERICH MUELLER, Photos: 136, 138, 145, 156, 158, 215, 221, 224, 226, 229, STEFANO PAOLILLO, Photos: 127, 131, 147, 161, 197, 201, 202, JONATHAN POSTAL, Photo: 119, JULIE POTRATZ, Photos: 211, 217, RUBY RAY, Photos, 20, 21, 35, 38, 126, 128, 135, 139, 140, 141, 142, 143, 164, 167, 170, JOE REES, Photos; 178-188, MARSHAL RHEINER, Photo: 150, WYNN RICHARDS, Photo: 237, GARY ROBERT, Photos: 3, 222, GEORGE SERA, Photos: 1, 176, 213, 214, 230, 233, WILLIAM SIGFRIED, Photos: 117, 134, 195, 220, RON SPENCER, Photo: 15, JAMES STARK, Photos: 118, 120, 122, 123, 137, ROOH STEIF, Photo: 70, JULIE STEIN, Photos: 173, 174, 223, ANN SUMMA, Photos: 5, 10, 12, 17, 23, 24, 26, 45, 49, 61, 66, 87, 104, COOKSEY TALBOT, Photos: 125, 172, ELAINE VESTAL, Photos: 8, 28, 144, 163, 177, 190, JILL VON HOFFMAN, Photos: 14, 16, 129, 169, ALEX WATERHOUSE-HAYWARD, Photo: 191.